Architecture as Nature

ARCHITECTURE AS NATURE

The Transcendentalist Idea of
LOUIS SULLIVAN

NARCISO G. MENOCAL

The University of Wisconsin Press

Published 1981

The University of Wisconsin Press
114 North Murray Street
Madison, Wisconsin 53715

The University of Wisconsin Press, Ltd.
1 Gower Street
London WC1E 6HA, England

First printing

Printed in the United States of America

For LC CIP information see the colophon

ISBN 0-299-08150-8

Para Marta,
a quien tanto debe
este libro

Ceux donc qui n'oublient pas la fonction de le squelette qui l'assure, l'articule et la soutient, pourront le revêtir de tous les vêtements possibles . . . pour tendre à la plus magnifique expression de la vie collective de l'esprit à ce moment-là.

Élie Faure

CONTENTS

ILLUSTRATIONS

PREFACE

THIS BOOK attempts to explain Louis Sullivan's conception of architecture. It focuses on the one important thought he conveyed in writings and architectural design throughout his life. My task has been primarily to interpret his beliefs, as reflected in his writings and in his architectural style in general, and for this reason buildings have been brought into the text mainly to highlight aspects of his thinking. I endorse the current view that it was Sullivan's partner, Dankmar Adler, who almost exclusively designed the commissions for which their firm is rightly famous. Sullivan is seen in this work as an ornamentalist favoring decoration and facade composition as means of expressing very rich and complex intellectual conceptions which, on the other hand, were not the result of systematic thinking. His thought was always closely bound to emotions related to events in his life.

So forceful was Adler's intervention in his career that it divides it into two parts—with and without Adler. Success was the keynote of the first half, forlornness of the second. Sullivan's uncompromising attitude toward clients is well known, and Adler cushioned him against realities he was unable to handle by himself. After the partnership was dissolved, a desire to compensate for the security Adler had once given him may have prompted Sullivan to use the Architectural League of America as a rostrum from which to influence the esthetic thinking of young architects. When this path to fulfillment was eventually closed to him, he entrenched himself further in his ideas. During the early years, Adler had provided him with a substantial number of commercial buildings on which he had been able to develop his ideas of composition and ornamentation. Later, by himself, Sullivan was capable of securing only a few commissions for rural banks and a handful of houses. For these and other causes he applied his ideas in an altogether different manner from one period to another.

This division of Sullivan's life into two main parts with an interlude between them determined the distribution of my material into sections that are more or less independent of each other. Each emphasizes the particular influences, attitudes, opportunities, and interests Sullivan had at that period of his life. By making each part seemingly unrelated to the others, I hope to single out the fact that variety was not only a product of his random thinking but was, more important, a result of emotional reactions to external circumstances.

I wish to express gratitude to the people who have helped me. William Bunce and his staff of the Kohler Library, Madison, Wisconsin, Marguerite Kaufmann, formerly of the Ricker Library, Urbana, Illinois, Daphne Roloff and John Zukowsky of the Burnham Library, Chicago, and Adolf Placzek and Herbert Mitchell of the Avery Library, all were particularly helpful. The Graduate School of the University of Wisconsin furnished me with the services of Anne Colman during the summer of 1978; a better research assistant would have been difficult to find. George Talbot of the State Historical Society of Wisconsin and Alan K. Lathrop of the Northwest Architectural Archives were more than generous with their material and time. Among the people who allowed me the use of their photographs is Thomas A. Heinz, who placed his superb collection of Sullivan slides at my disposal. Frank Horlbeck was equally generous. Jeffrey Dean also kindly allowed me to use several of his pictures. Hanque Macari's excellent drawings will undoubtedly increase the reader's understanding of Sullivan's residential architecture. I am also indebted to Paul Sprague for sharing with me his knowledge of Sullivan and his photographs, to Jan Vansina for enlightening me on aspects of Islamic architecture, and to Merton Sealts for clarifying for me questions about Emerson's thinking. Joseph Bradley kindly granted permission to publish his father's letters. Jon Buschke allowed me to use part of his Sullivan material. I have gained much knowledge about the Néo-Grec from David Van Zanten, who also read the manuscript and offered many valuable suggestions. Other scholars from whom the manuscript profited are Alan Laing, Marcel Franciscono, James O'Gorman, Adolf Placzek, Leonard Eaton, David Gebhard, William Storrer, David Hayman, Phillip Herring, Jane Hutchison, Frank Horlbeck, and Allan McNab. A very special word of thanks goes to Irving Rockwood, Norman Sacks, and James Watrous; more than others they made the book possible with their encouragement and support. I would also like to thank Mary Maraniss, my editor for the University of Wisconsin Press, for her generous assistance. Last, I wish to express my gratitude to two persons. One is Walter Creese, who in a

thousand and one ways has unremittingly supported my work from the very beginning, and the other is my wife, Marta. Without their encouragement this book would not have existed.

<div align="right">Narciso G. Menocal</div>

Madison, Wisconsin
June 1980

Architecture as Nature

1
The Autobiography of an Idea

LOUIS SULLIVAN (1856–1924) believed that the millennium, which he identified as democracy, would be achieved when humanity came to a communion with cosmic principles in an understanding beyond intellectual capabilities. A superficial knowledge of German transcendentalism, suffused with the poetry of Walt Whitman, served as the basis of this notion. Later, Nietzsche provided a further heroic dimension to Sullivan's thought, and French symbolist poetry furnished it with richer possibilities of expression. Sullivan saw himself romantically as fulfilling that fundamental tenet of transcendentalism that held man to be a hero who surrenders his individual volition to nature's supreme will and who understands that a sublime joy lies in that submission. His buildings were to be reminders that out of imperative necessity mankind must establish an intimate bond with nature. He believed that esthetic surroundings shape human behavior importantly and that democracy would finally come into being when all buildings were designed according to his ideas. His architectural style was a reflection of what he considered to be his intuition of nature's processes of creation. He thought of a pattern of stylized stars on a simple cubic tomb as an organic emblem, like blossoms on a branch. Vertical elements on his skyscraper facades were to evoke tall trees growing in a forest, as well as represent architecturally an anthropomorphic rhythm of muscular movement. The browns, golds, and greens of his banks were to serve as reminders of an autumnal landscape. Such symbolism would not only make buildings a counterpart of nature but would also evoke in man the sense of his own dignity as a work of nature.

This conception of democratic architecture, which issued from his perception of nature, was so central in Sullivan's thought that at the end of his life he wrote *The Autobiography of an Idea* to explain how he had developed it through years of questioning, and how importantly it had shaped his architecture.[1] Sherman Paul, who has assessed Sullivan's

3

position in American intellectual history, has suggested that the work was inspired by Taine, who in his *Lectures on Art* "had written of the resemblance between seeds and ideas and of beneficence as the test of art."[2] Charles Whitaker, the editor of the *Journal of the American Institute of Architects*, who commissioned the book, compared it to Henry Adams's *Education*.[3] But a closer source for *The Autobiography* would be Rousseau's *Émile* via Froebel's *Education of Man*. Sullivan's story of his life was a complement to his earlier *Kindergarten Chats*, in which he had shown how, because of an improper education, a student of architecture had had to suffer through a process of unlearning and reconditioning before achieving communion with nature. *The Autobiography* was meant to serve as a case study showing how that young man should have been reared. Sullivan believed that a proper development of the instincts during childhood would produce a correct attitude towards nature in adulthood, and he considered himself fortunate that during his childhood and youth many people had helped him develop his personality according to this view. Three-quarters of the book was devoted to events that occurred before he went to work for Adler at the age of twenty-three.

Sullivan's father, Patrick, born in Ireland on Christmas Day, 1818, had been abandoned by his father at a country fair at the age of twelve. After supporting himself first as an itinerant fiddler and later as a dancing master, he sailed for Boston in 1847, where he continued teaching dancing. Andrienne List, Sullivan's mother, was born in Geneva in 1835. She was the eldest child of Henri List, of Hanover, and of Anna Mattheus, of Geneva. Their two other children were Jennie, born in 1836, and Jules, born in 1841. The family arrived in America in 1850, and purchased a farm in South Reading—now Wakefield—then some seven or eight miles north of Boston, in Middlesex County. Patrick and Andrienne met in Boston, were married on August 14, 1852, and moved to New York. Their first child, Albert, who later became an executive of the Illinois Central Railroad, was born on September 17, 1854. About a year and a half later the Sullivans returned to Boston.

Their second child, Louis Henri Sullivan, was born in Boston on September 3, 1856. Presumably Patrick was doing well with his dancing academy, but nevertheless Andrienne helped him out by playing the piano for him. Under these circumstances, it was thought best to send the children to the farm, where their grandmother could supervise them better than Andrienne could. As a result of that decision, Louis lived with his grandparents between the ages of five and fifteen, attending first the local grammar school and later the English High School in Boston. Because of Andrienne's ill health, Patrick decided to move his

family to Chicago in November 1868, but left Louis behind in South
Reading. Three years later the List household was dissolved; the grand-
mother had died, and the grandfather moved in with his son Jules in
Philadelphia after selling the farm. So as not to interrupt his education
in Boston, Louis was boarded with neighbors, the Tompson family,
where he rounded out a musical education his mother had begun years
before. In 1872 he entered the school of architecture at the Massachu-
setts Institute of Technology. He studied there for a year under William
Ware and Eugène Letang, Ware's assistant, and then applied for a posi-
tion at Richard Morris Hunt's office in New York. Hunt had no open-
ings at the time, but recommended Louis to Frank Furness in Philadel-
phia, where he worked for only three months, the financial panic of
September of 1873 determining his early dismissal. Unable to find
work, Sullivan decided to move in with his parents in Chicago, and ar-
rived there for the first time on the eve of Thanksgiving, 1873. He soon
found work at William LeBaron Jenney's office, and there met John
Edelmann, who eventually became a major influence in his life. After
attending the École des Beaux-Arts in Paris in 1874–75, Sullivan re-
turned to Chicago a few months before his nineteenth birthday.[4]

Sullivan's early awareness of his own esthetic leanings is a recurring
theme in *The Autobiography of an Idea*. He always held that in the
final democratic utopia elegant behavior would be proper to all at all
times, and that as a matter of course gorgeous architecture would then
be the common background of every life. These thoughts may indeed
have been a result of his persistent responsiveness to beauty (which he
had begun to experience in childhood), but they may have been in-
duced by other causes as well. His desire to compensate with courtly de-
portment for his "Irish mongrel origins" is as important as his peculiar
romantic egalitarianism to the understanding of his notion that all men
should be equally refined. By the end of his life, when he wrote the
story of his Idea, Sullivan had perhaps learned from Emerson's essay
"Compensation" that love of elegant manners was not the only "retribu-
tion" he had sought all of his life for having been a child of immigrants.
Complicating the issue were other problems of social adjustment, such
as having had to contend with two different foreign traditions in his
family. Presumably, he had felt that he had to make a choice, and he
came to consider that his mother's Central European heritage was supe-
rior to his father's Irish. Not only did he write that his father had "the
eyes of a pig" and "an excessively Irish face," but he also recalled how in
Boston, where he was born, his family name "was scorned by all but its
owner."[5] Apparently, Sullivan's contempt for his father's nationality
had originated with his mother. Louis intimates that she would attempt
to pass as a Frenchwoman, struggling to disguise a German-Swiss par-

entage, which at the time was considered to be less refined than a French one. But being Mrs. Patrick Sullivan made matters worse for her; the name immediately conveyed the idea of an ignorant and rowdy "Paddy"—one of the "shanty Irish." She solved her problem, her son wrote, by Gallicizing *Sullivan* into *Tulive* "as a general cover-name, and thus secured a happy, life-long escape."[6]

Sullivan's self-encysting within his own philosophical beliefs was partly a defense against the emotional vulnerability which colored his thought with an extraordinary vehemence and sought release in artistic activity. It was mainly because of this intensity of purpose that he bound together the events of his *Autobiography* with three strands—the realization of his own esthetic emotions, the development of his intellect, and his turning the synthesis of these two into a conscious artistic intention. This latter consisted in seizing the transcendent essence of the universe and expressing it in buildings by bringing together symbols of the lyrical, rational, and heroic.

Following the best tradition of Rousseau and Froebel, Sullivan stressed in *The Autobiography of an Idea* how during childhood his lyrical instincts were allowed to develop properly by uninhibited contact with the land on his grandparents' farm. During these early years, he claimed, he saw in nature analogues of his own physical sensations. In short, by making his surrounding world the object of his imagination, Sullivan made nature satisfy his lyrical yearnings in a manner no playmate could. He was a self-centered child whose "Great Friend" was a large ash tree, which the boy believed to be imbued with importance, beneficent power, and wisdom. There was also "his domain," a small meadow crossed by a brook and bounded by a grove and a marsh. There he played often, and always alone.[7] Such a pervasive influence was nature in Sullivan's childhood emotions that he came to conceive it as a transcendent totality when he was only fourteen. As would be expected at that age, his enlightenment had the forceful spontaneity of youthful realization. His grandmother had died, and when he entered the room he was anguished by the fact that the dead body no longer seemed to be that of his grandmother as he remembered her. A strongly lyrical emotion soon assuaged this grief. Seeing the orchard in bloom and realizing what it symbolized, he felt intuitively that a rhythm of life and death sustained the universe and that his grandmother had become part of a larger existence, of a reality beyond the visible and tangible.[8]

The rational was also an important element in Sullivan's development. During late childhood and youth, and therefore again at the time recommended by both Rousseau and Froebel, his intellect was trained by a number of people who made him come to an analytical understanding of his idea of the visible world. His *philosophe* grandfather, a

rational agnostic in the mid-nineteenth-century sense, undertook Louis's earliest education. Apparently holding ideas similar to Froebel's, Grandfather List encouraged the child to reason out his enthusiasms with a method that would not destroy them in the process. "He knew well," wrote Sullivan of his grandfather, "[that] the child was living in the world of the senses."[9] Another influential teacher of Sullivan's was Moses Woolson, of the English High School. Besides convincing his pupils of the importance of an intellectual method, Woolson stressed the significance of a proper use of words and syntax, in what must have been lucid lectures on English literature. He also introduced his students to botany, and Asa Gray came often from Harvard to lecture to them.[10] One more key character in *The Autobiography* is Monsieur Clopet, Sullivan's instructor of mathematics in Paris. He plays a symbolic role, standing on the threshold of Sullivan's first awareness of a heroic purpose in life. It was he, and quite by chance, who gave Sullivan the idea of making architectural quality depend on a rule "so broad as to admit of NO EXCEPTION."[11] From that moment in the fall of 1874, Sullivan's main aim in life was to achieve a "Clopet synthesis" in architecture.

Eventually, Sullivan's intellectual development acted on his innate romanticism, and made him fuse his concepts of the visible world and of self into one single sense of cosmic unity intimately apprehended. Only then did he consider himself ready to begin what he called his "I will"; he saw his creative work as a heroic assertion of ego in communion with the primal essence. His definition of "Man the Reality" is self-explanatory: "Container of selfpowers: A moving center of radiant energy: Awaiting his time to create anew in his proper image."[12] Man, to Sullivan, was able to emulate the Yahweh of the Book of Genesis.

Such heroic fervor had moved Sullivan to see the male form as a symbol of power, as an image of ideal constructive force. Partly out of this interest in the male form, and partly as well out of conceptions then in vogue, came his desire to express power in design and a corollary interest in architectural anthropomorphism. He claimed in *The Autobiography* that "he came in a manner to worship man as a being, a presence containing wondrous powers, mysterious hidden powers, powers so varied as to surprise and bewilder him. So that Man, the mysterious, became for him a sort of symbol of that which was deepest, most active in his heart."[13]

Through accidental circumstance in 1863, when Louis was almost seven, his father played an unconscious role in the development of this interest. Sullivan recalls that during a vacation in Newburyport, after a swimming lesson, "he took note of his father's hairy chest, his satiny white skin and quick flexible muscles over which the sunshine danced with each movement. He had never seen a man completely stripped,

and was pleased and vastly proud to have such a father."[14] Patrick, one remembers, had the body of a dancer. Shortly after this incident, during a Sunday afternoon picnic, Louis strayed into a grove while his parents sketched. Suddenly he saw, half-concealed by the trees, the towers and suspension chains of the Merrimac Bridge. Recording what was possibly his earliest anthropomorphic identification of a structure, Sullivan remembers thinking that the towers were mighty giants turned into stone. The child became frightened and began to cry. His father came and soothed him, took him by the hand, and both crossed the bridge. At that time Louis changed his fear of the structure into admiration for whoever had built it. His idea of power as a destructive giant had been turned into one of a beneficent hero acting for the good of man. "On their way to rejoin Mamma, the child turned backward to gaze in awe and love upon the great suspension bridge. . . . And to think it was made by men! How great must men be, how wonderful; how powerful, that they could make such a bridge; and again he worshipped the worker."[15] A few days later his father took him to visit a shipyard: "Here were his beloved strong men, the workers—his idols. . . . He had his first view of the power of concerted action. . . . What could men not do if they could do this, and if they could make a great bridge—suspended in the air over the Merrimac."[16] Another similar experience occurred years later. Arriving in Chicago for the first time, he saw the task of reconstructing the city after the fire of 1871 as "primal power assuming self-expression. . . . These men had vision. What they saw was real, they saw it as destiny."[17]

Contemplating men in out-of-door activity and comparing them with sources of heroic constructive power were emotional and instinctive acts which Sullivan subsequently intellectualized to obtain the symbols of his ideology. His friend John Edelmann was important, later, in helping him develop his interest in the male form. Not only did he furnish Louis with notions of heroic symbolism during their philosophical discussions, but it was also he who brought Sullivan to the intensely philhellenic Lotos Club. There, whenever they had the occasion, members lived isolated from the community, engaging in athletic competition and exchanging ideas. Thomas Eakins's photographs of his disciples swimming and wrestling out-of-doors would probably furnish an image of some of the activities at the Lotos Club.[18] Sullivan enjoyed participating in the group, and analyzed what he saw. "When in the sunlight [Bill Curtis, the founder of the Club] walked the pier for a plunge," wrote Sullivan, "he was a sight for the Greeks, and Louis was enraptured at the play of light and shade."[19]

Sullivan believed that the coming together of lyricism, rationalism, and heroism was an inescapable circumstance foreordained by higher

powers to shape the thinking of all individuals living wholly according to the dictates of nature. Considering himself to be one such, he went back during his last years, through his writing of *The Autobiography of an Idea*, to reflect with fondness on the sources of a life totally dominated by an introspective search for nature and a compulsion to express this inner vision as absolute truth. Assuming that inasmuch as he was a work of nature he could find the totality of the cosmos encapsulated within himself, he held that looking inward was a way to understand not only himself but also his surroundings and beyond. And it was this unifying universal truth which he sought to represent in his buildings. Truth to him was one, and it expressed itself as fully in the highest of cosmic principles as in the lowest form of creation. Man as an artist— but more fundamentally as a part of all that is—could express only these principles in his work, if he wished his task to be valid and rewarding. The manner of acquiring this knowledge would be different for each person. To Sullivan, learning lyricism on his grandparents' farm, rationalism through teachers, and heroism through the contemplation of the athletic male form in action were accidents proper to his life only. The ulterior message of *The Autobiography* is that every human being must learn of these three components of the self because such is the command of nature. Only when the whole of the human race comes to an understanding of such a synthesis will mankind fulfill its proper role within the total scheme of things; only then will the utopia begin.

Sullivan endorsed these principles all of his life, from his first published speech in 1885 to *The Autobiography of an Idea*, the first copy of which he received on his deathbed. This production of almost forty years of writing more often than not is difficult to read and of inferior quality. It is very cohesive, however. It may be said to form one long, repetitious, and involuted poem in prose, holding the key not only to his thinking but also to the intellectual influences which helped to determine it. Moreover, the unifying thought which it expresses shaped his architecture and contributed to its esthetic importance. Only by taking his thought, as represented in his writings, and comparing it with his artistic production, can one hope to understand clearly his position within the development of American architecture.

The remaining conclusion of such analysis is deceivingly simple. It consists mainly in the realization that the idea his buildings express is the same one that his written works convey. Although today we rightly see differences in quality between Sullivan's architectural and literary productions, to him they had an equal worth. In his mind their merit depended not on the manner of expression but on the substance of the message, on the fact that he was stating not opinion but what he thought to be the absolute truth of nature.

2
Exploration and Assimilation

Early Transcendentalist Ideas:
The "Essay on Inspiration"

Some of the arguments current in the 1880s in favor of expressing national values in architecture paralleled Sullivan's esthetic ideals. Although not clearly defined, one of the notions of national style had become identified with a transcendentalist point of view which had by then percolated down to the level of popular culture. Strengthened in their zeal by the knowledge that similar developments were occuring in Europe, and directed more by their enthusiasm than by a methodical intellectual process, a number of American architects had embraced these ideas eagerly.

This attitude is clearly evident in the symposium "What Are the Present Tendencies of Architectural Design in America?" which the Illinois State Association of Architects held on March 5, 1887. The minutes of the meeting show Sullivan, along with such colleagues as John Root, Dankmar Adler, Clarence Styles, and William Boyington, searching for an identifiably national style of architecture and attempting to define constants in American society from which to derive it. Incongruities in their arguments reveal how much these men underestimated the magnitude of their task, and also how much they made up in self-confidence what they may have lacked in erudition and method. John Root, for instance, declared that there were four distinct and concurrent trends in American architecture. These were "catholicity, gravity modified by grace, utility, and splendor." Clarence Styles on the other hand, pleaded for Yankee ingenuity to invent a national style of architecture that would be "an outgrowth of American thought and feeling, and the result of conditions under which that thought and feeling has been developed."

10

Sullivan, countering Styles's proposition, held that an American expression could not be the outcome of methodical observation, analysis, and classification of social traits and conditions. Instead, he proposed an introspective method. "It seems to me," he said, "that the eventual outcome of our American architecture will be the emanation of what is going on inside of us at present, the character and quality of our thoughts and our observations, and above all, our reflections."[1] To him, culture consisted of the sum of instinctive means by which a nation sought the universal good. The main function of art was to make people conscious of these intuitive processes and to speed up a nation's quest for perpetual happiness. To that end, in an earlier article ("Characteristics and Tendencies of American Architecture"), he had identified "a spirit of liberty" as the salient quality of American culture. He had offered no explanation of how this "spirit of liberty" could be made manifest in buildings, but he did mention two important factors that in his opinion had determined American love of freedom. No foreign domination had interrupted the development of the culture, and the nation possessed the "fruitfulness . . . [of an] unexhausted soil."[2] The vastness of America, its self-sufficiency, and its spirit of egalitarianism were to Sullivan determinants of national identity.

Notions of a relationship between art and society had also been explored by Hippolyte Taine, the French art historian and philosopher, who had written in the "Conclusions" of his *Lectures on Art* (1864) that "the social medium of the present day, now in the course of formation, ought to produce its own works [of art] like the social mediums that have gone before it."[3] Like many architects of the period, Sullivan attached great importance to the teachings of Taine, which expressed better than others the new ideas on the relationship of art and culture. Moreover, he had read Taine's *Philosophie de l'art* and *De l'idéal dans l'art* in Paris in January of 1875.[4] The heightened interest in the expression of national values brought into Taine's thinking by the outcome of the Franco-Prussian War may also have influenced Sullivan as a student. Taine taught at the École des Beaux-Arts from 1865 to 1883, including, of course, the time of Sullivan's attendance. After Sullivan returned to America, these ideas were reinforced in his mind by similar ones that some of his American contemporaries were discussing. They were also reading Taine's works, which had been available in British editions since 1865 and in American ones since 1875.

According to Taine's "final definition," "the end of a work of art is to manifest some essential or salient character, consequently some important idea, clearer and more completely than is attainable from real objects."[5] Taine believed in an ideal function of art, but he also considered

that an observer could learn much about the society from which an artist originated by analyzing what "important ideas" he expressed in his art. Not only was a work of art determined for Taine "by an aggregate which is the general state of the mind and surrounding circumstances," but he also thought that national esthetic characteristics were as autochthonous as vegetation.[6] In addition, he maintained that although a modern esthetic would be non-dogmatic, it would nevertheless follow certain social, economic, and political laws.

Sullivan accepted these ideas as general guidelines for determining national characteristics in art; but he either felt cautious about implementing them or was at the same time following the lead of Herbert Spencer, who in his *First Principles* had written that "progress is effected by increments—all organization, beginning in faint and blurred outlines, is completed by successive modifications and additions."[7] Possibly extending this conception of Spencer's into architecture, Sullivan argued that a national expression would not come forth complete and all at once: "Works [in a national style] awaken imperceptibly, like a tinge of green upon the land, rejoicing in their lesser springtime gladness." This pronouncement, in which he foresaw developments in the relationship of art and culture, is one of the axioms of his "Essay on Inspiration." Although indeed the cornerstone of his ideology, the "Essay" has the disadvantage of being by far the most difficult to read of all his writings. It is an extremely verbose and convoluted poem in prose which he read to the Western Association of Architects on November 17, 1886, expressing his thoughts on the essence of nature, explaining how he had come to that knowledge, and stating his beliefs on the relationship of art and nature.[8]

In the "Essay" Sullivan translated into his own transcendentalist language Taine's well-known geological metaphor for analyzing characteristics of national art; changed Taine's "upper stratum, . . . the loose soil, a sort of soft alluvion and wholly external" into "lesser seasons"; and transformed Taine's "primitive granite, the support of the rest," into an everlasting principle of nature that seems to be very close to Spencer's concept of evolution.[9] "Yet, how tranquilly beneath the tumult and silence," he wrote, "persists a hidden power, mysterious, inscrutable and serene, qualifying imperceptibly both growth and decadence, leading both, sustaining both, denying none."[10] The existence of this creative principle of nature, which he called Inscrutable Serenity, could be felt through spring, a symbol of creative urge. Spring was like the "radiant soul"; through it man received inspiration from "Inscrutable Serenity," the process depending on the degree of harmony one had with nature at that time. The "radiant soul" sustained its joy by satisfy-

ing its aspirations to create, to generate beauty. Its procreant powers were inexhaustible, because the soul is able to renew them with the same sure recurrence of spring regenerating nature. Inspiration could also move from man to nature. The "radiant soul," enhanced "through ever-broadening springtimes," was eventually capable of returning to nature a measure of what nature had given it. This rounding out of the cycle was to Sullivan no steady force but an ever-increasing energy: "Now nevermore to cease in its crescendo, has the lark's refrain returned in part to thee, a rhapsody of echoes from my soul."

The hours of the day made Sullivan realize that inspiration is not nature's only secret; cyclic progression is another: "As day becomes twilight, Spring matures into Summer." Contemplating decay in autumn, he understood the roles that degeneration and death play in nature's economy. Finally, he came to the conclusion that nature's secret lies beyond the progression of life to death to life again. "Spring departed in sweetness," leaving him perplexed; "in vain [he] shuddered through the rustling depth of autumn's slow decay." Nature hints at the existence of its secret but does not reveal it. Extending a metaphor Baudelaire had used in Poem XIV of Les fleurs du mal, Sullivan described the mysterious similarities between universal and individual life by comparing nature and his soul to the sea, which veils the existence of its abysses, yet suggests them in the movement of its waves.

In a broader autobiographical vein, the next passage in the poem tells of the several stages of his enlightenment. He finally achieved peace when he realized that his anguish had been caused by arrogance. Approaching nature in humility, he discovered "the gladsome song of the soul at one with Inscrutable Serenity." Communion with nature, however, would not help him pierce the final mysteries, other than by making him aware of "the strangely complex thought of rhythm—for all is rhythm." This revelation became for Sullivan the closest man could come to understanding the essence of nature. Imitating nature's behavior and manner of production was to be his future satisfaction; teaching his fellow mortals what he had learned was to be his life's work. When death put an end to his efforts, he would return to nature.

There are a number of standard transcendentalist conclusions in the "Essay on Inspiration." Sullivan argued, for instance, that nature's most fundamental characteristic is an eternal becoming; the present is linked to the potential of the future. Man is rewarded for participating in a never-ending scheme of creation by the satisfaction of accomplishing tasks. Supreme joy lies in constructive work, and the production of art according to the precepts of nature falls into this category. Although, like Spencer, Sullivan considered that nature's rhythm had two

parts, growth and decay, his discussions of art concerned themselves only with growth. He never said how decay worked in art, but one may infer that in his thought Inscrutable Serenity would inexorably perform the task of rendering obsolete the work of previous ages. This is not to say that he doubted the existence of a universal and therefore unchanging method of design, but merely that he made a natural distinction between the esthetic aspects of art and those of its physical existence. To him, man could finally come to an immutable and perfect style by becoming one with Inscrutable Serenity through meditation. He also believed that an architecture following nature's precepts would create buildings retaining their identity as individual specimens, but that nevertheless their designs would be formulated according to unchanging principles, in the same manner that in nature the appearance of a species does not change in many generations, although each member of the group is recognizable as an individual. The purpose of historical becoming, in the Hegelian sense, consisted for Sullivan in a progressive understanding of nature through art: "The vital purpose and significance of art is that of attuning its rhythmic song . . . to the rhythms of nature as these are interpreted by the sympathetic soul." There is also a strong influence of Hegelian dialectics in Sullivan's conception of a contest between man and the awesome forces he is set to conquer. But in the 1880s these ideas were seldom found in a context similar to their original one. Most of the postulates of the "Essay on Inspiration" were but echoes of late eighteenth and early nineteenth century German transcendentalism mixed with a goodly amount of romanticism.

These theories had been popular for almost a century before Sullivan made them his own, and it may be argued that he could have assimilated them at fifth or sixth hand rather than deriving them from their German sources. Yet certain influences are too explicit in Sullivan's thought to have been acquired randomly. There is in particular the evidence of the nomenclature. Inscrutable Serenity, or the Infinite Creative Spirit, as he later called it, is very close to Fichte's *allgemeinen Ich* —the Universal Ego or Self. This is the World-Creating Action, the Moral World Order, the *ordo ordinans*. According to Fichte, and also Schelling, man achieves true humanity when his sensuous nature enables him to act morally with no effort. Schiller expressed this idea in the concept of the *schöne Seele*—the beautiful or radiant soul. The *schöne Seele* is so closely identified with the will of nature that it fulfills the moral law through its own inclination. According to Schiller, only through esthetic education, by apprehending the metaphysical essence of nature through sense and intuition, would man gain this nobility. Thus Schiller's *schöne Seele* became Sullivan's *radiant soul*. The only

appreciable difference between the two expressions is traceable exclusively to the language in which they were couched.[11]

Sullivan probably learned most of the German philosophy he knew from his friend John Edelmann.[12] (There is no evidence that Sullivan read German, and few works by German transcendentalists were available in English before 1885.) During many an evening at the Lotos Club, Edelmann, who had spoken German since childhood, introduced Sullivan to German transcendentalism. The friendship developed into an informal master-disciple relationship which lasted for seven years, until Edelmann moved to Cleveland in 1881. Edelmann apparently had a forceful personality. His voice, Sullivan wrote in his *Autobiography of an Idea*, was "rich, sonorous, [and] modulant, his vocabulary an overflowing reservoir." He was, Sullivan continued, "a man of immense range of reading, [having] a brain of extraordinary keenness . . . that ranged in its operations from saturnine intelligence concerning men and their motives, to the highest transcendentalisms of German metaphysics." Sullivan also remembered that Edelmann "was as familiar with the great philosophers as with the daily newspapers."[13]

Such high praise now seems excessive; Edelmann was never the scholar Sullivan assumed him to be. Recording more than anything else the joy he felt at the age of seventeen when Edelmann furnished him with an intellectual base explaining, reinforcing, and sanctioning his emotions, Sullivan exaggerated Edelmann's accomplishments. No evidence exists that Edelmann ever received a systematic education in philosophy. This fact, as well as his age at the time—he was but twenty-one—suggests that his apparent erudition in philosophy in general and his knowledge of German transcendentalism in particular had come from reading general textbooks on the subject. Only the most salient ideas of important transcendentalist philosophers—for the most part those one would expect a handbook to discuss—are present in Sullivan's writings. This was in all probability all of the information Edelmann had and passed down to him.

Walt Whitman's poetry helped Sullivan translate many foreign concepts into an American idiom. A letter to Whitman of February 3, 1887, which Sherman Paul has published, documents Sullivan's first reading of *Leaves of Grass* during the preceding year. "It is less than a year ago [hence 1886]," Sullivan wrote, "that I made your acquaintance so to speak, quite by accident, searching among the shelves of a book-store."[14] Sullivan first quoted extensively from Whitman in "The Artistic Use of the Imagination," a paper he read to the Chicago Architectural Club on October 7, 1889.[15] *Leaves of Grass* had reinforced his belief in the romantic truism that an artist is a creature of instinct

rather than reason. With an even greater emphasis than Wordsworth and Victor Hugo had used in stating the idea, and as if it were being proclaimed for the first time, Sullivan announced that "it is only when to the qualities of artist are added those of poet that reflection takes a powerful hand in shaping results." The poet was to him the man of vision, Whitman's "seer," the possessor of a "radiant soul," the "greater springtime." The artist was the "lesser springtime" following the poet's lead.

Such standard transcendentalist and romantic ideas and an extraordinarily flamboyant prose are the main characteristics of Sullivan's writings of 1885–89. Highly lyrical in style and explaining little about how to design buildings, they point clearly to the task Sullivan was setting for himself. The chief function of architecture would be to express philosophical concepts related only to what he considered to be the highest truths of nature. The writings of these four years are of extraordinary importance in understanding the rest of Sullivan's work. They established the bases of his thinking for the rest of his life. From this time onward, his work—architectural as well as literary—would be a further explanation, elaboration, and refinement of this message, but never a departure from it.

Geometry and Ornamentation:
Theory and Practice

Sullivan's idea of how the millennium was to be brought about matched the nineteenth-century notion that the entrepreneurial system determined progress. Science, industry, and commerce would release man from burdensome toil and discomfort and would render him free to devote himself to the pursuit of the better things. "Inscrutable Serenity" had created the power of financiers for the benefit of humanity, and a "Dionysian beauty" was evident in their energetic pace for putting up skyscrapers, extending railway lines, building bridges, and fostering in general the progress of civilization. The idea of such noble power evoked in Sullivan a heroic mental picture of titans: of "a company of naked mighty men, with power to do splendid things with their bodies."[16] America's "organized commercial spirit," he wrote, was equal to "the power and progress of the age, [and stood for] the strength and resource of individuality and force of character."[17] Industrialists were performing beneficent acts of power; and beauty, to Sullivan, was a product of the forceful assertion of a heroic ego. Nature was, after all, an assertion of the "Infinite Creative Spirit." His ideas, he implied many times, were not Apollonian ones.

Believing that what he called "the spirit of the age" was finally moving towards its destiny, Sullivan inveighed against artists for obstructing the way. By not using their art to proclaim that the soul of man was a reflection of the soul of nature, and by concerning themselves only with a selfishly effeminate gratification of their petty sensibilities, artists were avoiding their life's mission. Seeing how it allowed for "femininity" to dominate over "virility" in art, Sullivan deplored what he perceived to be but superficial elaboration in composition. In his opinion, most works of art of the period were "beautifully executed with much passion, earnest labor, and diplomatically tempered to the understanding." Unfortunately, art had become "too much a matter of heart and fingers, and too little an offspring of brain and soul." The quality of art, he considered, would improve only by bringing forth in it an explicit expression of power, and not leaving masculinity disguised under a feminine garb, like Hercules "at the feet of a modern Omphale."[18]

It had been primarily through Michelangelo that Sullivan had understood that power can be expressed in art. While a student in Paris, he had become excited by Taine's comments on Michelangelo and had spent two out of his three days in Rome in the Sistine Chapel. Realizing

17

that some of Michelangelo's figures expressed power as a harnessed force while others were thrust forward by a heroic impulse, he came to consider the Sistine Chapel nudes as paragons of the heroic figure. This impression never left him. In *The Autobiography of an Idea* he praised Michelangelo as he did no other man, considering his work the image of the Nietzschean superman.[19] Moreover, a number of Michelangelesque studies of nudes drawn by him in 1877–85 (now in the Avery Library and the Art Institute of Chicago) point to his heightened interest in Michelangelo at that time (plate 1).

Once he had come to know that power could be evoked by art, Sullivan's most fervid desire was to make such an expression the basis of his architectural esthetic. Yet he was unable to make manifest his ideal in his buldings because he found no contemporary design that could serve him as a stylistic prototype. He finally discovered such an example in Henry Hobson Richardson's Marshall Field Wholesale Store (Chicago, 1885). Possibly because this building translated into contemporaneous terms the austere monumentality of *quattrocento* architecture—which Sullivan admired to the point that he felt bound to Florence with "a net that seemed but of gossamer"[20]—the Marshall Field Store became for him such an embodiment of power and "masculinity" that years later, in *Kindergarten Chats*, he described it as "a man," "a virile force," and "an entire male."[21]

Having become a catalyst in his career, Richardson's building led Sullivan to his first success in the practical application of his conception of architecture. The final design for the Chicago Auditorium Building, of late 1886 and early 1887, became the first of his Richardsonian compositions and the first expression of his ideals in design (plates 2–3).[22] Sullivan had associated his earlier decoration with picturesqueness and hence with femininity, the Auditorium turned out to be so forceful a building that its "masculinity" excluded ornamentation from its exterior. In his words, it was a building "comely in the nude."[23] Other buildings also "comely in the nude" came immediately afterwards. Such were, for instance, the Walker Warehouse and the Kehilath Anshe Ma'ariv Synagogue (plates 4–5).

Aside from fulfilling an expressive purpose, these monumental manifestations of masculinity executed between 1887 and 1890 served Sullivan as a means of curbing his earlier Néo-Grec tendency in the composition of facades. His ornamental work of those years shows important change. In this respect, Paul Sprague has pointed out that Sullivan's decorative work progressed from "Victorian Gothic beginnings" (probably meaning what is recognized today as a Néo-Grec expression) to a highly personal naturalism "in which organic and geometrical motifs

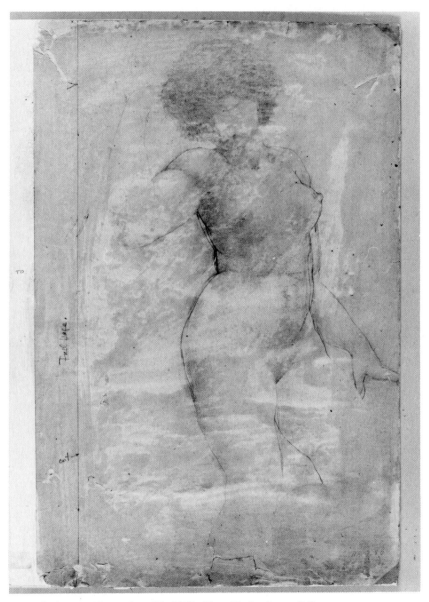

1. Nude figure, November 17, 1880, New York, Avery Library

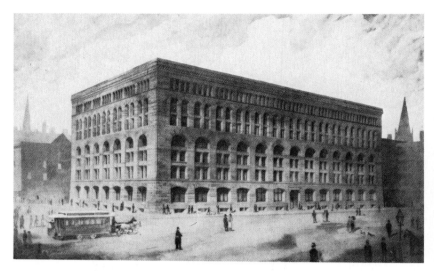

2. Marshall Field Wholesale Store, Chicago, H. H. Richardson, 1885–87

3. Auditorium Building, Chicago, 1886–90

4. Walker Warehouse, Chicago, 1888–89

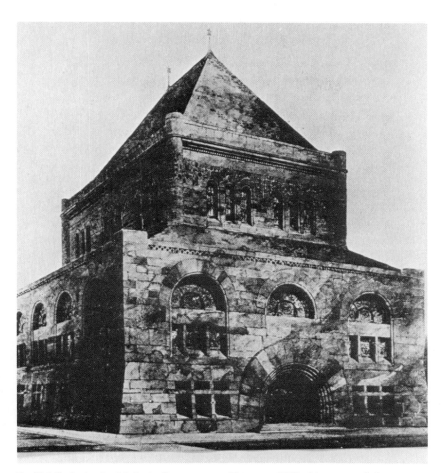

5. Kehilath Anshe Ma'ariv Synagogue, Chicago, 1890–91, original design

were mingled." For Sprague, this change in Sullivan's ornamentation reached a climax between 1888 and 1889, when the interior decoration of the Auditorium Building was being designed.[24]

It is possible that Sullivan's philosophical interests of 1885–86 made him design ornamentation more and more naturalistically to bring it closer to his new organicist ideals. But this explanation is not fully satisfactory by itself. A stylistic provenance for the new style must be sought, too, and Viollet-le-Duc's decorative work, which Sullivan knew well from his student days as well as from publications, provides a source.[25] Sullivan seems to have been greatly impressed by volume 1 of *Dessins inédits*, which was published posthumously in 1884 by a group of Viollet-le-Duc's disciples, Anatole de Baudot, the architect of Saint-Jean de Montmartre the most prominent among them. *Dessins inédits* is a collection of drawings, mostly ink washes, that Viollet-le-Duc had used in reconstructions of such medieval buildings as Notre-Dame of Paris, the Cathedral of Clermont, and the Castle of Pierrefonds. A large number of the drawings are of foliate designs, and many of these, in the manner of late-twelfth-century decoration, are botanically recognizable. A striking characteristic of the sketches is the way each leaf modulates light. The technique, nevertheless, is neither coloristic nor impressionistic, because the elements of composition are kept sufficiently few in number and their shape and place within the design are clearly stated. The fleshiness of these vegetal motifs helps them determine flowing rhythms that in the end resolve into simple geometric shapes. Thus the drawings achieve an excellent counterpoint between sensuous movement and the intellectual restraints of simple geometry (plates 6–7). Similar characteristics appear in Sullivan's ornamentation from the Auditorium on. Simple comparison of his work with Viollet-le-Duc's drawings will show a closeness in feeling, style, scale, general composition, and character. Yet in the end, Sullivan's fully developed lyricism contrasts with the typical mid-nineteenth-century French archaeological approach evident in Viollet-le-Duc's vegetal motifs, their natural appearance notwithstanding (plates 8–9). In spite of its importance, the influence of Viollet-le-Duc was short-lived. By 1890 Sullivan was in command of a personal ornamental style.

Although Viollet-le-Duc furnished Sullivan with a stylistic basis for his ornamental design, it was Emanuel Swedenborg, the eighteenth-century Swedish mystic, philosopher, and scientist, who produced the foundations of its ideological structure. Sullivan's acquaintance with Swedenborg's "correspondences" is documented; he referred to them in the April 2, 1887, symposium of the Illinois Association of Architects.[26] *The Autobiography of an Idea* gives no information on how Sullivan

learned the theories of Swedenborg, but there were people close to him who were interested in such philosophies. His mother, although belonging to no organized church, subscribed to religious convictions close to a Swedenborgian deism, and Sullivan claimed a strong affinity with his mother's beliefs.[27] His good friend, the architect John Wellborn Root, held philosophical notions similar to Sullivan's, belonged to the Swedenborgian Church, and attempted to establish principles of design based on Swedenborg's "correspondences."[28] Root's partner, Daniel Burnham, also belonged to that denomination.[29] John Edelmann is another possible source; at some time he might have been curious to know why transcendentalists were interested in Swedenborg. There were, moreover, a large number of books and pamphlets on the subject which Sullivan might have come across.[30] An important one among them, and one that he might have read, is Emerson's excellent monograph "Swedenborg or the Mystic," which appeared in *Representative Men: Seven Lectures* (1850).

According to Swedenborg, love and wisdom are God's most important attributes, emanate from Him, and sustain the universe. He also believed that universal rationality, or wisdom, comes into harmony with the masculine principle of the cosmos, and emotion, or love, with the feminine. Since to Swedenborg the realms of the physical and spiritual were part of a transcendent totality, he posited that correspondences of wisdom-love, reason-emotion, and masculine-feminine existed between the two spheres.[31] From such concepts Sullivan finally learned that the heroism he sought as the means of becoming one with nature could only be achieved by accepting the dictates of the universal law, by striking a balance between reason and emotion, and by expressing these in art as masculinity and femininity.

A System of Architectural Ornament, a portfolio of plates he produced between January 1922 and May 1923, suggests how Sullivan adapted Swedenborg's theories to establish a fundamental principle of design. This consisted in making organic efflorescence issue from a system of straight or curved lines or any other geometrical combination of them. As a result, the vegetal motifs, representing the "feminine-emotional," dominate visually, but the underlying linear system, standing for the "masculine-rational," sustains the design. Plate 1 of the *System*, for instance, shows well how the process works. It begins with an abstract and inorganic form, symbolized by a square signifying the rational or "masculine" beginning of design. By means of increasingly complex ornamental lines, Sullivan developed this shape into a decorative motif and made the dominant feminine-emotional content issue from the masculine-rational (plate 10). There is a botanical analogy

6. Viollet-le-Duc, decorative motifs from *Dessins inédits de Viollet-le-Duc*

7. Viollet-le-Duc, decorative motifs from *Dessins inédits de Viollet-le-Duc*

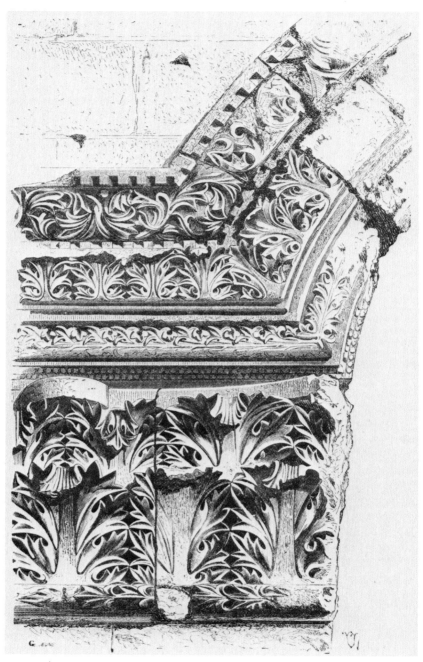

8. Viollet-le-Duc, Golden Gate, Jerusalem, *Discourses on Architecture*

28

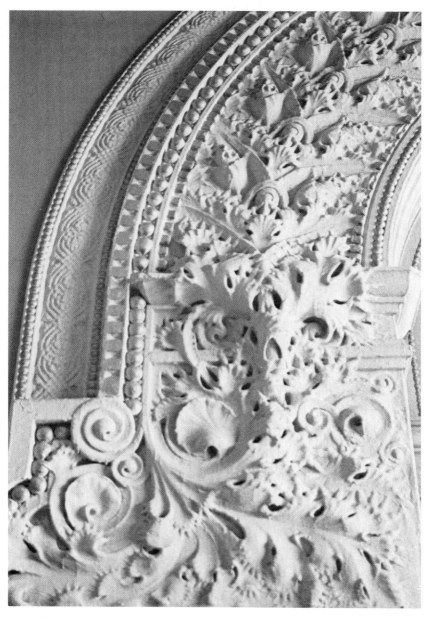

9. Auditorium Building, arcade of lobby

10. *A System of Architectural Ornament*, plate 1

here also. Any line in ornamental design may be compared with a young stem which in due time shoots out leaves, and although it may eventually disappear from view and even memory beneath the foliage, the branch remains always the controlling axis of the design. In the "Essay on Inspiration" Sullivan had considered that this correlation of geometry and the organic was the basis of nature's method of composition, that consequently it had a transcendental essence, and that it established a hierarchical organization where the feminine, although depending on the masculine, was superior to it. Inscrutable Serenity had determined that logic was "conscious and secondary" but that intuition, that is, emotion, was "vital and primary."[32] Sullivan also believed that as nature has dominion over the biological growth of plants, so man can control the esthetic growth of ornamentation. Plates 5 and 6 of the *System* show how a designer has the power of liberating the esthetic energy lying hidden within the confines of lines and geometric shapes, and of determining whether this release will create new geometric axes or new vegetal motifs (plates 11–12). These vital thrusts, according to Sullivan, always rush out with an outward and upward motion. This idea, he claimed, had come to him from reading about plant morphology and biological growth in Asa Gray's *School and Field Book of Botany* and in Beecher Wilson's *Cell in Development and Inheritance*, two books he recommended on plate 5 of his *System of Architectural Ornament.*

By adopting a method of composition that portrayed the two forces on which, according to Swedenborg, all creation depended, Sullivan made his work a reflection, or perhaps an extension, of the transcendent generative process with which Inscrutable Serenity sustained the universe. It was also from following these ideas that rationalism, lyricism, and heroism—the three themes *The Autobiography of an Idea* implies as having structured his life, his philosophy, and his work—finally came to shape his architectural design. Eventually, Sullivan extended Swedenborg's polarities from decoration into architecture, and related them there to geometric rigor and organic abandon also. The simple rectangular shape he finally favored for buildings expressed for him, through geometry, the existence of the inorganic as well as the intellectuality of the masculine-rational. His ornamentation, on the other hand, represented to him the organic and the lyricism of the feminine-emotional. Linking the two symbolized the heroism of acting like nature.

The realization of these possibilities in expression had not come to Sullivan all of a sudden. Rather, it had begun with the declarations of the "Essay on Inspiration" and similar writings, continued with his interior decorations of the late 1880s, and culminated in 1890 with the as-

11. *A System of Architectural Ornament,* plate 5

12. *A System of Architectural Ornament*, plate 6

sertion of his innate preference for rich exterior ornamentation over the
austerity of his 1887–89 style. In reality, the architecture which the Au-
ditorium Building had so brilliantly inaugurated signified but an inter-
lude in Sullivan's career, helping him to come to terms with the expres-
sion of masculinity in architecture and purging his design technique of
picturesqueness. Once purified, he could turn with confidence to build-
ings "clad in a garment of poetic imagery" and to "strong, athletic . . .
forms [that] will carry with natural ease the raiment of which we
dream."[33] This new style served him, among other things, to establish
what he saw as a fuller union of art and nature, to correlate more inti-
mately his conception and practice of architecture, and to satisfy his
urge for that "romanticism . . . [he] crave[d] to express."[34]

In the same manner that the Richardsonian Romanesque had been a
catalyst for the earlier style, Moorish architecture now served Sullivan
as a basis for studying exterior decoration, and he experimented with
Moslem forms and principles of design in three important commissions
between 1890 and 1892—the Getty and Wainwright tombs and the
Transportation Building of the World Columbian Exposition. Of these,
the Carrie Eliza Getty Tomb in Graceland Cemetery (Chicago, 1890)
was the first among his mature buildings to make an important use of
exterior ornamentation. It marks, therefore, his first bringing together
of Swedenborg's polarities in the design of a building and the first com-
plete application of his system of design. The composition was entirely
from his hand, with no influence or alteration from client or office assis-
tants.[35] Displaying an awareness on Sullivan's part that Moorish geo-
metric patterns serve as modules of design, as sensuous textures, and as
agents of esthetic pleasure, all the proportions of the Getty Tomb derive
from the pattern of octagons decorating the upper half of each wall.[36]
The front of the building is twelve octagons wide, and the side, sixteen
—a simple ratio of 3:4. The door and the masonry at each side of it have
equal widths, four octagons each. The dimensions of the archivolts
around the door also relate to the octagonal module, and the crowns
of the arches correspond in height to important points in the pattern
(plate 13).

In spite of its significance, the pattern is not the most prominent com-
ponent of the design. It plays an ordering role only, emphasizing the
importance of the door and of the windows, which because of their
shape, ornamentation, material, and position stand out against the rest
of the building and are the dominant features in the composition (plate
14). By giving a greater relevance to some elements than to others, Sulli-
van introduced a forceful geometric self-assertiveness in the design of
the Getty Tomb. Its character is strongly suggestive of Western taste

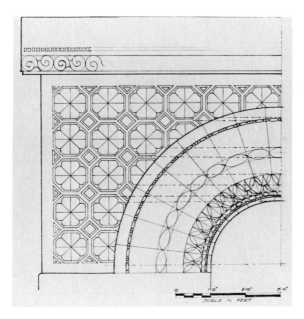

13. Getty Tomb, Chicago, 1890, diagram of ornamentation

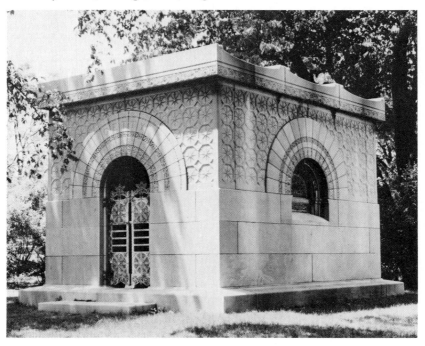

14. Getty Tomb

and matches the style of Sa'adian mausolea erected in Marrakesh under Andalusian influence in the sixteenth century. Their builders, coming from an area that had long been in contact with Christian architecture, had adopted many Western idiosyncrasies in design. One of these, and contrary to usual Islamic practice, was to emphasize door openings more as means of entry than as structural arches.[37] It is possible, as Dimitri Tselos has implied, that among the different varieties of Islamic architecture, Sullivan preferred the North African.[38] This fact would explain why the Getty Tomb cannot match the algebraic subtlety that determines the jewel-like quality of the best of the Moslem pavilions, like those of the Alhambra in Granada or the Alcázar in Seville, for instance (plate 15). Because his knowledge of outstanding Moorish buildings came only from prints and black-and-white photographic reproductions, Sullivan's understanding of Eastern elements was not sufficiently deep, and he disregarded their capacity, which Moslem architects had used with such sophistication, for homogenizing compositions into abstract backgrounds of superb refinement where no element is allowed to dominate sharply (plate 16). But although the Getty Tomb may not have fulfilled Sullivan's esthetic ideal, it nevertheless shows a remarkable integration of Eastern and Western characteristics in a highly controlled design technique. This served Sullivan not only to express in buildings what he thought to be the universal truth of a balance between reason and emotion but also to give vent to his lyricism while at the same time keeping it in check.

The Transportation Building for the Columbian Exposition in Chicago was the climax of Sullivan's use of Islamic forms, and in it he now introduced that most characteristic of Moslem features, polychromy; but as had been the case with the pattern on the Getty Tomb, his use of color bore the stamp of his own personality (plate 17). In this respect, it is entirely possible that having been impressed as a young man by the deep red courtyard surrounded by arcades in the Palais des Études of the École des Beaux-Arts in Paris, Sullivan now attempted to create a similar effect on the outside of the Transportation Building. Here a deep red also dominated, although about forty other tints were used in the design, evolved by Sullivan from February to September of 1891.[39] The main gate, called the Golden Doorway because of its color, was most obviously derived from Eastern architecture. This has been remarked by several architectural historians,[40] who have seen similar characteristics in the slightly later Wainwright Tomb in Bellefontaine Cemetery (St. Louis), one that also resembles a North African funerary *qubba* (plates 18–19). To the observations of these scholars may be added the facts that the designs of the Wainwright Tomb and of the

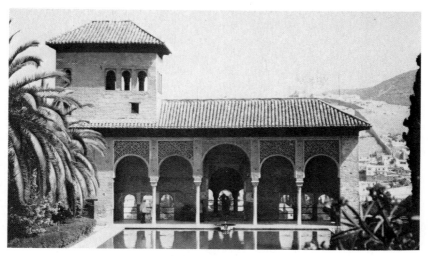

15. Alhambra, Granada, Pabellón del Partal

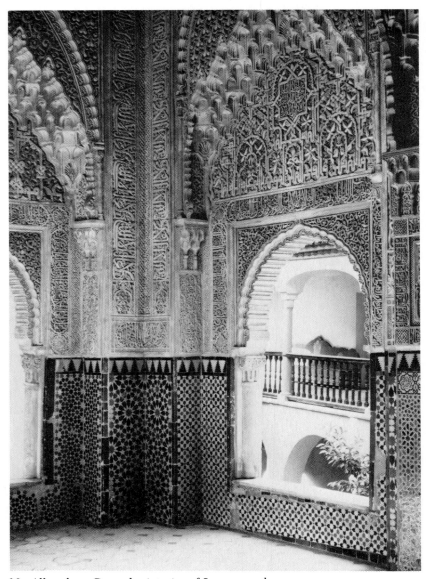

16. Alhambra, Granada, interior of La casa real

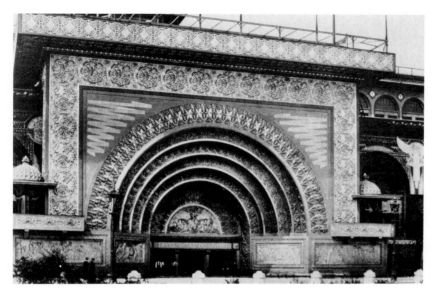

17. Transportation Building, Chicago, 1891–93, the "Golden Doorway"

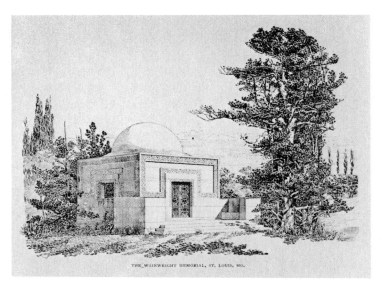

THE WAINWRIGHT MEMORIAL, ST. LOUIS, MO.

18. Wainwright Tomb, St. Louis, 1892

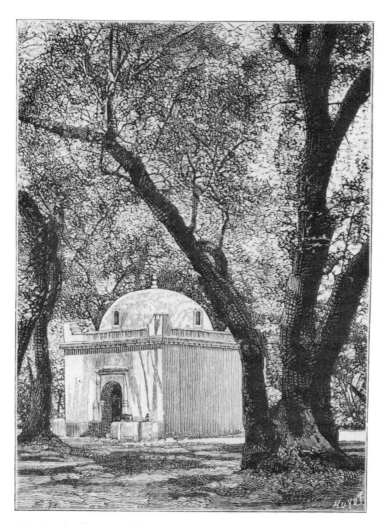

19. North African *qubba*

Golden Doorway derive from the Islamic *pishtak*, a raised square frame surrounding the entrance arch of important Moslem buildings, and that the ornamental borders surrounding the tomb and the main gate of the Transportation Building have decorative and compositional values similar to those of koranic inscriptions running along the edges of *pishtaks*.

The Transportation Building was very well received. Bannister Fletcher, the eminent British architectural historian, described it as being as "fresh as the first rose of summer to the jaded European."[41] In the London *Builder*, an anonymous critic called it the most important polychromatic exercise "erected in recent years."[42] In addition, the three medals (gold, silver, and bronze) of the French Union Centrale des Arts Décoratifs were awarded to it on the recommendation of André Bouilhet, the Union's representative at the Fair, who also took with him to Paris a number of casts made from ornament by Sullivan. These were exhibited there in 1894, and duplicates of them travelled as far as Russia.[43] It seemed, at least for a while, as if Sullivan's ornamented style was about to establish for him a permanent international reputation, probably because of its similarity to the then popular Art Nouveau.[44] But since European artistic ties with the United States were effected mainly through New York, where neither Sullivan nor Art Nouveau had any standing whatsoever, this promise of international renown did not materialize. Sullivan's name ceased to appear in the European architectural press, and except for a handful of admirers, he was soon forgotten.

"The Tall Office Building Artistically Considered"

The facts on how Sullivan became Dankmar Adler's partner are well known. Adler was an excellent structural, mechanical, and acoustical engineer. (The superb acoustics of Carnegie Hall, for instance, were partly the result of his having been brought into consultation for its design.) He was also an able and honest administrator, and had he lived in our times he would undoubtedly have been labeled a very good public relations man. Furthermore, he was one of the best architects of tall commercial buildings of his day.[45] Yet, feeling that his own artistic sensitivity was insufficient to achieve the quality he wanted for his commissions, he hired Louis Sullivan in 1879 to design facades and ornamentation. Sullivan fulfilled Adler's expectations so well that he was made a full partner when the firm was reorganized as Adler and Sullivan in 1883. (Sullivan's date of 1881 in *The Autobiography of an Idea* is incorrect.)[46] Until the end of the association in 1895, Sullivan's main contribution to the firm was the design of ornamentation and facades.[47] Since one of Sullivan's primary interests was to reveal as transcendentalist as possible a program on the exterior of buildings, his work within the partnership could not have been better suited to his vocation. Adler, on the other hand, believed that the working efficiency of a building, and not its appearance, should be a designer's primary commitment. Because of their differences of opinion, Sullivan regarded his role in the office as superior to his partner's, and came to fancy that the main purpose of Adler's work was to provide him with a base on which he could develop his own style of composition and ornamentation, which were to him the exclusive components of architecture. These notions were romantic exaggerations to Adler. He saw Sullivan's role as merely furnishing an excellent adornment rounding out the quality of a building's design.

The differences of opinion between the two partners may have been one of the causes for the dissolution of their association. Their respective ways of thinking are best illustrated in a controversy the two had in 1896 after they had parted ways. Sullivan had published a transcendentalist interpretation of the "form follows function" aphorism, and Adler responded indirectly that Sullivan was an impractical dreamer.[48] "Architecture," Adler wrote, "is not permitted to remain placidly contemplative of the march of events. The architect is not allowed to wait until, seized by an irresistible impulse from within, he gives the world the fruit of his studies and musings. He is of the world as well as in it."[49] "Form follows function" meant to Adler the manner in which a master craftsman puts a building together by availing himself of the best plan-

43

ning and technology of his age to solve architectural problems economically, efficiently, and nobly. Buildings eventually become historical records if designed according to this method, and their architects insure themselves a place in history. "Function and environment determine form" was to him a truth more important than "form follows function." The noted German architect Gottfried Semper, under the influence of Cuvier's theories of natural history, had made similar assertions in his *Der Stil* (1863). This work was known in Chicago, where John Root had published translated excerpts in 1889 and 1890 in *The Inland Architect*.[50] Perhaps Adler, whose native language was German, had read the book in the original.

According to George Elmslie, "Adler's written comment on Function and Form irritated [Sullivan] greatly, 'conditions and environment determine form.' The 'determine' idea is what got his goat; what was left for the creative genius?"[51] Because of these opinions, in "The Tall Office Building Artistically Considered" (the article causing the controversy) Sullivan dismissed those problems that were Adler's concern. The serving of physical functions, structural requirements, and the needs of clients and society were to Sullivan pedestrian matters to be solved by a judicious selection he took for granted, and which occurred before architecture would come to apply the law that "form ever follows function." To Sullivan, the function of architecture was exclusively to express the transcendental essence of a building as eloquently and as characteristically as life is revealed in "the sweeping eagle in his flight or the open apple blossom, the toiling work-horse, the blithe swan [or] the branching oak."[52] In a corresponding manner, Emerson, in his essay "On Art," had advanced the idea that the essence of each being existing in nature is best symbolized by its own appearance: a squirrel leaping from bough to bough has a flair that is proper only to that animal, and so forth. In an article of 1888, Sullivan had identified this peculiar relationship between appearance and character as *style* and had written about the style of a pine tree, the style of running water, the style of a cow grazing in a meadow.[53] Seeking similar analogies between the functions of external appearance in natural entities and in architecture, Sullivan had concluded that the only means by which a building's essential vitality could be expressed were facade composition and ornamentation and that these were the only constituents of the art of architecture. Because the essence of a living organism is most readily recognized by its outward appearance, the design of a facade must reflect a building's essential nature—that is, its *style*—as perfectly and as automatically as a person's likeness conveys the idea of his personality.[54] Planning and con-

struction, on the other hand, depending as they do on the physical needs of society and on technological progress, were not at all related to nature, but only to the material development of civilization. To Sullivan, the practical aspects of building were transient and of far less significance than the composition and ornamentation with which an architectural style of everlasting efficiency could be established. A corollary of this opinion was the belief that a final and permanent style would come only when buildings reflected the transcendent characteristics and processes of nature. In short, when understood by all, this manner of design would be seen as a reflection of nature's own, creating works with the timeless contemporaneity of, say, trees in leaf.

Because of his expressive interests, Sullivan searched for the building type that would reveal best that permanent "Dionysian quality"[55] that he considered the basic feature of American genius in its quest for progress through commerce. Presumably, when he formulated his concept of America, his temperamental preference for an urban and heroic dynamism prevented him from even considering the idea that American democracy could be represented architecturally by a Jeffersonian classical style. His observations had led him to believe that, on the contrary, the proper architectural symbol of American civilization should be commercial, urban, and modern. He therefore considered the skyscraper, although of recent invention, as important esthetically as "the Greek temple, the Gothic cathedral, [and] the medieval fortress,"[56] and its uniqueness, its *style*, to depend upon loftiness. Emphasizing the height of the skyscraper as well as its vertical thrust would convey best its transcendental essence, a fact he explained in "The Tall Office Building Artistically Considered." He also argued in that essay that a tall office building has three parts. There is, first, a two-story base, and each of these two floors is to be differentiated on the facade; immediately above, there is "an indefinite number of stories of offices piled tier upon tier, . . . an office being similar to a cell in a honey-comb"; finally, there is the attic, which along with the basement, houses the building's mechanical equipment. This function Sullivan called "physiological"; elevators and other mechanical devices were part of a "circulatory system."[57]

Sullivan's solution for the vertical expression of the skyscraper has been universally accepted as his most important contribution to architecture. It has generally been avowed that it issues from his earlier Richardsonian experiments.[58] That opinion is not totally accurate.

Sullivan's Richardsonian buildings of the late 1880s have relatively ample bays that correspond to the wide-spanning capabilities of the Ro-

man arch rendered in cut stone. The method is a load-bearing one, and Sullivan confronted no difficulties with it in masonry designs. The Auditorium Building, the Walker Warehouse, and the Anshe Ma'ariv Synagogue have strong lithic expressions blending well with their building technique. But in buildings supported by metal structures, height and method of construction conflicted with this heavy, load-bearing, and essentially tectonic treatment. In 1890 when the firm received its first skyscraper commission, the Wainwright Building in St. Louis, Sullivan rightly realized that the style he had been developing for commercial buildings would not be appropriate in this instance, and hence made the Wainwright "a proud and soaring thing"[59] by going to an expression he had not used before, the Gothic (plate 20).

The Cathedral of Reims, which Sullivan most likely visited during his year's sojourn in Paris, furnishes clues to the Gothic provenance of his skyscraper facade solution. On the inside of the west wall of Reims, below the glazed triforium, a system of horizontal and vertical lines determines alternating rows of vertical panels above and of smaller horizontal rectangles under them. The large vertical panels frame cusped niches and the horizontal ones contain a decoration of naturalistically rendered foliage. If one imagines the large rectangles enclosing windows instead of niches, the similarities between the Reims wall and the Wainwright facade become evident. Although in 1903 Sullivan told his friend Claude Bragdon that the idea for the Wainwright facade had come to him in a flash of inspiration,[60] the stylistic evidence suggests that a dormant memory of Reims was a source of Sullivan's solution for expressing the verticality of the skyscraper (plates 21–22).

Presumably, Sullivan remembered Viollet-le-Duc's advice to draw lessons applicable to modern work from the Gothic, to transform its principles of design into personal ones, and to avoid copying medieval styles verbatim. Accordingly, Sullivan translated the spirit of the Gothic structure from cut stone into metal and terra cotta. His facades for such buildings as the Wainwright, the Trust and Savings Bank Project, and the Guaranty are reinterpretations of the interior elevation of a Gothic cathedral, with its gallery, in many instances, becoming Sullivan's important second floor.

The nave of the Cathedral of Paris was another chief source of inspiration for him. He had become familiar with the building during his student days, and that feeling of ascension typical of the Gothic, which he wished to adapt for his skyscrapers, was to him possibly best embodied in that monument. The influence of Notre-Dame is clearly evident, for instance, in the interior elevation of the Transportation Building, which he designed about five months after the Wainwright, and which

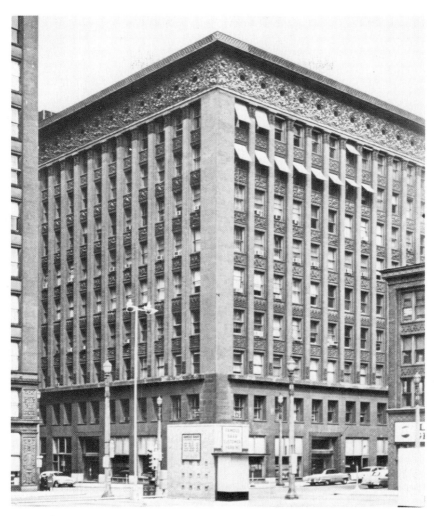

20. Wainwright Building, St. Louis, 1890–91

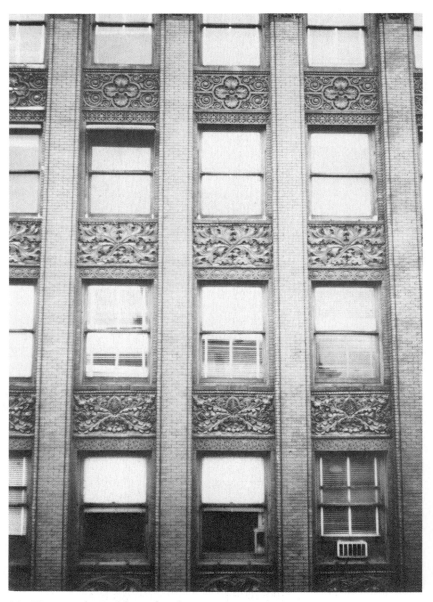

21. Wainwright Building, detail

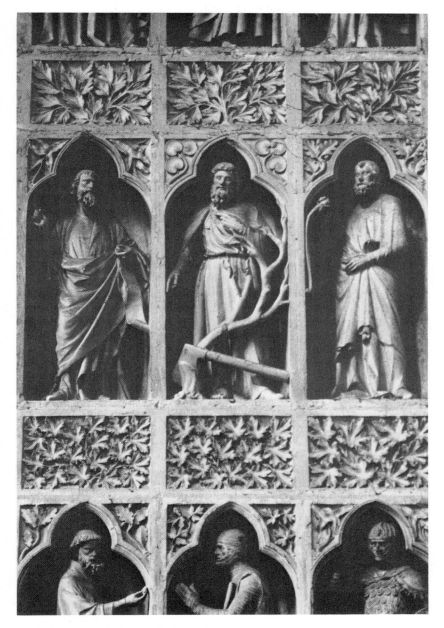

22. Reims Cathedral, detail of interior west wall

was another important experiment reinforcing his confidence in the solution he had worked out for skyscraper facades. As Dimitri Tselos has noted, the interior elevation of the Transportation Building, with its four parts—a ground-floor opening, a gallery above it, a circular window at the triforium level, and a clerestory—follows Viollet-le-Duc's bays in the transepts and nave of the Cathedral of Paris (plates 23–24).[61] In the Transportation Building, each two bays from the gallery up corresponded with only one on the ground floor, which was doubly wide. Thus from the second floor upwards every other pier was a nonsupporting element, a mere decorative feature useful only to establish a rhythm of verticals. Because of this design, roof loads were transferred downward only by those supports that continued uninterruptedly to the ground. This could be construed as further evidence that Sullivan adapted the interior elevation of Notre-Dame for his design of the Transportation Building. A similar ambiguity of expression occurs in the Cathedral of Paris, where although its sexpartite vaults called for an alternation of thicker and thinner piers on the nave elevation, the architect provided no such succession of major and minor supports, and made them all look alike (plate 24).

The facades of the earlier Wainwright Building and of the later Guaranty (Buffalo, 1894–95—now the Prudential Building), where alternating piers and mullions look like each other, evidence also Sullivan's interest in Notre-Dame. Moreover, in the Guaranty—and now bringing the design of a skyscraper facade closer to the interior elevation of Notre-Dame—the first-floor columns are cylindrical, have capitals, and support thinner piers above them (plate 25). But not only such medieval buildings as the cathedrals of Paris and Reims influenced Sullivan's solution for the skyscraper facade. Winston Weisman has noticed that such Gothic Revival structures in Philadelphia as the Jayne Building (1849–51) and the Masonic Temple (1853–55), which had facades resembling giant Gothic windows and which Sullivan knew well from his Frank Furness days, helped him to decide how to express the loftiness of the tall commercial building (plate 26).[62]

Gothic applied sculpture also helped Sullivan bring added meaning to the area under the cornice of buildings. It will be recalled that medieval designers delighted in creating the impression that trusses and cornices were held up by angels. For instance, around the exterior of the chevet of the Cathedral of Reims there are a number of frontally posed angels who support the cornice of the apsidal chapels on the tips of their outspread wings. These angels could well be the source for the figures on Sullivan's Trust and Savings Bank in St. Louis and on his Bayard Building in New York (plates 27–28).[63] On the other hand, angels with

outstretched wings standing in the aedicules atop the south-side but-
tresses of Reims hold the instruments of the Passion in a gesture like that
of the Transportation Building figures (possibly designed by Frank
Lloyd Wright) which hold scrolls with inscriptions of names of people
prominent in the history of transportation. One of the Reims angels, the
one most resembling the Transportation Building figures, was illus-
trated by Viollet-le-Duc on page 17 of the first volume of his *Diction-
naire*, and a preliminary sketch for the Transportation Building, done
before the final refining of the winged figures, is very close to it, al-
though of course, the style is different (plates 29–30).

Despite Sullivan's brilliant solution for skyscraper facades, he would
find from time to time that his "Gothic elevation scheme" could not take
in some prominent feature Adler had determined for a building. In such
cases he resorted to a picturesque composition bringing discordant parts
into harmony. For example, the Late German medieval style of the St.
Nicholas Hotel (St. Louis, 1892–93) reconciles undulating bays and a
top-story gabled roof (plate 31). There were also occasions when Sulli-
van would adapt someone else's design to fit his needs. The similarity of
Daniel Burnham's Ashland Block of 1892 and Sullivan's Chicago Stock
Exchange Building of 1893–94 is a case in point (plates 32–33).

Pragmatic necessities in day-to-day architectural practice had caused
these departures from ideology. Studying them is of less interest than re-
alizing how the confusing anomaly of alternating non-supporting and
supporting piers looking alike on his facades clarifies his idea of "form
follows function." The tenets of "The Tall Office Building Artistically
Considered" and his mixing the nave elevation of the Cathedral of Paris
with the interior west wall of Reims demonstrate his conviction that tall
buildings were to reveal their essential loftiness by a closely spaced
rhythm of uninterrupted verticals, even if ambiguities in mechanical
expression had to be committed to achieve it. In the end, expressing a
transcendental character was to Sullivan the fundamental reason for
design, and his skyscraper facades clearly reveal this fervid belief.

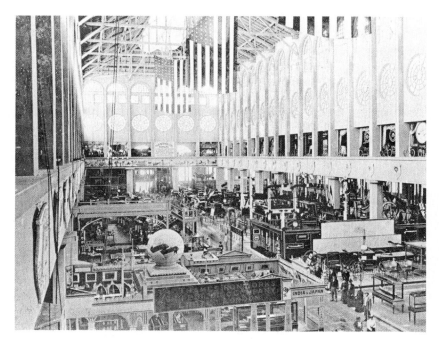

23. Transportation Building, interior

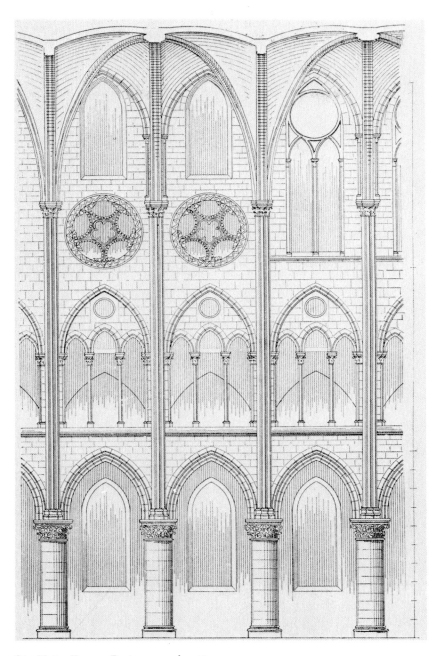

24. Notre-Dame, Paris, nave elevation

25. Guaranty Building, Buffalo, 1894–95

26. Jayne Building, Philadelphia, William L. Johnston, 1849–51

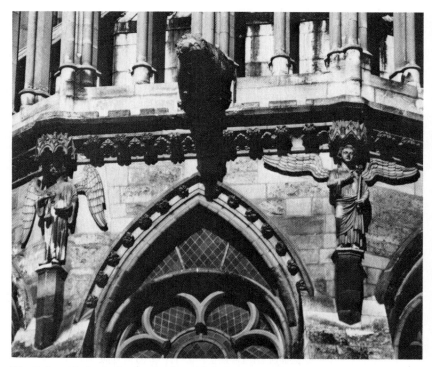

27. Reims Cathedral, angels of apsidal chapels

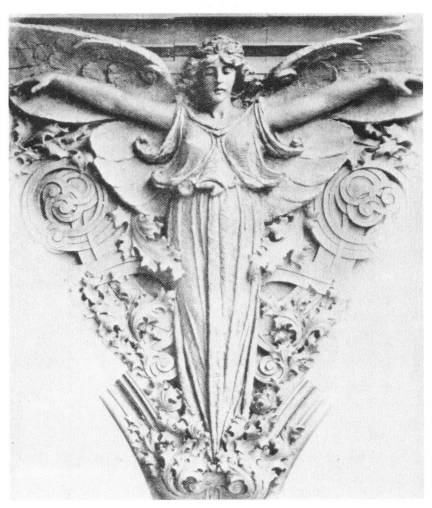

28. Bayard Building, New York, winged figure

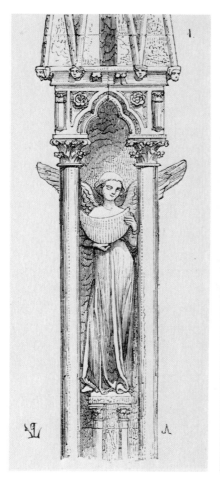

29. Reims Cathedral, angel in aedicule of buttress

30. Transportation Building figure, preliminary drawing

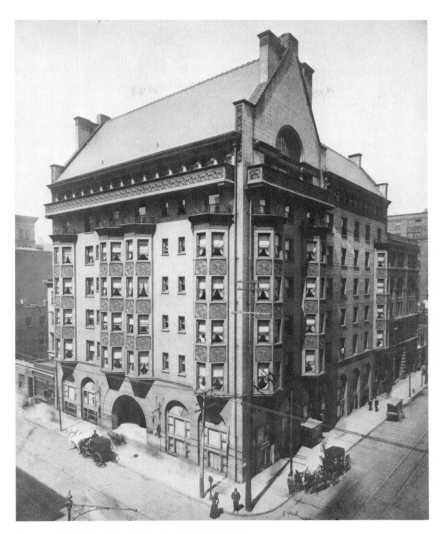

31. St. Nicholas Hotel, St. Louis, 1892–93

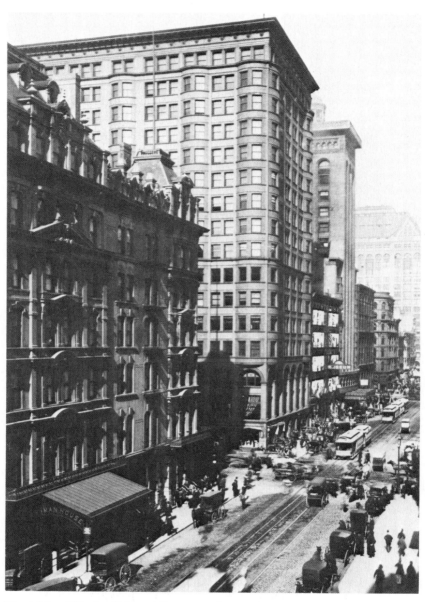

32. Ashland Block, Chicago, D.H. Burnham and Company, 1892

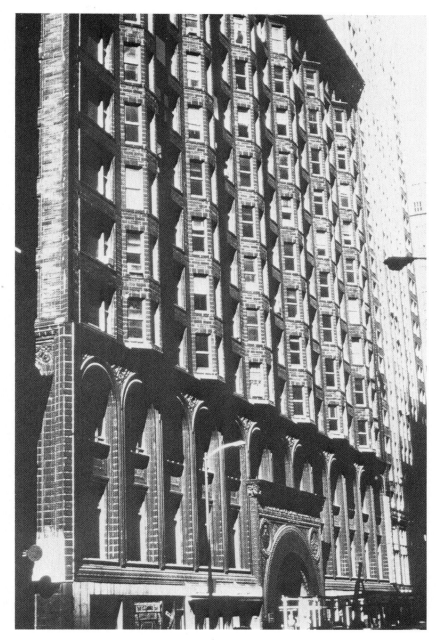

33. Chicago Stock Exchange Building, Chicago, 1893–94

Architectural Anthropomorphism

Sullivan's "Dionysian propensities" had been partly responsible for the dynamism with which his architecture echoed his idea of a universe constantly recreating itself. Man's understanding of his position within this constant becoming would lead to that perfect, dynamic culture attuned to cosmic rhythm.

That man could understand these truths and reach for the operative principle sustaining the universe became the optimistic message of Sullivan's compositions. Evoking human aspiration became his important concern, and the notion that a slenderly Gothic structural system suggested an upward-thrusting movement had shaped his esthetic in an important way. These were principles that rested on well-established organic precedents. A number of eighteenth and early nineteenth century writers, having found a similarity between piers and vaults and trunks and branches, had compared the interior of Gothic cathedrals to growing forests.[64] Obviously by 1890 the idea was by no means new, but Sullivan gave it new significance through his continued effort to make architecture an extension of cosmic truths, and more important, by turning a simile of organic growth into an image of transcendental aspiration, of movement towards the ideal.

He followed three major steps to achieve this end. First, he favored an anthropomorphic image more than he did an arboreous conception of structure. Second, he transmuted the idea of elasticity inherent in the concept of growth into the muscular signification of an upward-reaching movement. Finally, beginning with the Wainwright Building, he subdued the intensity of his achievement by using ornamentation of organic derivation. In this manner, Swedenborg's two principles, the masculine and the feminine (which Sullivan had first fused in the Getty Tomb), became fundamental to his tall office buildings also.

Applied decoration is not the only prominent esthetic factor in his skyscrapers, however. A tension between two irreconcilable goals is also important in these buildings. Their designs express the intimate relationship between architecture and the law of gravity, but at the same time their structures have been turned into something akin to a human frame reaching upward in lofty aspiration. Sullivan wanted a pier to express physical compression (like the trunk of a tree supporting branches), to evoke an illusion of vertical growth, and to suggest a leaping action, a soaring towards the ideal.[65] Besides the obvious opposition between objective stress and subjective strain, a second contradiction between two metaphors, one dealing with human form and the other with plants, seems to be present in this segment of Sullivan's ideology. Although in his writings he favored an anthropomorphic notion over a

62

phytomorphic one, in reality both images seem to have meant the same thing to him, as if both were expressions of the same concept or different aspects of the same substance. Yet whether using a phytomorphic or an anthropomorphic language, his thought always came back to Swedenborg's concept of opposites: "Rhythm of Death" and "Rhythm of Life" were the terms Sullivan used to signify downward compression and upward tension.[66]

A stress of physical pressure acting against a subjective strain became for him the means of achieving a "Dionysian dynamism" through an illusion of arrested motion. Two important effects would derive from this idea. First, by evoking possibilities open to the human being, buildings would come to possess a subjective potential for motion, and that dynamism (or illusion of arrested motion) could be made to suggest the idea that, like a hero, a building was gladdened by the joyful knowledge of its noble individuality. The second result is linked to Sullivan's concept of style, to the belief that the outward appearance of a work of nature is always the image of its essence. Through a method of composition parallelling nature's, a design could be made to express the "heroic soul" of a building. That is to say, it could portray its transcendent individuality in the same way that a picture of a human being could be the best expression of that person's physical and moral character. By means of facade composition evoking the thought that life should be a constant striving towards the ideal, architecture would perform its most important function, thus taking its place within the universal scheme of things.

Although Sullivan did in fact invent a personal style, the doctrines behind it were not new; they had been developing for a long time. Early in the century Hegel and Schopenhauer had claimed (from a classical point of view) that the exclusive function of architecture was to make manifest the universal idea of gravity through the post and lintel system.[67] In time, romantic ideas of associationism, and the belief that a building should reflect the function it serves, had modified that concept, and a second generation of transcendentalists argued in favor of the accidental and the typical. An insoluble conflict (clearly discernible in Sullivan's architectural thinking) was created by the coming together of romanticism and transcendentalism. The functional and essential realities of each building were to be portrayed in each design, but at the same time architecture was to express a universal objectivity common to all buildings. A self-contradicting term, *subjective idealism*, was brought into use to denote a simultaneous association with the typical and the universal.[68] From the middle third of the century on, an increasing interest in tectonics became the means of bringing together in design these mutually exclusive ideas. Even more than in preceding

periods, protruding and receding volumes were used to indicate the relative importance of parts of buildings, while at the same time massive compositions created geomorphic evocations suggesting the universal idea of matter. As a philosopher of the period explained it, architectural elements which until then had been considered inert came to have dynamic possibilities, as if they shared characteristics of the observer's life. Vertical lines now "soared upwardly," horizontal ones "broadened out," etc.[69] This notion was at the core of the concept of *Einfühlung*, or empathy; that is, an act of inner imitation, or the lending of our humanity to forms without souls; the reading of ourselves, as it were, into inorganic nature.[70] Architecture, besides expressing the universal idea of matter and the individual characteristics of buildings, became symbolic of the movements of man and by extension of man himself. In the opinion of the day, this identification was the highest degree of poetry architecture could achieve.

These notions became part of Sullivan's ideology mainly through the writings of Leopold Eidlitz.[71] Born in Prague in 1823, Eidlitz arrived in New York twenty years later, finding that Emerson and his followers had created a sympathetic intellectual climate there for his beliefs.[72] Eidlitz was soon prominent in architectural circles, helped found the American Institute of Architects in 1857, and published around that time a series of articles in the *Crayon* presenting his views on architecture. Those articles served him later as the basis for his *Nature and Function of Art, More Especially of Architecture*.[73] No archival evidence has shown that Sullivan owned a copy of Eidlitz's book, nor did he ever mention Eidlitz's name in any of his writings. But John Root, whose opinions Sullivan regarded highly, considered that of all definitions of art, Eidlitz's was "the most nearly true."[74] It is hard to imagine that Sullivan did not read Eidlitz's book carefully, for even some of his metaphors seem to have been borrowed from Eidlitz. One instance is Sullivan's statement that a part of the facade of a skyscraper should be treated as a honeycomb; Eidlitz had used the same simile in his book.[75] As Sullivan did later, Eidlitz referred to nature to establish a connection between a building and the transcendental idea from which its design emanates. His thoughts on the relation of nature and art are like Sullivan's. According to Eidlitz,

a work of art, like a work of nature, is a realized idea, and the ideal is the essence of architecture. It is the godlike attempt to create a new organism, which, because it is new, cannot be an imitation of any work of nature, and, because it is an organism, must be developed according to the methods of nature. It is this fact which places architecture . . . above all other arts. If a building can express no idea, as ideas are expressed in the works and through the laws of nature, then architecture never was an art.[76]

So numerous are the points of agreement between Eidlitz and Sullivan that their writings may be considered different expressions of the same manner of thinking. Ideas that the transcendent essences of natural organisms serve as archetypes for works of art, and that the word *art* itself had been debased to signify sophistry in the handling of form, while poetry is "the expression of an idea in matter";[77] Eidlitz's deploring that "adornment is not considered as an integral element of the structure,"[78] while to Sullivan ornament should "come forth from the very substance of the material . . . [as] a flower appears amid the leaves of [a] . . . plant";[79] all are examples of the fact that within the development of American architectural thought, Eidlitz was undoubtedly Sullivan's precursor.

In Sullivan's mind, the kinship between the composition and decoration of a building determined the characterization of its image. As the student in *Kindergarten Chats* expressed it, "a building, to be good architecture, must, first of all, clearly correspond with its function, must be its image, as you would say."[80] Eidlitz held also that the form of a building must reflect the essence of its particular function, and that therefore no design solution could ever be repeated with success. "No two species, no two individual monuments of the same species," Eidlitz argued, "emanate from conditions so exactly alike as to make imperative the same expression of strength and refinement."[81] In giving such emphasis to "strength" and "refinement" in this passage, Eidlitz implied, as Sullivan also believed, that character in a building depends on composition and as such should be considered the all-important factor in architecture. According to Eidlitz, it was primarily through composition that art portrayed emotion, and he noted how painting and sculpture achieved this by capturing a gesture on canvas or stone—by arresting motion.[82] Lacking the representational range of painting and sculpture, architecture could only hope to express emotions associated with stress and strain. Inasmuch as the human body is the noblest of all natural organisms, architecture, according to Eidlitz, should refer to it, as painting and sculpture do, to suggest feelings:

The human frame does mechanical work, sometimes with the labor of the carrier of burdens, and then again with the ease of the athlete. It is these gradations of ease, grace, directness, and expression with which . . . mechanical work is done by the human frame, which furnish to the architect the elements of art expressions in his structures. . . . Every structure, like the human body, that assumes to be a work of art, must also be possessed of a soul.[83]

Although Eidlitz was a major influence in Sullivan's consideration of buildings as paradigms of athletic virility, a difference in verve is obvious when one compares the reasons each brought forth to justify the use

of anthropomorphism in architecture. Eidlitz is more rational than Sullivan. "It is the problem of the architect," he wrote, "to depict the emotions of the structure he deals with; to depict, as it were, the soul of that structure."[84] Sullivan stated his reasons far more forcefully in *Kindergarten Chats*:

The architecture we *seek* shall be as a man, active, alert, supple, strong, sane. A generative man. A man having five senses all awake; eyes that fully see, ears that are attuned to every sound; a man living in his present, knowing and feeling the vibrancy of that ever-moving moment, with heart to draw it in and mind to put it out. . . . To live, wholly to live, is the manifest consummation of existence.[85]

Because life was part of a greater essence to Sullivan, the individual attuned to his innate feelings was able to sense "the vibrancy of that ever-moving moment," that is, "Inscrutable Serenity"'s constant re-creation of the universe. The "heart to draw it in" refers to an intuitive understanding of nature's process of creation, while the "mind to put it out" signifies an ability to express this knowledge through art and life. This process of "drawing in" and "putting out" established for Sullivan the fundamental rhythm of the relationship between man and nature. Hence his interest, probably prompted by his reading of Eidlitz, in giving his skyscrapers an appearance that was both elastic and anthropomorphic, characteristics which constituted their *style* as both Sullivan and Eidlitz conceived the term. In this manner also, and through Eidlitz, Sullivan linked anthropomorphism with his previous ideas that a balance of reason and emotion sustains the cosmos, that emotion (expression) is intuitive and reason (structure) intellectual, and that only those who understand this balance are able to create art that reflects nature. In addition to these contributions to his conception of architecture, it may have also been through Eidlitz that Sullivan became aware that eighteenth and nineteenth century romantic writers had often compared the inside of Gothic cathedrals to groves of trees. Eidlitz quoted at length Thomas Hope's excellent example of such a simile.[86]

Sullivan's manner of making evident "the soul of a building" is manifest in his increasingly dynamic facades of the late 1890s. Among these, he considered the Bayard—later called the Condict—Building (New York, 1897) "his most satisfactory skyscraper."[87] Vincent Scully agreed with this judgment in his seminal "Louis Sullivan's Architectural Ornament" (1959), where Sullivan's architecture was first categorized as "empathic."[88] The essential elastic loftiness of the design of the Bayard Building is revealed by its piers (plate 34). They bring together the "Rhythm of Life" with the "Rhythm of Death." This is done by their establishing a closed circuit with the moldings decorating them. Beginning at any point of a pier, one can follow the design down, then, with

34. Bayard Building, New York, 1897–98

no interruption, across the second-floor sill, up the next pier, and finally, closing the cycle, across the top through the arch beneath the attic. As this circuit may be established clock- or counter-clockwise, neither the subjective expression of upward movement nor the objective statement of physical pressure is compromised. Like limbs in a human frame, the piers seem to give the impression that while carrying the weight down to the floor they are also capable of a leaping gesture. The anthropomorphic dynamism of the closed circuit gives elements at the top of the building an appearance contradicting their structural behavior. The arches seem about to burst out from tension while appearing to be held by knots at their springpoints. Winged female figures, symbolizing the ascensional essence of the piers, issue from them; their upward movement is stopped only by the building's cantilevered cornice. Sullivan thus made the transcendental Rhythm of Life seem more important than the structural and hence real, downward Rhythm of Death. This anthropomorphic scheme is further reinforced visually by the opposing character of the design of the first floor, where the lintel works as a summer beam in its etymological sense of *sagma*, or pack saddle, carrying visually the weight of the superstructure and symbolizing, along with the columns below it, the emotion of an Atlas-like feat.

The Bayard Building was not the first design of Sullivan's to use this kind of anthropomorphism. Scully has noticed incipient characteristics of the style in the Wainwright Building (1890), and the style used with a greater maturity in the Guaranty (1894). The Bayard Building was merely a high point in a line of designs to which a two-tower project of 1892 for the Victoria Hotel in Chicago Heights (with winged figures under the eaves), the Trust and Savings Bank Building Project for St. Louis of 1893, and the Eliel Apartment Building Project of 1894 also belong (plates 35–37). A similar stylistic statement is evident in a sketch of an elevation and plan for a country club, dated June 26, 1898, which Sullivan jotted down on the back of a business card now in the Avery Library. The facade has the same elastic appearance, with an entrance arch representing compression below, a soaring arcade above, and a cornice finally boxing up all forces within the surface (plate 38).

Scully's reading of the anthropomorphic program of Sullivan's Gage Building facade (1898) emphasizes the horizontal elements of the composition. His contention that the "pair of decorations upon the upper cornice are like the clasps of giant fibulae from which the piers are hung, and which clasp the cornice against the downward pull" seems difficult to reconcile with Sullivan's statements on the ascensional character of the skyscraper facade (plate 39).[90] The visual divorce between the lower and upper parts of the Gage facade—cast iron and terra cotta —gave Sullivan problems. He had not designed the building, only the

facade, and he had to work around Holabird and Roche's system of con-
struction, in which the central piers are behind the storefront at the
ground floor and consequently cannot be seen from the street. Sullivan
had no visual continuum from the ground up to work with, and neither
had he the broad summer beam of the Bayard Building or the country
club; he had no "saddle" to place his building on. He solved these prob-
lems, first, by making the cast-iron decoration framing the first floor
function like the entrance arch of the country club; second, by reinforc-
ing the downward-bearing impression of the outside piers by depriving
them of ornament; and third, by adding acanthus decorations to the
tops of the two central piers, he made them look as if they were growing
upward like abstracted palm trees. Thus the four piers seem to form
two equal torques, one attempting to move clockwise and the other
counterclockwise (plate 40). Once more, Sullivan made architecture ex-
press the emotion of stress and strain.

The anthropomorphic systems of the Bayard Building, country club,
and Gage facades are set on a single frontal plane. They can be com-
pared to an athlete who, with feet planted on the ground, stretches his
thoracic muscles and arms upward before taking a leap. But in the
Schlesinger and Mayer (later Carson-Pirie-Scott) Store in Chicago, the
dynamic play does not happen along a single plane. There, a strong ver-
tical tower defines a corner, and horizontal lines recede from it in per-
spective. The building's anthropomorphic counterpart in classical art
could be the *Nike of Samothrace*, where a similar relationship exists be-
tween the body and wings. As always, Sullivan applied the law that
form follows function in an expressive fashion, and conveyed the es-
sence of how a corner tower anchors two equally important facades in a
manner strongly reminiscent of Paul Sédille's Au Printemps department
store (1882), by then the most important department store in Paris and
one of the most publicized French buildings of the 1880s (plates
41–42).[91]

The Schlesinger and Mayer Store is in more than one way a promi-
nent landmark in Sullivan's career. It was his last skyscraper. Its design
ends a line which started in the Wainwright Building's adaptation of
the Gothic to express physical loftiness, and which in eight or nine years
evolved into designs where important universal aspirations were ex-
pressed and mirrored in compositions of the utmost refinement. What
Sullivan's skyscrapers would have looked like had he continued design-
ing them is, of course, a moot question. The fact altering his life was
that he could not develop his ideas further along this line because he re-
ceived no more commissions for skyscrapers. With its free-flowing bo-
tanical decoration and unacademic look, his style seemed antiquated to
his contemporaries.

35. Victoria Hotel Project, Chicago Heights, 1892

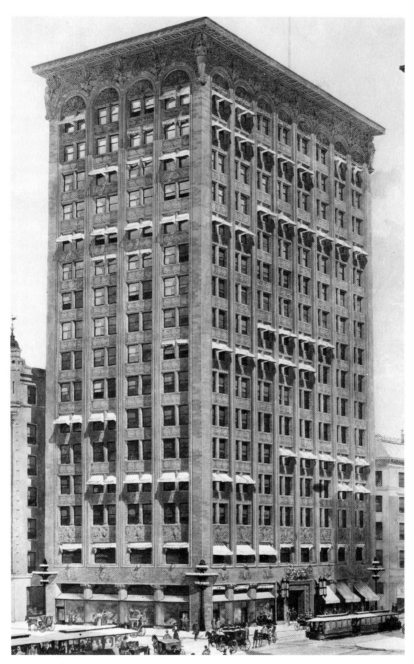

36. Trust and Savings Bank Building Project, St. Louis, 1893

37. Eliel Apartment Building Project, Chicago, 1894, New York, Avery Library

38. Drawing of a country club, June 26, 1898, New York, Avery Library

39. Gage Building, Chicago, 1898–99

40. Gage Building, diagram of visual forces

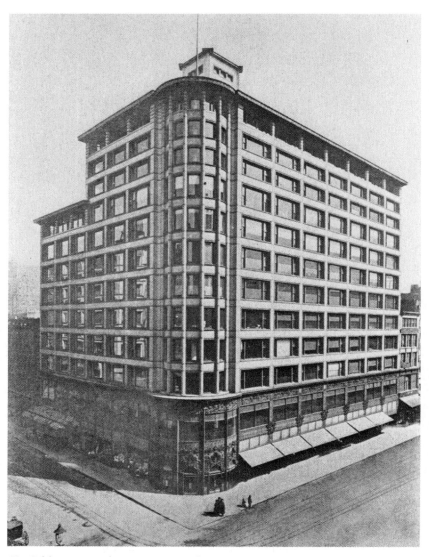

41. Schlesinger and Mayer Store, Chicago, 1898–99, 1902–3

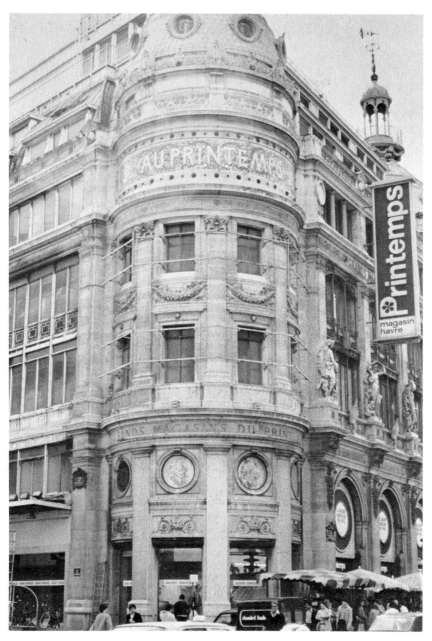

42. Au Printemps department store, Paris, Paul Sédille, 1882

3
Indian Summer

A *Professional Morality: The Architectural League and* Kindergarten Chats

Believing that physical beauty strengthened and prepared men's souls for moral beauty, Sullivan held that man needed only to see the beautiful to be good. All creations of nature had a moral character; contemplating them heightened this virtue in man. Nature had given man its objects, and after understanding them, the human mind created new existence based on a knowledge of natural essences. But art was not only nature created by man. It was, also, the best vehicle for knowing the good, the true, and the beautiful. This relationship between art and nature was inescapable to Sullivan. Nature had opened itself to man and shown him its variety to perfect his judgment in truth, its marvels to stimulate his desire to imitate them in beauty, and its difficulties to strengthen his spirit in virtue. The desire to synthesize the true, the good, and the beautiful in art was a product of that "Dionysian drive" Sullivan had seen as basic to the development of culture, because attaining to a feeling of elation was the manifest aim of humanity. Ecstasy was to Sullivan, as it had been to Emerson, "the law and cause of nature."[1] Anthropomorphism was his manner of expressing through architecture this exultation. The strain in reaching for virtue, the harmony of beauty and virtue in the final knowledge that one's existence is but a part of a greater, ever-changing whole, and the joy of comprehending that fundamental mystery are parts of the message Sullivan conveyed on his skyscraper facades. Their soaring effect expressed, also, the confidence that all of nature existed for the benefit of man. But to profit from that heritage, man must first understand its purpose; architecture, the most visible and necessary of the arts, was to stand in the forefront, showing humanity the way to its final destiny.

During the early years of Sullivan's career, a segment of the Chicago architectural community had shared these beliefs to a greater or lesser extent. But by the time Sullivan was finally able to produce the designs of enormous sophistication he had always dreamed of, a dramatic change in taste had occurred, as the city grew out of the effects of the 1893 depression and new buildings responded to more current academic trends. Partly because of this change in architectural fashion, Sullivan was receiving few commissions. This made him angry and anguished, not only for financial reasons, but more important to him, for ideological ones. The new trends were a threat to his beliefs, and on countless occasions at the turn of the century he repeated, emphasized, pleaded, and cajoled people into thinking that they should allow the will of nature to work through them. Addressed almost exclusively to young architects of the period, Sullivan's message appears on the surface to be supremely optimistic, but in reality it was inspired by fear. Feeling insecure and vulnerable, he hastened to strengthen his position by attempting to make people realize how wrong their new ways were. He also deluded himself into thinking that by the mere broadcast of his ideas people would be convinced of their error, come to truth, and finally establish the utopia.

Under the influence of Whitman, Sullivan translated his transcendentalist ideal into a nationalist one. American buildings would reflect more clearly than others the fundamental traits of humanity, because the American character, being the freest, would eventually lead mankind to the culmination of history. "American architecture will mean, if it ever succeeds in meaning anything, American life," he wrote in *Kindergarten Chats*.[2] An American architectural character excluded, for him, the use of European modes, which had evolved out of aristocratic taste and were therefore unable to express such crucial natural traits of man as a heightened sense of freedom and a greater dependence on individuality. This idea was not new with him, but now more than ever, as he had insisted in 1885 in "Characteristics and Tendencies of American Architecture," architects were guilty of arrogance for imposing foreign styles upon the nation, and of retarding the evolution of a truly American architecture.[3] "American architecture," he cried out, "is composed, in the hundred, of ninety parts aberration, eight parts indifference, one part poverty and one part Little Lord Fauntleroy. You can have the prescription filled at any architectural department-store, or select architectural millinery establishment."[4]

Sullivan's first important opportunity to express his ideas among the young came toward the end of 1898, when the T-Square Club of Philadelphia put to a number of leading architects and professors of architec-

ture the question, "An unaffected school of modern architecture in America [that is, 'unaffected' by European styles and past trends], will it come?" His reply to this query is important for gauging his psychological mood at the time.[5] He was no longer an esthete playing with ideas and contemplating them at leisure for his own gratification. Neither was his concern, now, to explain how nature could be expressed in buildings. He simply repeated, time and again, the more basic and urgent message that architecture must be grounded in nature and that architects must begin immediately to put this idea into effect. Since proselytizing was his new concern, he changed the terms of the question in his reply, and "unaffected school of architecture" became "indigenous architecture." Significantly following Walt Whitman, he used the terms *feudal* and *democratic* in opposition to each other for the first time in his writings.

To Whitman as well as to Sullivan, the salvation of world civilization hinged on the maturing of American democracy through a series of emotional, intellectual, and social developments. "The United States," Whitman wrote, "are destined to surmount the gorgeous history of feudalism, or else prove the most tremendous failure of time."[6] American political institutions as they then existed, however, were democratic in name only. As such, they were unable to bring about the desired evolutionary changes towards the millennium. Only "the poet" (defined as "the esthetic worker in any field"[7]), by taking "possession of the more important fields,"[8] could create a truly democratic climate. The poet alone understood that "democracy can never prove itself beyond cavil, until . . . it luxuriantly grows its own forms of art, poems, schools, theology, displacing all that exists."[9] These new forms, created by "new races,"[10] were to be grounded on the expression of nature, both as a transcendent force and as a cultural reality. Sullivan repeated this Whitmanesque message time and again in the hope of forestalling the trend of the period away from this mode of thinking. In the zeal of his crusade, in his answer to the query of the T-Square Club of Philadelphia, he wrote: "Before we can have an indigenous architecture, the American architect must himself become indigenous. How this is to be done is very easy to explain, but rather difficult of performance; for it is equivalent to asking him to become a poet, in the sense that he must absorb into his heart and brain his own country and his own people."[11]

This idealistic quest for a typically American architecture found an echo at the turn of the century among some of the young. Their yearning to express national values through design had been intensified by William Jennings Bryan's Populist Movement, which advocated a return to grass roots and fostered economic policies benefiting the down-

trodden, especially in the agrarian community. High industry and finance were accused of plotting to create an international oligarchy to squelch the noble and simple foundations of American democracy. "A vast conspiracy against mankind has been organized on two continents and it is rapidly taking possession of the world," charged the Populist platform.[12] Bryan had come from Illinois, and the first nominating convention had met in Omaha in July of 1892. Understandably, the movement had its greatest support in the Midwest. Populist conviction that the conservative intellectual establishment was anti-American paralleled some of Sullivan's ideas on the intrusion of foreign values in national culture, and young architects sympathetic to the movement felt inclined to listen to Sullivan's iconoclasms. For approximately two years around the turn of the century, many architectural associations of the young received Sullivan's pronouncements favorably. But eventually these groups found out that he would not teach them what they wanted to learn, namely, what to do when confronting a blank sheet of tracing paper. The academic method gave everyone a feeling of professional self-confidence, and it prevailed in the end.[13]

In Chicago there were also social reasons for these changes in taste. The city, which had grown very quickly, achieved during the 1890s a new awareness of its own image. Familiarity with the Columbian Exposition and with an increasing number of Beaux-Arts buildings, such as the Art Institute and the Chicago Public Library, helped develop a new consciousness. The appearance the city had had during the preceding decade, lacking in institutional and governmental buildings of note and dominated almost exclusively by mercantilist interests erecting skyscrapers, was no longer considered wholly desirable. The new concern for urban decorum, which eventually led to the Burnham Plan of 1906–9, altered earlier conceptions of architectural design. Concurrently, the emerging progressive style, because of its kinship with romantic and organic ideas, became almost exclusively proper to suburban residences. Neither Frank Lloyd Wright nor any of his followers designed a major building in Chicago's commercial district. Moreover, Prairie architects shared in the period's belief in the propriety of different expressions for urban and suburban designs. Wright's Larkin Building and Unity Temple, for instance, have much more of a classical stance than any other of his buildings.

Chicago's progressive movement developed in suburban architecture and interior design as strongly as classical taste did in urban buildings. Ideas about creating a modern art devoid of influences from the past were exchanged in clubs and associations, some of which had even been established for that purpose. The Chicago Architectural Club, to which

most progressive architects eventually belonged, had been founded in 1888, and this had been followed nine years later by the Chicago Arts and Crafts Society, patterned after its English parent movement. In 1889 the Industrial League had been established, and four years later, the William Morris Society. Some stores sponsored this movement. Marshall Field and Company and the Tobey Furniture Company sold William Morris fabrics, wallpapers, and furniture, and in 1902 the Tobey Furniture Company installed a "Morris Memorial Room." Also, from 1902 onward, the Art Institute helped these movements through Bessie Bennett, its first curator of decorative arts.[14] Philosophies like Louis Sullivan's were central in the organizations concerned with architecture, which to a large extent were composed of idealistic young men.

The Architectural League of America provided Sullivan with a means for making his views known to the new generation. The association brought together most young people's architectural societies in the nation, and more important for Sullivan, the Chicago Architectural Club, of which he was a prominent member, played a major role in the League's foundation. Delegates from every architectural group in the country were invited to Cleveland to the June 1899 founding convention "to increase co-operation between the various clubs, especially in matters of education and exhibitions." Ten architectural clubs and three chapters of the American Institute of Architects sent a total of ninety-seven delegates, averaging thirty-two years of age. Approximately half of them were practicing architects and half were draftsmen.[15]

Sullivan did not attend the meetings. He sent a paper to be read by Henry Tomlinson, who was elected the League's first secretary.[16] The Chicago delegation was familiar with the contents of the paper: Sullivan had read it to the Chicago Architectural Club on the Tuesday preceding the Friday, June 2, opening of the Cleveland convention.[17] This sequence of events indicates that he had prepared the members of the Chicago delegation in advance, perhaps even prompting them about probable discussions and debates, but that he did not attend the meeting out of fear that his arguments would not be strong enough to convince the assembly—an unsuccessful face-to-face confrontation would have damaged his prestige. These worries, if they indeed existed, proved to be totally unfounded. His paper was the greatest of successes and he emerged as the uncontested leader of the League, the main point in its constitution stating that the association had been formed "to encourage an indigenous and inventive architecture, and to lead architectural thought to modern sources of inspiration."[18]

Sullivan's paper had all the makings of a manifesto; it does not take more than five minutes to read.[19] The creation of the League, he ar-

gued, "is an auspicious opening of a new era in the growth of architectural thought." He relied upon "the power, self-confidence and idealism of youth" to bring it about. "The stage is set for the most intense and passionate drama in all history," he wrote—but did not explain that he saw the substance of that drama as the contest of "feudalism" and "democracy." He invited his audience "to cast away as worthless the shopworn and empirical notion that an architect is an artist—whatever that funny word may mean" and accept his assurance that the architect "is and imperatively shall be a poet, and an interpreter of the national life of his time." (Because it was not developed, this important statement may have been misunderstood by many.) In the ensuing paragraphs he finally unfolded a concise theme, one his audience would easily understand. A trust had been bestowed upon them. They were to be the creators of the new architecture, and as such they must come to know their culture and their nation. They should not plagiarize from the past. "You know in your own hearts," he said, "that you are to be fakers or that you are to be honest men"; and ended the address by stressing once more that the new architecture must be based entirely on the present and on those trends within it that would be developed in the foreseeable future: "Your youth is your most precious heritage from the past: I am with you."

Sullivan's paper caused such furor that some members of the League moved to adopt the epigram "Progress before Precedent" as the organization's motto. Many thought that such a pithy statement could be misconstrued, as indeed it was by some. George Dean, a former president of the Chicago Architectural Club, subsequently wrote a circular letter to set the meaning straight and ask for the recipients' opinions on the matter.[20] The letter was self-explanatory, but it also indicated that speaking for the Chicago Architectural Club and for the League, Dean was willing to clarify the pronouncement but was not ready to budge from his endorsement of Sullivan's position. He pointed out, for instance, the progress "the movement" had made in the nation, principally in the Midwest. Clarence Blackall, who was then president of the Boston Architectural Club and a well-established architect, replied to Dean's letter giving an interpretation of Sullivan's aphorism that was typical of most members of the League. In Blackall's opinion, to assume that progress and precedent are irreconcilable "is to be blind to the teachings of all history." At the same time, conditions of contemporary architecture indicated to him that following stylistic precedents from a remote past should be avoided.[21]

Sullivan used his answer to Dean's letter as an opportunity to promote his ideas further and to attempt to influence the young. He began

by doubting the importance of a dictum. He then stated that architectural progress "lies specifically with the rising generation, and it will answer in its own way, maxim or no maxim." Dogmatic statements would solve no problems, but "reasoning logically and unwaveringly from cause to effect" would. The chaos he saw in the architecture surrounding him was caused mainly by the fact that only a few architects of his own generation designed in the way nature had prescribed. "Architecture is an art yet without status in modern American life. Practically it is a zero," he complained. He doubted, however, whether there were enough young people available with the necessary insight and purity of mind to solve these problems. With an apparent change of heart about the future generation, he said, "that the young men have it [the ability to bring forth an American art] is conjectural."[22] This mistrust echoed earlier statements of the "Essay on Inspiration," where he had made use of Herbert Spencer's doctrine of the survival of the fittest to imply that only the best architects would achieve a national style and that this process would have a discriminating effect in the profession. "The weak are denied," he had written in 1886, "surely the autumn nipping winds dispose of the loose and tremulous, leaving the hardy sound."[23]

Although the Architectural League was a progressive force at the turn of the century, it presented no cohesive front. It was divided into two camps. The eastern clubs represented an intermediate position between the midwestern section on the one side and the more conservative eastern Beaux-Arts establishment on the other. The latter was outside the League and consisted of older and more successful architects. In reality, the midwestern group was the only segment of the League to be totally under Sullivan's aegis. The eastern section was, in the main, dominated by the American Institute of Architects and by the schools of architecture.[24] Nevertheless, having organized itself well, the midwestern representation carried the day at the second meeting of the League, which took place in Chicago. The New York delegation wished to veto the Chicago proposal that the motto "Progress before Precedent" be adopted, but the motion was not carried. Also, members of the Chicago Architectural Club were elected to fill all executive posts for the next two years instead of one.[25]

Because of its strong midwestern and Populist flavor, the 1900 convention of the Architectural League marked the high point of Sullivan's prestige among the young. He attended all the working sessions, received applause at all times, was the speaker at the closing banquet (which was held in the Auditorium Building), and Albert Kelsey, a Philadelphian who had been elected president the previous year, de-

clared officially that "Mr. Sullivan's letter to the society at the Cleveland convention is the corner-stone of our organization."[26]

A paper by Elmer Grey serves as a standard to help gauge the tone of the meetings. It is such a distillation of Sullivan's ideas that some of its passages are clearly paraphrastic.[27] After Grey delivered his paper, Sullivan, who was in the audience, was invited by the president to comment on it. His reply is useful for surveying continued changes in opinions he had originally stated in the "Essay on Inspiration."[28] While in 1886 he had argued for the slow but progressive emergence of an American architectural expression, he now demanded an immediate one, as he had done in his paper for the T-Square Club of Philadelphia. Presumably considering that the development of his own style during the last fourteen years was enough precedent to justify his entreaty, he denounced once more the worthlessness of using past architectural styles, which he thought were valid only as historical and social records. An influence of Taine is still obvious in his thinking, but it is now transmuted into a heroic individualism. "As Mr. Grey has truly said, the style is the evolution, if there be nothing other than the expression of its personality. . . . What counts, what is final and of consequence is the individual. This has always been true, is true now and always remains true."

Sullivan delivered his most important speech to the convention at the closing banquet. His address is clearly didactic, one proper for its intended audience, and it was immediately published under the title "The Young Man in Architecture."[29] He began by arguing from a romantic position of selectivism, dividing history into two cycles. One, more common, is of turmoil. It occurs when "war menaces man's life and religion menaces man's soul." (This was the first time that Sullivan publicly denounced organized religion, a theme he would later develop in *Democracy: A Man-Search*.) From time to time, however, mankind has known "golden epochs," which come few and far-between. Although he did not state it in so many words, he led his audience to believe that historical circumstances were favorable and that they could immediately establish one of these rare periods.

In spite of such optimism, which more than anything was wishful thinking, Sullivan's zeal was becoming strained. In another section of the address he contradicted himself and revealed his lack of confidence in the times. The knowledge that a majority of influential architects did not share his ideas, as well as public preference for academic forms, made him despair of people's ability to define what architecture should express. The influence of Nietzsche on Sullivan is now evident. "Ninety-nine years of the hundred," he said, "the thoughts of nine hundred and ninety-nine people of the thousand are sordid. This always has been

true. Why should we expect a change?"[30] He implied that the worst peo-
ple in this majority were the "Ruskinites," "Spencerites," "Tennyson-
ites," "aesthetes," "reformers," and all others who, understanding little
of what they were doing, followed philosophical systems as a matter of
fashion, and who, in searching for truth, preferred the comfortable but
erroneous method of reading books rather than the more difficult one of
realizing that they carried the truth within themselves, like all produc-
tions of nature. "The logic of books," Sullivan charged, "is at best dry
reading; and, moreover, it is nearly dead, because it comes at second
hand. The human mind, in operation, is the original document. Try to
read it. . . . Should I begin by putting into your hands a book or its
equivalent, I would, according to my philosophy, be guilty of an intel-
lectual crime."[31] He then advocated the method he had been endorsing
publicly since 1885. A national architectural expression would issue
only by instituting a spirit of self-reliance in the land; communion with
nature would allow a conscious manipulation of esthetic facts which
before had only been foreshadowed through intuition. Once more he
stressed his new belief that an American architecture could come forth-
rightly:

If anyone tells you that it is impossible within a lifetime to develop and perfect a
complete individuality of expression, a well-ripened and perfected personal
style, tell him that you know better and that you will prove it by your lives. Tell
him with little ceremony, whoever he may be, that he is grossly ignorant of first
principles—that he lives in the dark.[32]

He ended "The Young Man in Architecture" on a note that is both hope-
ful and apprehensive:

You have every reason to congratulate yourselves that you are young—for you
have so much the less to unlearn, and so much the greater fund of enthusiasm.
. . . But I warn you the time left for an answer in the right way is acutely brief.
 For young as you are, you are not as young as you were yesterday—
 And tomorrow?
 Tomorrow![33]

During the second half of the year 1900, immediately after his success
at the Chicago meetings, Sullivan thought of incorporating all his prin-
ciples into one work; *Kindergarten Chats* was the result.[34] An impor-
tant aim of the *Chats* was to show young architects how to dispossess
themselves of all preconceived academic notions, embrace nature, be-
gin a new life, and establish a new architecture. In spite of the apparent
clarity of these objectives, letters written by Sullivan during this period
establish the paradox that it was mainly to the people that the *Chats*
were addressed. Also, the word *architect* in these documents seems to

relate to academic practitioners only. For instance, in writing to his New York friend Lyndon P. Smith, Sullivan stated that "The architects will not understand much of what is in [the *Chats*] but the laity, more open-minded, will. . . . It is among the *people* that we want to work." In another letter to Smith, he insisted: "Try to spread them as far as you can among the laity, for they will be free of technicalities. I am writing for the people, not for architects."[35] To Sullivan, democratic ideals had their purest existence in the subconscious of the people, but he also believed that the masses had no clear understanding of their instincts. They had to be taught what the architecture expressing their desires should look like. This would not only give the people important conceptual lessons in democracy but would also solve the architectural problem finally. Once the masses were enlightened, new architects would issue from them to replace the present ones, whose faculties for bringing about a democratic architecture had been irreparably dulled by a persistent academic method.

Sullivan gave an excellent summary of *Kindergarten Chats* in a letter to Claude Bragdon, one in which most members of the Architectural League could have seen themselves reflected:

A young man who has "finished his education" at the architectural schools comes to me for a post-graduate course—hence a free form of dialogue.

I proceed with his education rather by indirection and suggestion than by direct precept. I subject him to certain experiences and allow the impressions they make on him to infiltrate, and, as I note the effect, I gradually use a guiding hand. I supply the yeast, so to speak, and allow the ferment to work in him.[36]

Sullivan's letter also explains how a bond between the young man and nature could be established. At first, in summer, the teacher reduces the importance of the pupil's former education by giving him a new awareness of nature, finally taking him to the country, where a storm "impresses him crudely but violently; and in the tense excitement of the tempest he is inspired to temporary eloquence; and at the close is much softened. He feels in a way but does not know that he has been a participant in one of Nature's superb dramas." The disciple then remains in the country and becomes superficially poetic, receiving his first impression of the possibility of a life of ecstasy. When he returns to the city, Sullivan introduces him to notions of responsibility, democracy, and education. This placid, rational stage corresponds to what Sullivan calls "Autumn Glory." Next comes "Winter," a period of questioning and despair leading to the heroic enlightenment of the last out-of-doors scene, "Spring Song," in which Sullivan described the woods around his vacation house on Biloxi Bay.

The most salient message of *Kindergarten Chats* is that one should

strive for childlike perception. Responding to natural instincts and not allowing organized society to condition one's behavior are ways to attain to true freedom. "Let us remain children as we grow old," Sullivan wrote, "for I tell you if you kill the child in man you kill the man in man."[37] Although none of his writings mentions Friedrich Froebel, the German pedagogue who created the kindergarten system, it is difficult to believe that Sullivan was ignorant of Froebel's work, especially since at that time Froebel's method of instruction was being much discussed by the Chicago "progressives" in connection with the teaching of architectural design.[38] The very title of *Kindergarten Chats*, as well as the following passage from it, point to Sullivan's familiarity with Froebel:

The study of the child, the study of the young has been pursued . . . with intelligence and devotion; and the *kindergarten* has brought bloom to the mind of many a child; and all this is the result of a growing philosophy of education. But there is, alas! no *architectural kindergarten*—a garden of the heart wherein the simple, obvious truths, the truths that any child might consent to, are brought fresh to the faculties and are held to be good because they are true and real.[39]

Froebel had favored a similar bond between human consciousness and the physical world, and had also grounded his educational method in nature, considering the universe a reflection of God.[40] Although Froebel was a religious man in the conventional sense and Sullivan was an agnostic, Sullivan's Chat XXX, among others, shows similarity with Froebel's ideas on the divine, especially if the term "Infinite Creative Spirit" is replaced by "God":

If I say that such and such a thing is an outworking of the Infinite Creative Spirit, it may sound mysterious and inaccessible to our facilities. But if I say: It's a fine day; you say, "Why yes, it's a fine day,"—and take it as a matter of course. Now as a matter of working fact, this Infinite Creative Spirit of which I speak is as much a matter of course as your fine day—if once you place your mind in a receptive mood, free from the inhibition of awe or of factitious veneration.[41]

In Chat XXVI, when the young man returns to the city and tells the master of new feelings following the summer storm, he is told that these emotions are not really new to him—they were a part of his infancy. They had been "lying dormant" because they had been suppressed by his education. He is also warned that he will be anguished while they surface to consciousness.[42] Here, for the first time, Sullivan presented his important concept of "suppressed functions." In *The Autobiography of an Idea* he claimed that John Edelmann had explained the notion to him at the Lotos Club many years before.[43] No grounds exist to disclaim Edelmann as a source, but in fact this idea also goes back to Froebel, who had written of the need to cultivate the natural qualities children

are born with.[44] Froebel, in turn, had derived these concepts directly from Jean-Jacques Rousseau, who had stated in *Émile* that education should be mainly a progressive understanding of one's natural instincts.[45]

Viollet-le-Duc had also dealt with the education of the young. In the year in which he died, 1879, he published his ideological testament in the form of a novel, *Histoire d'un dessinateur*, a work that shows a certain similarity to *Kindergarten Chats*, dealing as it does with the upbringing of a young architect.[46] One of the characters in the book, Monsieur Majorin, is obviously Viollet-le-Duc himself—a man well versed in architecture, art, mathematics, history, botany, geology, and several other disciplines. Taking into his custody a promising child of twelve called Petit Jean, Monsieur Majorin tests his theories of education. Eventually Petit Jean becomes a superb designer; he has been taught how to think logically and how to search always for the relation between cause and effect. His creations are useful as well as beautiful. He understands the workings of each part in relation to the whole, and gives each the proper expression demanded by its function. A less-fortunate friend educated at the Academy cannot do as well, because he applies at all times the one rigid method of design his professors have taught him rather than discovering for himself the rules proper to each problem.[47]

Viollet-le-Duc distilled his architectural theories into the teachings of Monsieur Majorin:

Many volumes have been written about the role of the beautiful in art, but really they are quite useless, because all that paper is incapable of helping one create a beautiful work of art. And if one really wishes to understand this word beauty as something else beyond a convention or canon, the only way for it lies in the observation of the manner in which nature operates, not in the reproduction of an eclectic type. The beautiful is nothing more than the harmony, the exact concordance, between form and function.[48]

In spite of the Sullivanesque ring of this quotation, there are marked differences between Viollet-le-Duc and Sullivan. While Sullivan's attitude was romantic, Viollet-le-Duc's was strictly scientific, issuing from mid-nineteenth-century positivism. Viollet-le-Duc, for instance, derived geometric principles from organic forms; Sullivan, to design ornament, stood on geometry to embrace nature. Viollet-le-Duc elicited the existence of the pentagon from a vine leaf; Sullivan turned a pentagon into an organic motif (plates 43–44). To Sullivan, as to Whitman, the poet was a seer;[49] Viollet-le-Duc's concept of poetry was more objective, and substituted accuracy for Sullivan's empathy. "If by poetry one understands a particular type of visual impression or the description of a natural fact," Viollet-le-Duc wrote, "nothing would link better all the

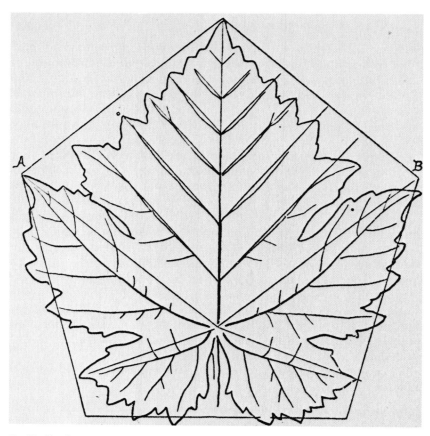

43. Viollet-le-Duc, *Histoire d'un dessinateur,* figure 7

44. *A System of Architectural Ornament*, plate 4

elements of poetry (whose function is to uplift the spirit) than the careful observation of nature; in other words, scientific observation."[50] If indeed *Histoire d'un dessinateur* influenced Sullivan's *Kindergarten Chats*, it was only in the initial idea of presenting a theory of architecture under the guise of a pupil's progress. The psychological developments of the two youths, like the ideologies conveyed, were different. Viollet-le-Duc showed the benefits of his systematic method by analyzing Petit Jean's development, a process that took several years to complete. *Kindergarten Chats* is different. Sullivan's romantic fervor prevented him from even considering an objective didactic scheme. A sweeping metaphorical cycle comprising the four seasons was his method of presenting educational ideas.

This use of symbolism precluded *Kindergarten Chats* from accomplishing what Sullivan set out to do. The general public, for whom they were intended, never read them, and since they were difficult to understand, they did not succeed in bringing the Architectural League—the vanguard of the profession—to a transcendentalist conception of architecture. Publishing the work in the Cleveland *Interstate Architect* was another mistake. The weekly was only one year old when Sullivan began writing for it and was little known. Furthermore, it circulated mostly among people primarily interested in the technical problems of construction. The periodical was rarely read outside this circle, whose concern with esthetics and philosophy in general was limited, to say the least. Serialization was another blunder. *Kindergarten Chats* outlines one fully developed plan, and its unity is apparent only in book form. As Sullivan himself stated, "*Kindergarten Chats* are not intended to be a series of disconnected weekly articles, but a *thesis*, gradually and organically developed."[51] Thinking that they were reading a series of disconnected articles, many people failed to perceive the one important idea that Sullivan was unfolding. The cohesiveness of the *Kindergarten Chats* can be appreciated only if they are read as a whole; it is completely lost if they are read on consecutive Saturdays as fifty-two articles. Apparently Sullivan did not sense that serialization diluted the strength of his message. His main concern while writing the *Chats* seems to have been gratifying an urge to put his thoughts in print; he wrote more for himself than for an audience. At best, he wrote for a group of imagined potential Louis Sullivans who, for instance, would share in his enthusiasm for dramatic rhetoric. "A considerable part of the K.C.," he wrote to Claude Bragdon, "is in rhythmic prose—some of it declamatory. . . . It really should be read aloud, especially the descriptive and exalted passages."[52] In short, he made no effort to convince people who might have been unfamiliar with or skeptical of his ideas. The work, as written, was totally impractical.

In his misplaced confidence, Sullivan thought that *Kindergarten Chats* would provide each reader with an experience like the one it described. He shared with Rousseau, Froebel, Emerson, Carlyle, Thoreau, and Whitman, among others, the belief that every human being is possessed of innate genius. The union between man and nature through art would reinstate this quality of genius, and thus the condition in which man had lived before the Fall would be restored. According to Sullivan, any person who accepted the tenets of *Kindergarten Chats* unquestioningly would undergo a process of fulfillment like that of the protagonist. Only through the work of all men acting as geniuses in communion with nature could architecture be brought to a quality equal to nature's.

Few could see this purpose clearly, and even fewer could have implemented it. The broadcasting of these ideas, which most considered to be extravagant, caused Sullivan to lose his precarious position of eminence in the Architectural League; indeed, many came to see him as an obsolete relic. With his influence waning in the group, the eastern establishment filled in the vacuum and gained control of the association. Sullivan attended neither the 1901 meeting in Philadelphia—to which he sent his greetings in a telegram[53]—nor the 1902 one, which was held in Toronto. By this time the advantages of a systematic architectural education had asserted themselves over the irregularities of the apprenticeship method as well as over the heroic demands of Sullivan's transcendentalism.

The essay "Education," of 1902, was Sullivan's last for the Architectural League.[54] Robert Spencer, the Prairie architect, read it to the meeting in Toronto in Sullivan's stead. This was also the last participation of any progressive midwestern architect in that organization.[55] Considering the circumstances, the tone of the paper is odd. There are no signs in it of denunciation or indignation. It could well have been written by someone enjoying victory after a long struggle. An explanation for this strange complacency is that Sullivan wrote the address three months after the publication of the last installment of *Kindergarten Chats*. He might have overestimated whatever favorable comments he received about that work and thought the battle won. He no longer suspected, as he had on several occasions before writing the *Chats*, that the younger generation was unable to establish the new society. Man, according to this article, "is now free to move toward the goal of the race. . . . The tyranny alike of church and state has been curbed, and the power is now to reside where forever it must remain—in the people." He proclaimed that youth must have pride, "that sure quality of honor . . . and the sense of moral responsibility." A young man must be distinctly taught "his responsibility for his fellow men. . . . He should

be taught that he and the race are inseparably a part of nature and that his strength must come from her bounty." Sullivan summarized these Nietzschean notions at the end of the paper by implying that his own work was the basis of a new culture: "And thus would I lay the foundation for a generation of real architects—real, because true, men, and dreamers in action."

A *Universal Morality:* Democracy: A Man-Search

FEUDALISM, (without a pun) signifies for the few. It means, in essence, denial, repression, segregation; class distinction; aristocracy; robbery of your fellow men in every way, shape and manner. It means, specifically, irresponsibility, unaccountability. It leads directly to usurpation, and, finally, to a declaration of divine right. It is the insanity of civilization because it breeds the disease, the dishonesty, the crime, the cant, the hypocrisy of civilization. It prefers to receive rather than to give. It is founded on selfishness. Its power lies in the corrupted Dollar; this power means Death. The aspiration and goal of Feudalism is Absolutism.

DEMOCRACY, signifies of by and for the people. It means equal rights, responsibility toward the neighbor and kindliness toward him. It means that we receive our individual divinity from nature, as a gift at birth. It implies the brotherhood of man, and universal love because of universal accountability. The rock of its foundation is Character. Its motive force is natural thought. Its animating principle is Life. Its aspiration, its goal, the uplifting of man. Justice is its life blood.

Therefore: Every unjust judge, every crooked merchant, every hypocritical preacher, every evasive workman, every hide-bound teacher, every lofty-nosed scholar, in short every man who betrays a trust is, in the essence of his thought and drift of his action, Feudal. In short, the Dishonest Man is Feudal.

Your true scientist is a Democrat; so is your manly man; your real philosopher; your real scholar; your true teacher; your real mechanic, or any real man laboring with hands and brain; so is your man who helps his fellow men; and, greatest and best of all, every Honest Man is a Democrat.

In spite of his fiasco with the Architectural League, in spite of the fact that his words fell increasingly into a vacuum, Sullivan's enthusiasm for enlightening the young endured, as this passage from "Natural Thinking: A Study in Democracy" demonstrates.[56] Symptomatically, this was the first of his addresses not to be published immediately after delivery.[57] Yet he continued writing extensively in 1905–8, enlarging the scope of his ideas into a "system" for attaining universal morality. In that sense, his ideology reached a culmination in that period.

In "Natural Thinking," following an argument he would later develop extensively, Sullivan reasoned that to live in universal harmony humanity must listen to the forces of nature wholly, with the five senses, with "the entire muscular and even physiological system." In standard transcendentalist fashion, he expanded the word *listening* "into a comprehensive association with . . . 'feeling.'" "Natural thinking" was to him the method for acquiring this perception, whose power he compared to those constant and nondramatic actions of nature that in the long run are more effective than sudden bursts of force. "Lightning

is but a little power—and noisy," wrote Sullivan. "Dew-fall is a great power—and quiet."[58] Like most romantics, Sullivan believed that understanding the cosmos is innate and that therefore analytical thinking had to be a common concern of humanity. If it were only the province of the few, true democracy would never be achieved. "But," he also wrote, "your scholar, your man of culture, and even your teachers are prone so to believe—because of the Feudal Tradition. It is a wondrous pity that they do not know better. It seems not to occur to them that thinking, like walking, is a natural process: That it is the essence, Life, that thinks, just as it is the essence, Life, that walks."[59]

Sullivan expanded this thesis in *Democracy: A Man-Search*, a book of approximately 180,000 words, of which the holograph, in pencil, bears the completion date of 1 July 1907 and a revision date of 18 April 1908.[60] The work is divided into six chronological "Groups," each consisting of several chapters. "Group I: Parting of the Ways" shows man at a crossroads: feudalism and democracy are the two choices available to him. Groups II, III, and IV, "Face to Face," "The Man of the Past," and "Dreams," represent the past. They show the evils born of misuse of power in the feudalization of money and property, how the people have been denied by the tyranny of feudal aristocracy, and man's persistent search for God and for a definition of his own spirit. "Group V: The Man of Today" presents the feudal power of money and the democratic power of the artist struggling for the soul of modern man. "Group VI: The New Way" describes the future. Social peace will result when democracy, as nature's ally, destroys feudalism. Man will then understand that what he thought of as God was really a rudimentary concept of nature. Relating to a deity through liturgy will finally be perceived as a misunderstanding of man's aspirations for integrity with nature through art. The influence of Hegel's *Philosophy of History* is apparent in Sullivan's assumption that events follow a law of becoming, which he described as follows:

The Man of the Past, in his way sought Justice. The way was tortuous, obscurely lighted. He could not detach right from might, nor right from cunning. He dreamed, aspired and fell. Again aspired, again to fall. But at each recurring crisis he aspired higher, and fell perhaps not quite so far. For, somehow, somewhere in his heart sang the small voice of Democracy. He heard it now and then in flitting moments. When not too busy at his engrossing feudal tasks, he heard its song—and was cheered, he knew not quite how or why.[61]

The teachings of Christ were one of those forces of the past which have helped man to catch a glimpse of democracy.[62] But paradoxically Christianity, out of cowardice, lives in dread of Christ's gospel. "So

western thought . . . in its fanatical resolve to deny the great life and exist boastfully madly apart from it—has reared a Church and many churches wherein to imprison the Christ, that His real voice may not be heard abroad. . . . Indeed it requires the power of a great hierarchy and an army of priests to keep the little voice duly muffled." In reality, Sullivan thought, Western man "has the same love of man on Easter morn that the wolf has for sheep on Easter morn."[63] Responsibility for this condition rested not with an abusive minority but with everyone. A process of universal self-reformation was imperative in the final establishment of democracy. The principal obstacle to progress, he emphasized, lay in the cowardice of man, and he accused humanity of dreading truth. Man's fear makes him dishonest. It prevents him from following his instincts to make his life a continuous proclamation of that truth he carries within him. Everyone, absolutely everyone, is to blame for the evil in the world:

Poor and rich, the broken, the demented, outcast, criminal are [responsible for evil], all just like you and me! There is something interchangeable in us that fits exactly with them all; . . . the *Feudal Thought*; the axle-thought of all civilizations of the past and of today.[64]

Feudalism, Sullivan explained, depends on man's inability to grasp his relation with nature. This inability is the product of man's "singular perversion of his intellect, called vanity, and that equally singular intellectual repression of his heart, called hypocrisy, [which] have obscured his sanity of vision. So, to fortify himself in his vanity and hypocrisy, to 'prove' that his vision is clear, he has invented philosophies, doctrines, religions, dogmas galore—vain and hypocritical as himself."[65] Stating earlier ideas in a different fashion, Sullivan stressed that feudal thinking did not issue from the desire of a privileged few to dominate the masses, but from

an unadulterated conception of self-preservation in the individual and the mass which evoked the spirit of might . . . as right. . . . Thus the dream of absolutism, as an ambition and a goal, came boldly and bodily imagined forth of the multitudes to lure on prince and priest. And thus, in the dream of the lowly, came the ferment of man's intellectual madness. For the dream of force and cunning, of glory and power, of dominion and servitude, of master and man, made his world unreal.[66]

Although man's feudal character makes him debase himself in searching for a false security, the situation has improved in the process of history. Eventually those entities called "property, vested rights, the law, the constitution, the government, the army and navy, which

seem . . . preposterous [to democratic men, will be seen in the end] as fictions."[67] "It is not because men are essentially vicious that they are feudal," Sullivan insisted, "it is merely because they do not clearly understand the essential and concrete nature of their relationship to their fellows, to the earth, and to the spirit of integrity."[68] The existence of curiosity shows that there is hope for man. It pushes him to circumvent his fears in his search for the meaning of life. But in his ignorance, man has thought that science is the ultimate means for comprehending the cosmos, of which he vaguely understands himself to be a part.[69] As his search for the meaning of life continues, he will come to realize that this attempt to understand nature through reason alone is vain and feudal. It is then that democracy will become the fulfillment of history. Man will comprehend that his essence and nature's are the same. Democracy, Sullivan defined, "is but the ancient primordial urge within us of integrity or oneness. . . . For Democracy and the oneness of all things are one."[70]

Sullivan concluded his book by defining the foundations of democratic society. In ascending value, they are art, science, poetry, thought, and Ego. Concerning art, he said:

We in our sensible, practical, ghostly way assume art to consist in painting pictures, or something of that sort; and just so long as we assume this, we shall remained diseased. For, while painting pictures may be a special manifestation of Art; the reality of Art consists simply and universally in this:—

DOING THINGS RIGHT

So long as we do things wrong, we shall be inartistic, diseased and weak, and civilization must be a misnomer. When we do things right, we shall . . . stand for the uttermost reach of Art, namely, the full expression of the full life of a people.[71]

Science, Sullivan's second foundation of a democratic society, is no mere attaining of erudition for its own sake, as it was considered to be in feudal thinking. Science should be the use of knowledge for two exclusive purposes: to explain to man his intuitive love for nature, and to help him develop methods to express this love through art. "Science is the Spirit of man confronting the Universe," Sullivan noted. "The practical enquire of Science is:

HOW TO DO THINGS RIGHT."[72]

The poet, on the other hand, is the interpreting "man of VISION. . . . He sees Life with the eyes of Life." A poet is not necessarily a writer of verse, but "the man who sees things rhyme; for rhyme is but the suggestion of harmony; and harmony is but the suggestion of rhythm; and rhythm is but the suggestion of the superb moving equilibrium of all things."[73]

The fourth constituent of a democratic society is thought or intelligence. This was to Sullivan the seat of man's power, which is not to be used cunningly by men to achieve dominion over others. To Sullivan, the term *power* did not imply unjust dominion by force, but rather, that innate capacity everyone has for fulfilling his potential. As such, in the long run, it is of more value than rights. "Thought is self-assertion—POWER," Sullivan wrote.[74] Since power will be exerted to its fullest in the final democratic society, everyone will be perfect and all inequalities among men—intellectual, artistic, emotional, social, and even pathological—will disappear, because they arise from a feudal consciousness.

The last stage of the process towards democracy will come when every man realizes that his true vocation consists of a full existential comprehension of self: "The universe and all therein may be expressed by the word Ego." Since Yahweh defined Himself as "I am," Ego, to Sullivan, "is therefore the I AM of things. . . . Life sings its song:—It is the song of Ego. . . . Man has not believed in Integrity; hence his anguish. . . . Man sings the song of death—the song of fear, the song of distrust—for he knows not Ego. He will not believe that Ego is I AM—and that there is but one I AM, universal, and himself."[75] *Democracy: A Man-Search* is but Whitman modified by Nietzsche. The final outcome will be a race of supermen for whom life will be a constant ecstasy because of a fully realized insight into the essence of the cosmos.

Democracy: A Man-Search was one of Sullivan's great efforts. Indeed, it is certainly his most ambitious, and possibly his best, literary work; never before had he presented his ideas as cogently. Yet the book has its failings. It attempts to establish a philosophical system, but it does not, for lack of a dialectical method. Rather than proceeding through logical disputation, Sullivan chose to convince through the emotional appeal of poetic imagery.[76] However good some of Sullivan's poetry may be, such as some passages in "Dance of Death,"[77] the sustained excellence of the dialogues in *Thus Spake Zarathustra* is not evident in *Democracy: A Man-Search*, where the quality is uneven, touching at times on the melodramatic. Moreover, Sullivan shares Nietzsche's self-contradictions. This is inherent in the manner of exposition they both chose, disregarding dialectics in favor of an unsystematic exposition of their deep conviction. Sullivan, as Nietzsche had done, rambles; his obsession with certain ideas drove him to repeat himself time and again, presumably for fear that the reader might miss the point. Scholars have argued that Nietzsche's erudition was not great enough for a proper development of all the themes he touched upon.[78] Nietzsche, however, had a solid education behind him. He had attended the gym-

nasia of Naumburg and Pforta and the Universities of Bonn and Leipzig; Sullivan's only academic diploma was from the English High School in Boston. Yet his philosophical program was as ambitious as Nietzsche's.

Although *Democracy: A Man-Search* reveals Sullivan's limited schooling and his naive conception of history, it also shows his ability to establish coherently a synthesis of ideas acquired from others. Like many intellectuals with limited academic training, Sullivan tended to make use of thoughts he found in books and elsewhere as if they were his own, if they clarified intuitions he had been unable to express clearly by himself. For instance, his definitions of art, science, and the democratic man are found almost verbatim in Aristotle's *Nicomachean Ethics*.[79] Other examples are his close paraphrases of Schiller, Swedenborg, Eidlitz, Froebel, and Taine in earlier works. But he was never overawed, as many eclectics have been, by the brilliant exposition of a concept not conforming to his beliefs. In spite of the strong impression *Thus Spake Zarathustra* had made on him, he never endorsed Nietzsche's immoralism. Nietzsche had seen his contemporary German culture as static and had vented his frustration on it; to Sullivan American culture was highly dynamic—his message is both optimistic and ethical. But he was mistaken in thinking that the book would be well received; cultural conditions in America in 1908 were not the same as those of the preceding generation—Whitman and populism were things of the past. *Democracy: A Man-Search* was antiquated from its inception.

Sullivan's bitterness at being ignored moved him to write "What is Architecture: A Study in the American People of Today."[80] This piece reveals his disenchantment when he finally realized that the social and architectural trends of the day ran contrary to his ideals. It also shows his disappointment with the architectural press, which not only had rejected him but had espoused the cause of "feudal" architecture. "Our architectural periodicals float along, aimlessly enough, drifting in the tide of heedless commercialism," he accused, "their pages filled with views of buildings, buildings, like 'words, words, words.'"[81] Three years later he developed this subject further in "Is Our Art a Betrayal rather than an Expression of American Life?"[82] He saw himself almost as a new Elijah, and wrote:

If I were asked to name the one salient, deeply characteristic social condition, which with us underlies everything else as an active factor in determining all other manifestations, I should without the slightest hesitation say *betrayal*. It is so clear that no one can avoid seeing it who does not take express pains to shut his eyes. . . . The first and chief desire, drift, fashion, custom, willingness, or whatever you may choose to call it, of the American people, lies in this curiously passionate aptitude of betrayal.

Sullivan was fifty-two when he wrote this article against a society which had left him behind. For the next fourteen years, until two before his death, he would encyst himself in his ideas and produce no more writing of this kind. Few were willing to publish it and even fewer to read it. In that same year of 1909, his friend and apologist Claude Bragdon summarized the situation when he complained, "Outside of this little circle [of Prairie architects] Mr. Sullivan was either unknown, ignored, or discredited by those persons on whose opinions reputations in matters of art are supposed to rest."[83]

4
New Ventures, New Perspectives, and Their Failure

The Houses

Pride, stemming mostly from a deep commitment to his convictions, was an important cause for the decline of Sullivan's practice at the turn of the century. George Elmslie, his assistant for many years, once said that his employer "could be arrogant and unnecessarily decisive. . . . He lost many jobs because he would not compromise his ideas, nor play fast and loose with vital conceptions of what was fitting for the purpose intended."[1] Intrinsic in Sullivan's prejudices was also a large measure of uneasiness. Known best to such of his contemporaries as Montgomery Schuyler, John Root, and Daniel Burnham as an ornamentalist, Sullivan attempted to prove that he was capable on his own of doing more than simply design facades and ornamentation.[2] His anguish in this respect was such that shortly after the dissolution of his partnership with Adler, he went so far as to publish the drawings of the Guaranty Building with only his name on them, in an attempt to take credit for planning and construction as well as for composition and decoration.

Problems in his personal life were also troubling him. He had approached middle age, and with it he felt a greater need for tenderness. Adler's home was no longer available to provide him with the borrowed domesticity he had often enjoyed there, and he had quarrelled irrevocably with his brother Albert in 1896. Willard Connely has suggested that Sullivan's drinking dates from that year. But soon other events seemed to anticipate the coming of better times. There were commissions for the Schlesinger and Mayer and the Bayard buildings, and for a while a

number of young architects appeared to be endorsing his views through the Architectural League. With renewed confidence and feeling a need for family life, he married Margaret Davies Hattabough, a divorcée fifteen years his junior, on July 1, 1899.[3] Yet ultimately things took a turn for the worse. The Architectural League went over completely to the Beaux-Arts position, and new commissions failed to materialize after the Schlesinger and Mayer Building. Matters became so bad that even that building's new owner, Carson-Pirie-Scott, called upon Daniel Burnham when an addition was built in 1906. The Sullivans, who had moved to Louis's bachelor suite at the Windermere Hotel after their marriage, were forced to move to the cheaper Virginia, and in the summer of 1905 to a seedy apartment in the Lessing Annex Building. Margaret was not enough to compensate Sullivan for all that he felt he lacked. He continued to drink, and she had no wish to be the wife of an impoverished alcoholic. They separated in 1907, although she did not sue for divorce until ten years later.

His cottage on Biloxi Bay near Ocean Springs, Mississippi, had always given Sullivan, more than a feeling of proprietorship or even of home, a sense of identity. It was there that he communed with nature and wrote at his most exalted. Ridden with debt after the national financial crisis of 1907, he filed for bankruptcy in 1909 and had to sell his cottage as well as his works of art and books. Years later, he recalled the first time he had seen the Biloxi Bay property and what it had meant to him. He was too embarrassed to admit he had lost it through insolvency, and invented a myth to romanticize its loss. In the midst of a rhapsodical description of the estate, he wrote: "This reverie is written in memoriam. After eighteen years of tender care, the paradise, the poem of spring, *Louis's other self*, was wrecked by a wayward West Indian hurricane."[4] Although much remodelled, the house is still standing.

In 1909 he was also compelled to move his office from the Auditorium Tower to cheaper rooms below, and it was at this time that Elmslie left him; Sullivan had not received a single commission during the previous year, a circumstance that would recur in years to follow. Forced to resign from the Chicago Club in 1910 for defaulting on his dues, he was given an honorary membership in the Cliff Dwellers Club through the good offices of friends. A year later he moved from the Lessing Annex Building to the Warner, the dilapidated hotel where he would die thirteen years later in a nine-dollar-a-week room. In 1913 he lost his membership in the American Institute of Architects because he had not paid his fees for a long time. His finances not improving, in 1918 he had to move his office again, this time to an ordinary and even cheaper room

on the Wabash side of the Auditorium Building. He was evicted from this room two years later for lack of payment. Only through the generosity of William D. Gates, president of the American Terra Cotta Company, did he have a room to call his office at the end of his life. Gates admired Sullivan's work, and remembering past associations, provided him with a back room free of charge.

Aggravated by his worries and increasing forlornness, Sullivan's alcoholism became acute, and was probably made worse by a dependency on drugs toward the end of his life. ". . . now he had come to bromides. His physician said his heart was bulging between his ribs. He had 'gone off,' as they say, frightfully," Frank Lloyd Wright has reported.[5] Sullivan's dereliction is also evident from the reminiscences of William Presto, his associate in the Krause Music Shop commission, of 1922: "Hopelessly insolvent, Sullivan made no secret of it, and was not above asking for a modest fifty cents, perhaps for carfare, perhaps for a bit of lunch."[6] Also, on at least three occasions in 1911, he had asked for money from Daniel Burnham.[7] When he died on April 11, 1924, his circle of friends was indeed small. There were George Elmslie and Frank Lloyd Wright; George Nimmons and Max Dunning, two young architects from the Cliff Dwellers Club who from time to time rendered him assistance; Jens Jensen, the landscape architect; a few other sundry friends; and his faithful mistress of seventeen years, the henna-haired milliner mentioned by Frank Lloyd Wright.[8]

Without commissions of substance from almost the turn of the century onward, Sullivan accepted residential work, which he had never enjoyed. These houses did not bring him success; three out of five were rejected by the clients. A fourth would have also been refused had it not been a gift from a father to his daughter and had the couple been allowed to choose their own architect. Such a high percentage of dissatisfied clients suggests that Sullivan may not have been a competent residential architect. An analysis of his houses will reveal that although they are excellent as works of art in the abstract, almost none of them functioned efficiently as family dwellings.

Sullivan had designed a few houses during his early years, but when Frank Lloyd Wright came into the office he was charged with the firm's residential work during his term of employment (February 1888 to June 1893). One reason for Sullivan's indifference to domestic architecture was that, as he became increasingly absorbed in enunciating his principles of architecture, his main professional interest lay in experimenting with facade composition and ornamentation as expressions of his ideas. Circumstances worked to his advantage. Everyone in the office, as well as clients and the interested public at large, expected that type of work

from him. There was perfect agreement between what he wanted to do, what he did best, and what he was expected to do. In fact, Sullivan always understood his vocation. From the beginning he had sought first an education and then a practice that would prepare him for the work he enjoyed doing. His early training in the École des Beaux-Arts (designing decorative ceilings) and in Chicago (decorations of the Moody Tabernacle and of the Sinai Temple), as well as his work with Adler from 1879 to 1895, had served him to discover and subsequently refine what he had been interested in finding from the beginning, an identification of architecture with estheticism.

However, Sullivan's belief that the manifest goal of humanity was a permanent state of esthetic voluptuousness interfered with the quality of his residential architecture. His propensity for gorgeousness and stateliness distorted common sense in his planning of domestic buildings. He allowed himself the right—or perhaps considered it his duty— to impose upon clients designs best suited for a universal manner of behavior of his own choosing. Without Elmslie's tempering influence Sullivan could not have met some of the reasonable anticipations of clients who had come to him because they admired his commercial architecture and expected, as a matter of course, houses that would fulfill their needs efficiently and comfortably. Sullivan was working from the conviction that, as a law of nature, all human beings should be artists; that each man, as Emerson had put it, "must disindividualize himself, and be a man of no party and no manner and no age, but one through whom the soul of all men circulates, as the common air through his lungs. . . . He is not to speak his own words or do his own works or think his own thoughts, but he is to be an organ through which the universal mind acts."[9] Only such a man, an abstraction existing outside of family life and without personal idiosyncrasies, would have been happy in a Sullivan house. Nowhere in Sullivan's writings is there mention of the family as the social core of democracy.

William Gray Purcell once noted in his diary, "Mr. Sullivan simply had no concept whatever of American family life."[10] Purcell's observation bears attention. Not only was Sullivan a child of foreigners but also, during childhood, his relation to his parents had been peculiar. He had been reared by his grandparents from the age of five, and although this oddity caused the child no apparent trauma, it certainly made him an introvert. The *Autobiography of an Idea* makes no mention of playmates and even emphasizes how much Sullivan relished playing alone. He fended for himself as a young man and married late in life. Marriage did not bring him a feeling of settled domesticity—the Sullivans had no children and lived in hotel rooms. It is not surprising, then, that Sulli-

van was not able to express in his clients' houses what he himself did not know. He could plan well buildings with simple layouts and few functions, such as warehouse-like department stores or commercial blocks with a large central corridor and offices on either side, and then turn these designs into superb works of art by means of facade composition and decoration. But when he suddenly confronted such questions of domestic architecture as room size, scale, relationship of functions, and the needs and tastes of families, his plans did not function well. He was not sufficiently familiar with the problems he was solving and furthermore had no interest in training himself to solve them. The Bradley House, for instance, has worked splendidly for over sixty years as a fraternity house, that is, as a somewhat impersonal combination of a dormitory and club for university students, but from the beginning it failed as a family dwelling.

Sullivan's planning technique for residential architecture was different from that of his midwestern contemporaries. It lacks the geometrical intensity and cohesiveness of the best Prairie work. However much Prairie architects may have accepted Sullivan's ideas as intellectual abstractions, their style evolved from sources different from his. Their designs were products of a Queen Anne–Shingle tradition modified by a Japanese influence, among others, and later by Arts-and-Crafts and Viennese design. Progressive midwestern architects usually concentrated their spaces around a central vertical axis, generally the staircase or a cluster of fireplaces, and formed a "pin-wheel" dynamic design around it.[11] Sullivan, however, favored sequences of spaces developed in the grand manner or turned to borrowings from other architects.[12] As a result, although there are points of contact between Sullivan's residential architecture and the Prairie School, their syntax is not the same. Integration of building with site, for instance, is a major difference between the one and the other. Prairie architects, and especially Wright, usually attempted to correlate interior and exterior either by large openings, or in the best examples, such as the Willitts House, by an interplay of spaces. But Sullivan, because of his classical preferences in planning, seems to have sought a divorce between the house and its surroundings. Most of his residences stand high above the ground on a podium-like basement floor. This dissociation of building and garden also produces the typically classical anthropomorphic effect of making the dwelling proclaim its presence.

The unexecuted house for Albert W. Goodrich in Harbor Springs, Michigan (dated August 10, 1898), gives the tone of things to come.[13] The house was to be massive, sitting on an elongated tract of land and covering it almost entirely. Over a high basement housing storage, me-

chanical equipment, laundry, and kitchen was to be a first floor of formal rooms and above it a second one with bedrooms. There also was to be a smaller third floor surrounded by an arcade and capped by hipped roofs. This story was to contain guest rooms, servants' quarters, and a large playroom for the children. Fenestration was to create a surface tension on the facade. Window sizes were not standardized, but lintels placed at uniform heights brought order to an otherwise random composition. The drawings give no indication of materials, but if one imagines the elevation rendered in brick with raked horizontal joints, the effect is indeed splendid, especially with the broad-eaved roofs hovering above the deep shadows they would have cast on the third-floor arcade (plate 45).

The plan of the main floor is an adaptation of Richardson's Billings Library in Burlington, Vermont (1883–86), which Sullivan knew from his copy of Mariana Van Rensselaer's book on Richardson (plates 46–47).[14] Richardson's Reading Room and Memorial Hall became Sullivan's hall, the nook-and-seat facing the main door was a retake of Richardson's fireplace, and the circular dining room was a translation of the sixteen-sided Marsh Collection Room in the Billings Library. On the other side of the Goodrich hall, the library proper in the Burlington building became, in Sullivan's project, the living room, a gallery, and a terrace. The entrance sequence, however, was entirely Sullivan's. It was to be a majestic composition consisting of a vestibule first, and then a flight of eight steps leading to the main hall. All of this was to form part of an imperial staircase developed around a high well, creating a Baroque *Treppenhaus* effect.

No information has been discovered explaining why Mr. Goodrich rejected the design, but the reasons seem fairly obvious. There would have been, in the first place, a question of sheer size and cost. One could better imagine this house in Newport than in Harbor Springs. Secondly, the planning is much too formal for intimate family vacations. It evokes visions of pale-colored satin gowns, pearl chokers, and gentlemen in full evening attire; but one cannot imagine children tracking in sand from the beach and running about, as some family photographs in the McCormick Collection of the State Historical Society of Wisconsin suggest was the Goodriches summer way of living.

A number of inconveniences in planning show, furthermore, that Sullivan was more interested in creating an imposing effect than in providing comfort for the family. On the second floor, for instance, the children's bedrooms would have been forty-five feet away from their bathroom, and the elder Mrs. Goodrich's bathroom would have had no tub, nor would there have been a closet in her bedroom (plate 48). The

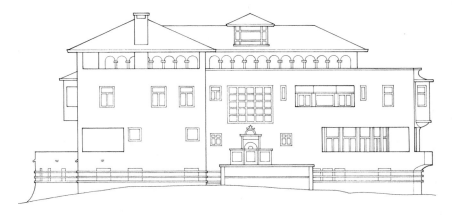

45. A.W. Goodrich House Project, Harbor Springs, Michigan, 1898, west elevation

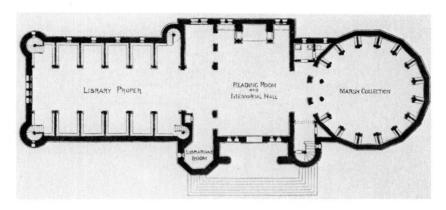

46. Billings Library, Burlington, Vermont, H. H. Richardson, 1883–86

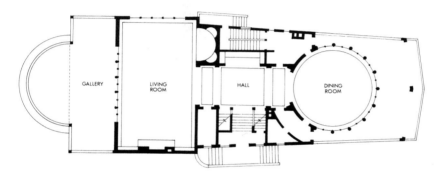

47. Goodrich House Project, first-floor plan

109

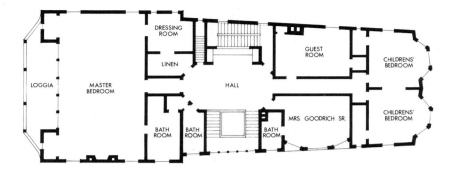

48. Goodrich House Project, second-floor plan

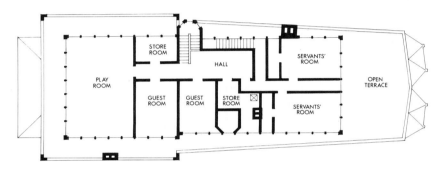

49. Goodrich House Project, third-floor plan

110

plan of the third floor borders on the absurd. Although plumbing and extra space were to be available in what was to be a much too large cleaning closet next to the servants' rooms, their bathroom would have been three floors below, in the basement. Two guest rooms were also planned for this floor, but no bathroom was furnished for them either. (Presumably guests would have to walk down to the second floor to take a bath or brush their teeth.) The children's playroom, also on this top and perhaps dangerous floor, would have faced north and would have been surrounded by a balcony five feet wide, while on the sunny south side, facing the servants' rooms, there was to be an ample terrace, seventeen by twenty-nine feet (plate 49).

The Nettie F. McCormick Cottage project, designed for the widow of Cyrus McCormick, founder of the International Harvester Company, was planned for Lake Forest, Illinois, and is dated August 1901. According to H. Allen Brooks, the side facade owes a debt to George Maher's Farson House in Oak Park and to Wright's rendering of the William Winslow House (plates 50–51).[15] The plans of the McCormick Cottage bring additional evidence of Sullivan's limitations as a residential architect. Apparently feeling unable to produce an original design, he derived the ground-floor plan from McKim, Mead and White's Isaac Bell House in Newport, of 1882 (plates 52–53). Presumably uneasy about whether the design was sufficiently progressive, he seems to have attempted to integrate the house with the garden in the new Prairie manner by modifying McKim, Mead and White's design with Wrightian elements. But he was not successful. He was unable to control all aspects of his design, and gave more thought to the approach to the house from the grounds than to the sequence from the main entrance. Coming in from the garden, there would have been first a covered porch running the full length of the building, and then an oblong living room connected by broad openings with the dining room to the left and the entrance hall to the right. A large fireplace in the living room would have provided a focus to this approach. This sequence from the garden recalls the entrance to Wright's Oak Park Studio, as well as that of his Winslow House. Off the McCormick dining room, a passage would have led to a large octagonal pergola, a motif that seems borrowed from the library of Wright's Studio.[16]

Unfortunately, Sullivan changed some of the features of the Bell House for the worse. His sequence of spaces from the entrance door onward, for instance, would have diminished family privacy.[17] The McCormick vestibule would have functioned only as a space separating the main door from the living room. A servant could not have opened the door without first crossing the full length of the living room. If the fam-

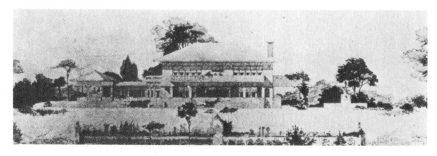

50. Nettie F. McCormick Cottage Project, Lake Forest, Illinois, 1901, side elevation

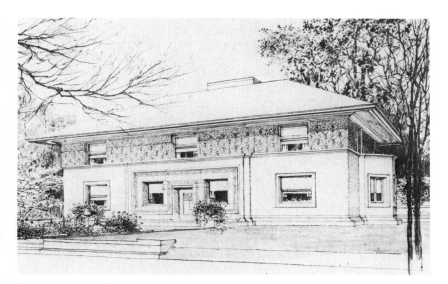

51. W. H. Winslow House, River Forest, Illinois, Frank Lloyd Wright, 1893

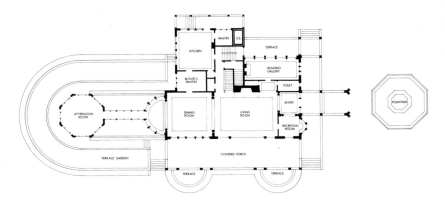

52. McCormick Cottage Project, first-floor plan

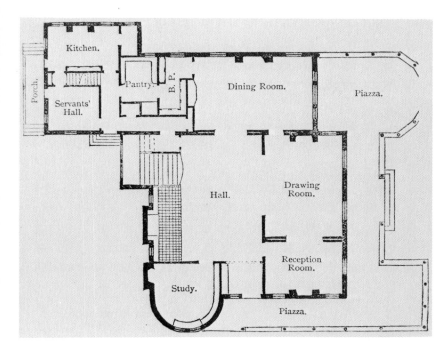

53. Isaac Bell House, Newport, Rhode Island, first-floor plan, McKim, Mead and White, 1881–82

ily were gathered there and did not wish to see anyone, it would have been impossible to dismiss an unexpected caller with some excuse, because the living room would have been in full view of the vestibule. This is not true of the Bell House, where the drawing room is enclosed. A fifteen-foot-wide opening between the living room and the dining room would have created further problems in the McCormick Cottage. Without using draperies or cumbersome portable screens, it would have been impossible to shield the view into the dining room while the table was being laid or cleared—a problem solved in the Bell House with sliding doors. It is possible, furthermore, that Mrs. McCormick expected her staircase to come into a hall rather than into her living room, and this points to the main problem of the design: Sullivan mixed the functions of living hall and drawing room in one single space, an error McKim, Mead and White had avoided.

The bedroom floor of the McCormick Cottage, which, unreasonably, was to be far more formal than the ground story, seems to have been Sullivan's own conception, not an adaptation. It was designed around a grand Beaux-Arts effect of a staircase coming to a large octagonal rotunda surrounded by an engaged colonnade (plate 54). The hall probably would have been dark, perhaps needing constant artificial lighting in spite of the windows opening onto the staircase; the elevation gives no evidence of a skylight in this space. The five bedrooms on this floor would have each had a large closet and a private bathroom. Sullivan did not repeat, here, his mistakes of the Goodrich House.

The Henry Babson House (Riverside, Illinois, 1907) was Sullivan's most livable. Presumably George Elmslie was more involved with its layout than with those of the preceding projects; by this time Sullivan's assistant was well aware of the subtleties of making a Prairie house comfortable. In a letter to Frank Lloyd Wright of June 12, 1936, Elmslie wrote: "I was loyal to you too. You have forgotten how often I went to Oak Park to do a bit of drawing for you."[18] The plan resembles that of Wright's Husser House, of 1899, an influence that should not be disregarded (plates 55–56). The exterior of the Babson House was in keeping with the Prairie Style (plate 57). Horizontal lines dominated, the eaves were broad, and the roof was low-pitched. Against a background of tapestry brick and horizontal board-and-batten siding, there was a porch to the left, a projecting half-octagonal veranda to the front, the elegant arch of the breakfast porch to the right, and most prominently, a cantilevered arcaded balcony on the second floor that brought together all the elements of the composition.

In 1909 Sullivan was commissioned by Charles Crane of the Crane Plumbing Company to design a house in Madison, Wisconsin, for his

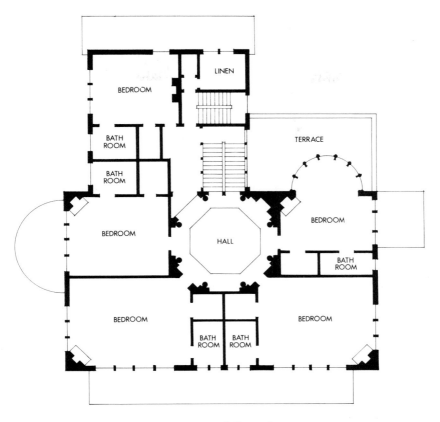

Image labels: BEDROOM, LINEN, BATH ROOM, BATH ROOM, TERRACE, BEDROOM, BEDROOM, HALL, BATH ROOM, BEDROOM, BEDROOM, BATH ROOM, BATH ROOM

54. McCormick Cottage Project, second-floor plan

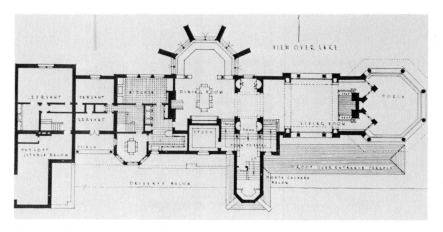

55. Joseph Husser House, Chicago, floor plan. Frank Lloyd Wright, 1899.

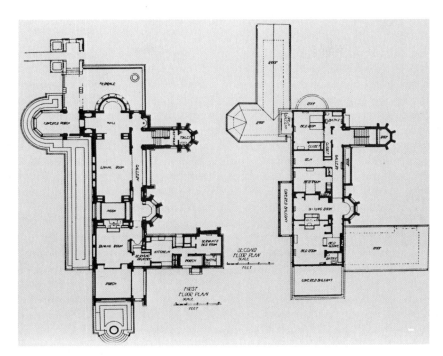

56. Henry Babson House, Riverside, Illinois, floor plans, 1907

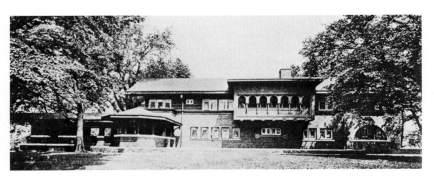

57. Babson House

119

son-in-law and daughter, Harold and Josephine Bradley. A first plan was in the shape of a cross. It featured a central hall from which opened a den to the north, a dining room to the south, a very large living room to the west, and a staircase and vestibule to the east (plate 58). The Bradleys rejected this first design as too ostentatious, because they wanted to live "the life of the average professor's family."[19] A compromise design was finally reached and this was executed. But in the long run it did not suit the Bradleys either, and in 1914 they commissioned Purcell and Elmslie to build them a new house in Shorewood Hills, a suburb of Madison. They moved to their new residence in 1915 and sold the Sullivan house to the Sigma Phi Fraternity, which still owns it.[20]

Mrs. Bradley was deaf, and a house where rooms were closed off from each other would have presented difficulties for supervising the children she expected to have. She wanted to keep them within view, since she would not be able to hear them playing or calling for help. To fulfill Mrs. Bradley's need Sullivan adapted, for the second design, the plan of Wright's "Home in a Prairie Town," a fact H. Allen Brooks has noticed.[21] Sullivan, however, rejected Wright's fluid horizontality and furthermore, he did not reduce the sizes of the rooms sufficiently to achieve a feeling of domesticity (plates 59–60). The resulting scale is not intimate enough and still suggests the grand formality the owners had rejected. There are, moreover, a number of anomalies in this second design. The new living room faces north, a location improper for Wisconsin winters, and it is much smaller than the dining room, which remained in the same position as before and more or less of the same size. Sullivan lengthened the hall also, making it the largest area in the house, but because of its corridor-like proportions, it could not function as a Queen-Anne living hall. And finally, the new den, on axis with the hall, would have been difficult for a professor to use as a study; shelf space in it is indeed scanty. Despite these problems, Sullivan's sense of composition and decoration were sufficiently strong to establish a beautiful architectural composition, inside as well as out. The structure is powerfully self-assertive, and a bold anthropomorphic scheme determines its most characteristic feature: on the second floor, cantilevered beams ending in large rectangular ornaments suggest extended arms with closed fists supporting a balcony (plate 61).

Sullivan's last residential project was commissioned in 1911 by Carl Bennett, vice-president of the National Farmers' Bank of Owatonna, Minnesota. The building was probably conceived in November of that year, and the drawings bear the date of February 1912 (plates 62–63).[22] The house was to be three stories high and to face north. The first floor was to contain the entrance, a playroom for the children, and the utili-

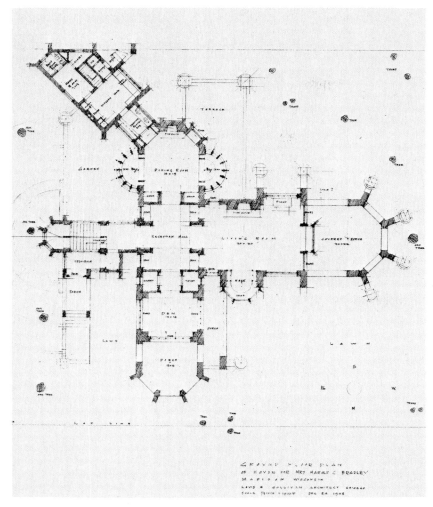

58. Harold C. Bradley House, Madison, Wisconsin, first-floor plan of original design, 1909.

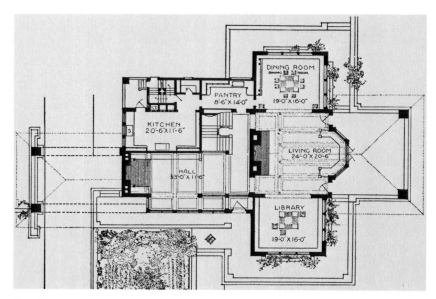

59. "Home in a Prairie Town," Frank Lloyd Wright, 1901

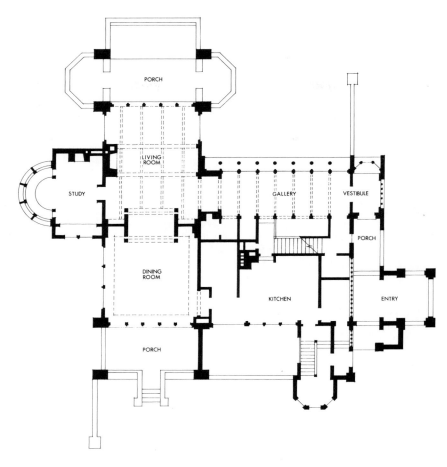

60. Bradley House, first-floor plan of executed design

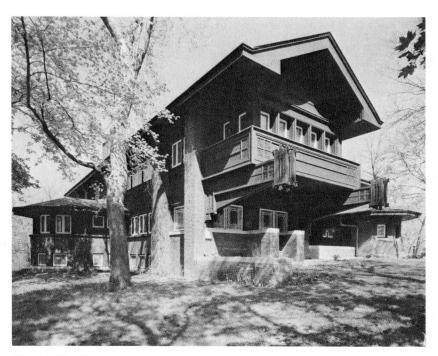

61. Bradley House

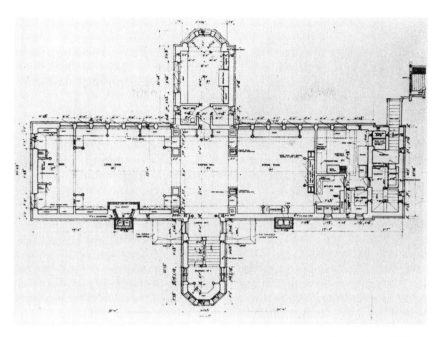

62. Carl K. Bennett House Project, Owatonna, Minnesota, floor plan, 1912

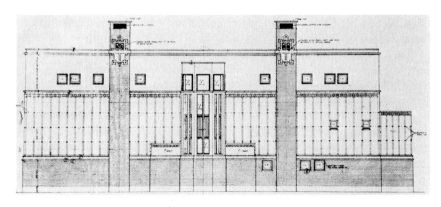

63. Bennett House Project, elevation

ties area; the second, formal reception rooms and kitchen; five bedrooms and two bathrooms would be on the third floor. The division into three levels, as well as the type of rooms on each, is reminiscent of the Goodrich House, but like the ground floor of the first Bradley design, the second story was to be in the shape of a cross. Separated from a central vestibule by columns Brooks has labeled "Adamesque,"[23] the living room and the dining room were to be to the left and right respectively and the staircase and den to the front and back. The bedrooms, on the third floor, were to be in a row facing south and were to open onto a corridor running along the front of the building, as in the earlier Babson House.

The front elevation of the Bennett House would have been impressive, with its three floors corresponding in proportion and expression to the Renaissance division of base, *piano nobile*, and attic. The ground floor was to be in brick, while the second story, the tallest, was to have vertical board-and-batten siding capped by a cornice-like stringcourse in an arrangement suggesting the colonnade in that long-standing formula that had begun with Bramante's House of Raphael. The top story would not have looked at all like the bedroom floor of an American house, but rather like a stuccoed attic in the Renaissance-Baroque tradition. Finally, the central stair was to be balanced left and right by tall and slim brick chimneys decorated at the top with bold rectangular terra cotta interlaces. Because of the grand, formal scheme of the facade, the reception rooms could not have windows to the front. Since the building would have sat high above the garden because of a classical division of parts in elevation, there could have been no integration between outside and inside in the rear. Nor would the need for ventilation of the rooms below have allowed for the construction of a terrace extending out from the second floor reception rooms toward the garden and then descending to it by means of a staircase. The formality of the Bennett House would have been quite suitable for an *hôtel particulier* housing European aristocracy. It would have been a splendid example of a formal house within the early twentieth-century European avant-garde had it been designed abroad; Hoffmann's Palais Stoclet in Brussels, however dissimilar, comes to mind. The Bennetts, clearly understanding that Sullivan's design would be totally out of place in a rural midwestern town with a population of six thousand, rejected the project. In 1914 they engaged Purcell and Elmslie to design their house, as the Bradleys of Madison had also done during that year.[24] In the Bennett project, his last house, Sullivan completed a cycle in his residential design. Clearly showing his preferences, he reverted to the expression he had favored before he had allowed Elmslie a free hand in planning.

The imbalance between design and function in Sullivan's residential work clarifies further his conception of architecture. In his zeal, he never realized that he was mixing two different myths in his houses, one relating to nature and the other to what he considered to be man's innate need for ceremony; to him both were part of the same whole. Neither did he see that to express them he was forcing a synthesis of Prairie composition and Beaux-Arts planning, two incompatible design techniques. Because of his lack of vision, his expressions of these myths often stifled one another, as one can plainly see, for instance, in the Mc-Cormick and Bennett houses. Three other factors compounded the problem further. Sullivan's interest in broadcasting through architecture the message of the perfectability of man, his previous and almost exclusive training in composition and ornamentation, and his notion that style was of a higher order than planning moved him to uphold architectural symbolism at the expense of comfort and common sense. Seldom did he take into account all of his clients' needs and much less did he make their houses function as was expected of them. Because of his obstinacy, practically all of his designs were rejected in one way or another and, for want of commissions, his career as residential architect gradually came to an end.

The Banks

Sullivan's career culminated with the new style of the National Farmers' Bank in Owatonna, Minnesota, of 1907, where he finally mastered the integration of interior and exterior, not through experiments with architectural space, as Wright did, but typically, by giving color and light a new poetic function in his architecture.

A combined influence of French symbolist poetry and impressionist music may have been important in the formulation of his new esthetic. Since the 1880s such poets as Mallarmé, Rimbaud, and Verlaine in France and Maeterlinck in Belgium, expanding ideas first explored by the Parnassians and Baudelaire before them, had used the material universe to express the immaterial realities of thought and feeling through correspondences, allegories, and consciously invented symbols. Behind every incident, almost behind every phrase in this literature, one is aware of a concealed universality, of the adumbration of greater things. Maeterlinck, for instance, believed that revealing the infinite, as well as the grandeur and secret beauty of man, was the supreme mission of art. He also believed that artists were imbued with a special sensitivity to the universal and that it was their task to give lesser beings a glimpse of that vision through art. To Maeterlinck, art was a metaphor, because the artist is unable to express directly the breadth and intensity of his intuition, and even if he could, the people would not understand it. Symbolist poets also sought to represent the unity of all feeling by integrating effects from other arts into poetry. Their verses, for instance, attempt to evoke the colors of the painter and the rhythms of the musician. These are all esthetic objectives that Sullivan recognized as very close to his own, and his awareness of this movement is quite probable. These comments on Symbolism are but a restatement of Richard Hovey's introduction to his two-volume translation of Maeterlinck's plays, of which Sullivan kept a copy in his summer cottage in Mississippi.[25]

Musical associations were also important to Sullivan's new style. Debussy, Satie, Ravel, and other impressionist composers were seeking to express in music what the Symbolist poets sought in words. Debussy's pieces evoking color are well known, and so is the fact that he based his only opera, *Pelléas et Mélisande*, on Maeterlinck's play, and translated Mallarmé's *L'Après-midi d'un faune* into music. Sullivan's awareness of such links of color, rhythm, and allegory is manifest in a letter he wrote to Carl Bennett, the vice-president of the Owatonna bank:

My whole Spring is wrapped up just now in the study of color and out of doors for the sake of your bank decorations—which I wish to make out of doors-in-doors

128

if I can. . . . I am almost abnormally sensitive to color just now and every shade and nuance produces upon me an effect that is orchestral and patently sensitive to all the instruments. I know in my own mind what I am trying to achieve for you and I have in Millet [who worked on the decoration] the best chorus master that could be found. I want a color symphony and I am pretty sure I am going to get it. I want something with many shades of the strings and the wood winds and the brass. . . . There never has been in my entire career such an opportunity for a color tone poem as your bank interior plainly puts before me. . . . I don't think I can possibly impress upon you how deep a hold this color symphony has taken upon me. . . . Suffice it further to say that I am wrapped up in your project to a degree that would be absurd in connection with anyone but yourself.[26]

Sullivan had found in Bennett a sympathetic ear for his new ideas. In fact, the quality of the Owatonna bank was to a large extent a product of Sullivan's confidence in Bennett's understanding of his esthetic aims. A love of music linked the two men. According to Robert Warn, Bennett's main interest in Harvard "had been music both as chorister and a conductor of music groups. In 1889–90 he led the famed Pierian Sodality —the Harvard Symphony Orchestra."[27] Presumably Bennett encouraged Sullivan's enthusiasm for creating an architectural composition that would symbolize a harmony with poetry and music through color and light. In 1911 Bennett wrote Sullivan a highly complimentary letter in which he said, "I have often likened your work to that of the great musicians or poets, and have thought of ourselves as though we possessed exclusively . . . one of the symphonies of Beethoven."[28] Furthermore, Bennett's belief that his bank "mark[ed] a new epoch in American architecture," as the title of his 1908 article in *The Craftsman* indicates,[29] may point to his confidence that in the Owatonna bank, and for the first time in American history, Sullivan had been able to fuse architecture, music, and poetry.

Tapestry brick had been important in Sullivan's new vision. With each brick different in color from those around it, he had made the tone of walls vary from soft pinks through reds, yellows, different hues of brown, purples, and black. The material suggested to him "the tone of a very old oriental rug,"[30] and served to establish a unified tension of texture and color on large expanses of exterior masonry. It was a treatment splendidly suited to soften, through color and texture, the shape of the building, which had been given a box-like appearance to make it look strong and solid, "a safe place for keeping money and valuables (plate 64)."[31]

Inside, brick, although homogeneous in color, helps nevertheless to sustain a memory of the exterior (plate 65). All elements within the banking room are also in superb accord with each other. Counter tops

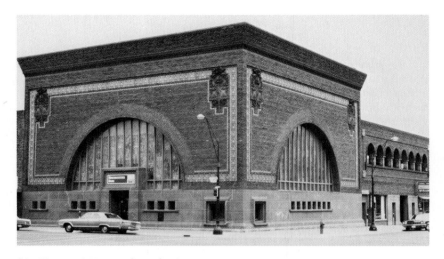

64. Farmers' National Bank, Owatonna, Minnesota, 1907–8

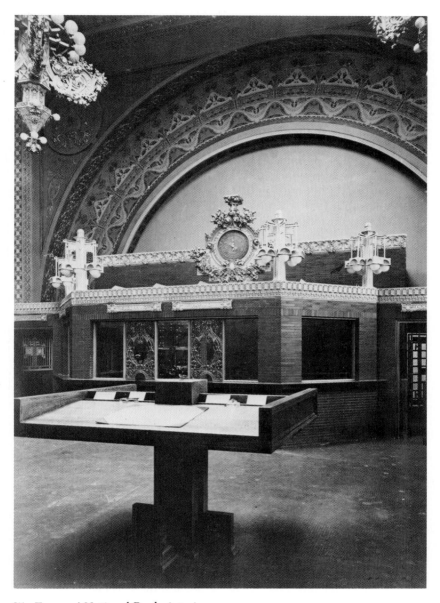

65. Farmers' National Bank, interior

and deal plates of Belgian black marble, green terra cotta ornaments and light fixtures, stencil and plaster decorations around the arches and on the edges of the ceiling, and two large murals with pastoral subjects pick up, at times boldly but more often delicately, the different hues of the exterior tapestry brick, creating a harmonious effect of the greatest sophistication. Light coming in through the stained-glass windows and the skylight contributes significantly to the glowing aura of this interior. Green is the predominant color in the glass, worked out in different tones ranging down to alabaster yellow. This pervading green light reinforces the green of the walls, tones down the reddish browns of the brick, and softens the gilding used in most of the decorative accents. The result is an exquisite atmosphere evoking autumn or early spring, and this in turn enhances the building as a symbol of a midwestern community.

A persistence of American values had been for Sullivan the most striking feature of life in Owatonna, and he was moved to express this endurance of Whitman's democracy. The hope of America, he presumably came now to believe, depended on farmers and not on his earlier heroes, the urban entrepreneurs, who by becoming "feudal" had betrayed his trust in them. In this Owatonna commission, therefore, Sullivan had seen an excellent occasion for achieving what he considered a work of democratic architecture, one that would express, in a manner unimagined up to then, the pleasure derived from estheticizing life in accordance with the rhythms of nature.

Unfortunately, Sullivan did not develop the Owatonna style in his next commissions. The personal anguish of the years 1907–9, compounded with his increasing alcoholism, either fogged his vision or weakened his trust in his esthetic intuition; he changed his style twice, and for the worse, between 1910 and 1914. Attempting to make his architecture more appealing to modern taste, as he himself implied in an article in 1912,[32] he experimented first with starkness and geometric severity in the People's Savings Bank (Cedar Rapids, Iowa, 1911) a change in style that Montgomery Schuyler immediately noticed (plate 66).[33] Other buildings, such as St. Paul's Methodist-Episcopal Church, in Cedar Rapids, designed in October 1910, and the Bennett House, of 1912, share an air of sternness with the Cedar Rapids bank. These new austere forms are very close to those used earlier by Sullivan's friend and admirer Hugh Garden in the Schoenhofen Brewery Powerhouse (Chicago, 1902) and in the "Project for a Theater for Marion, Indiana," displayed in the Chicago Architectural Club's annual exhibition in 1901 (plates 67–68). Apparently dissatisfied wih this new style, Sullivan reverted in 1913 to importantly stated exterior ornamentation, and at-

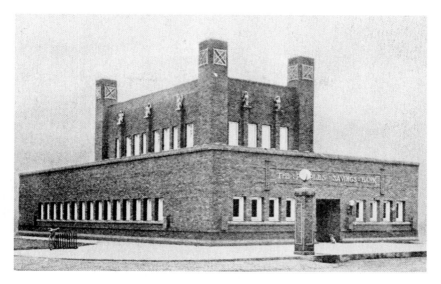

66. People's Savings Bank, Cedar Rapids, Iowa, 1911

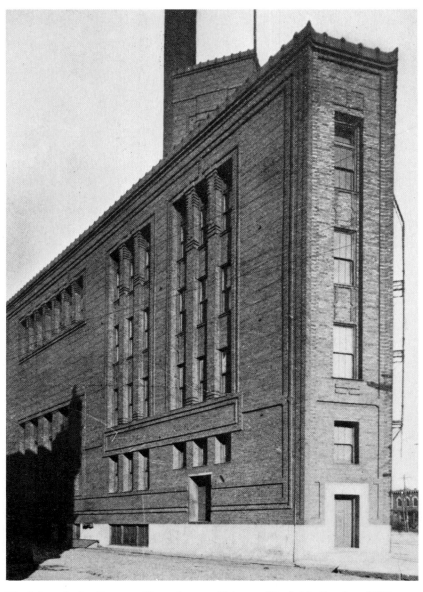

67. Schoenhofen Brewery Powerhouse, Chicago, Hugh M. Garden, 1902

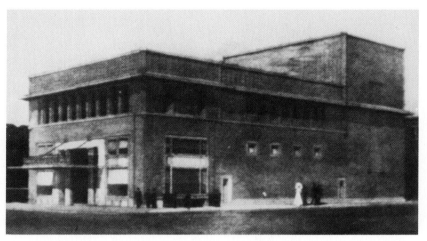

68. "Project for a Theater for Marion, Indiana." Hugh M. G. Garden, 1901

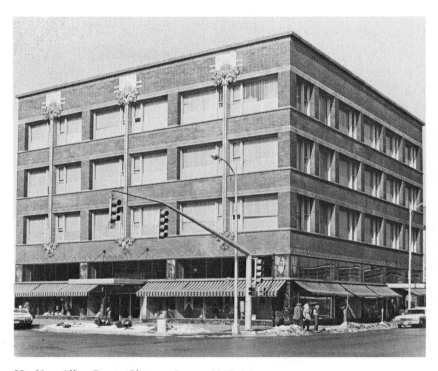

69. Van Allen Store, Clinton, Iowa, 1913–15

tempted to recapture with it the anthropomorphic quality he had achieved in his skyscrapers of the turn of the century. The outcome, unfortunately, was at best picturesque. In the Van Allen Store (Clinton, Iowa, 1913–15), he placed three thin, pier-like decorations on only one of the facades of a corner building, giving the impression of an incomplete program (plate 69). In the Home Building Association (Newark, Ohio, 1914), both the anthropomorphic program and its scale seem excessive for the size of the building (plate 70). In that same year, however —seven after the Owatonna design—he finally approached its esthetic quality in the Merchants' National Bank in Grinnell, Iowa, an achievement he repeated in 1917–18 in the People's Savings and Loan Association in Sidney, Ohio, which according to Connely, Sullivan considered his best bank.[34] Color and light are used in these two buildings as effectively as in Owatonna, and their designs partake of the same exquisite air of dignity and monumentality, which clearly achieves a symbolic quality (plates 71–73).

His last bank, the Farmers' and Merchants' Union (Columbus, Wisconsin, 1919) is about half as big as the two preceding ones. Presumably satisfying a desire for the sort of grandeur expressed in many of his residential designs, Sullivan disregarded the relation between the size of the building and its setting (plate 74). The location stifles the monumentality of an anthropomorphic program consisting of a highly decorated terra cotta and marble summer beam upheld by three piers and in turn supporting an arch above. This scheme would have worked well in a much larger building on that site or in an even smaller structure than the Columbus bank, if the building had stood in isolation like his earlier tombs. But the design is too much for the location. In that typical two-story-front commercial street of an ordinary midwestern town, the facade becomes an incongruous rhetorical accent.[35]

Sullivan's final work came in 1922, a facade for the Krause Music Shop, a small two-story building designed by his former draftsman William C. Presto (plate 75).[36] Sullivan rendered the exterior in very pale green terra cotta. The main features are a large ornate portal splayed inwardly and a large letter K set within a decorated circle. This insignia looks like a shield and stands banner-like above an engaged pier issuing from a wreath. Such ornateness is far more suitable to a garden pavilion built for royal ceremonies than to a modest shop in a commonplace Chicago neighborhood. Faced with such facts, Hugh Morrison wrote, "We have only to compare it with the conventional facades of the adjacent stores which have since been built up around it, to realize as forcefully as ever that even in his least significant works Sullivan was still a master."[37] In order to praise the Krause Music Shop facade, Morrison

70. Home Building Association Bank, Newark, Ohio, 1914

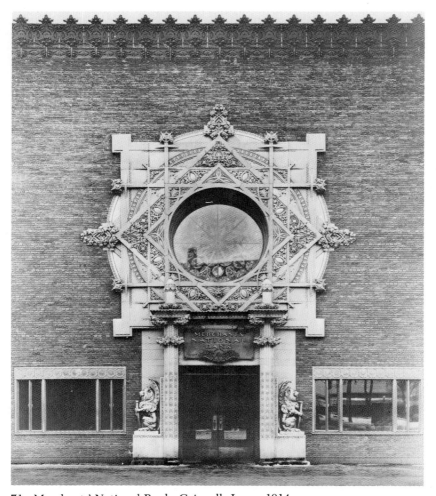

71. Merchants' National Bank, Grinnell, Iowa, 1914

72. Merchants' National Bank, interior

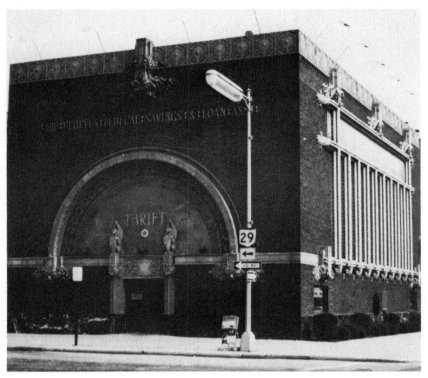

73. People's Savings and Loan Association Bank, Sidney, Ohio, 1917–18

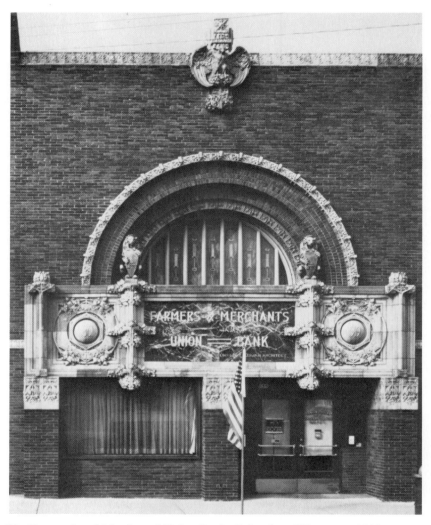

74. Farmers' and Merchants' Union Bank, Columbus, Wisconsin, 1919

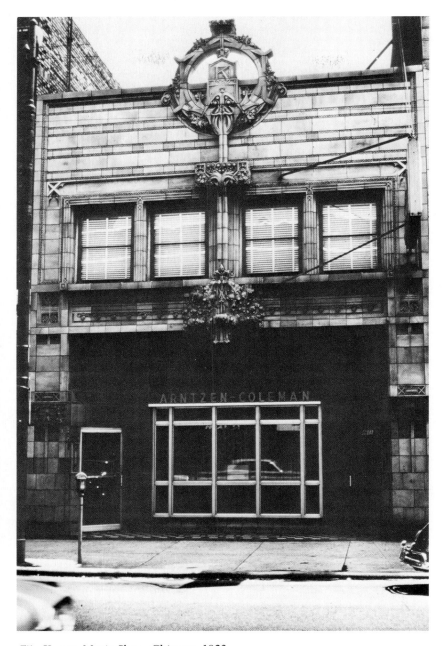

75. Krause Music Shop, Chicago, 1922

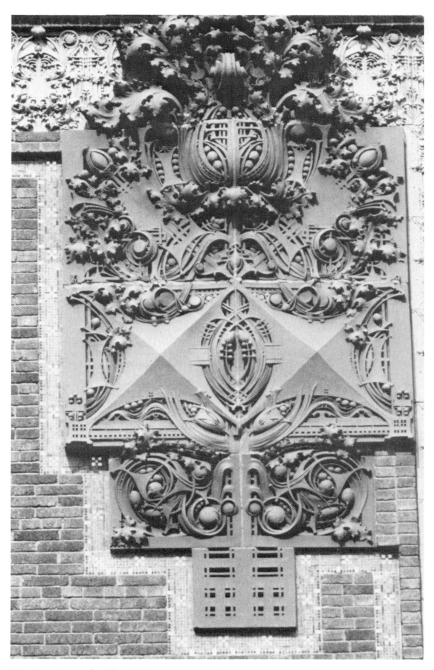

76. Owatonna bank, cast-iron ornament

144

prudently chose to compare it to the fourth-rate designs of insensitive contractors and anonymous builders that surround it.

Sullivan's ornament shows a similar process of decline. At its best, his ornamentation consists of systems of strictly controlled geometric axes and simple linear figures coming to life through effects of flowing plasticity. With the resulting superb integration of geometric and organic efflorescence, it takes a skillful eye to realize where the one ends and the other begins, as works of the quality of the "Golden Doorway," the Getty Tomb, and the Auditorium will bear witness. But Sullivan's later decorations, with the exception of a number of plates in *A System of Architectural Ornament*, show no evidence of that careful integration. They are either dry, as on the Cedar Rapids bank, or rhetorical rather than lyrical, as on the Van Allen Store and the Newark and Columbus banks. There is also, here and there, a certain medievalizing grandiloquence. His symbolism of earlier years became bastardized by the use of lions, griffins, panaches, and spread-winged eagles. Even in the Owatonna bank, the large cast-iron ornaments of the facade resemble heraldic escutcheons (plate 76).

Misfortune and chronic alcoholism had done much to determine an uneven pattern in the quality of Sullivan's production after Owatonna. Sometimes almost as good as Owatonna but never better, and sometimes self-conscious and dry, Sullivan's late work often bore the deteriorating mark of his personal tragedy. How much more or better he might have expressed his exquisite vision of American ruralism had his personal circumstances been different, no one can say. Owatonna, Grinnell, and Sidney lure us with their beauty and prompt the tantalizing question.

5
A Concept of Design

SULLIVAN'S LIFE followed a tragic pattern, and no one writing about him can completely detach himself from it. Many of his apologists have misunderstood his adversity, however. His martyrdom was not that of a prophet doomed by forces of evil and neither was his Promethean self-conception necessarily accurate. Closer to the truth is to consider that Sullivan was emotionally unable to cope with his own belated romanticism.

More than anything else, it was his obstinate dedication to anachronistic conceptions that led him to unhappiness. A tendency to accept uncritically his assertion that his aim was to achieve a national style based on modernity has masked the fact that such a pronouncement was practically a solecism by the time it was made, because his idea of modernity was intimately linked to a transcendental concept of nature. Sullivan extended into architecture a trend that Emerson had begun in literature with the publication of *Nature* in 1836, but in half a century, by the time Sullivan published his first address, these ideas had worn thin. Moreover, in a matter of a few years, his goal of suggesting the rhythms of nature in buildings and his impatience with the use of European modes to represent American realities completely contradicted the new architecture of the period, which sought an international expression through the use of academic forms. Neither did his system of design, in spite of his "Dionysian" concept of trade, fit the standard relationship between an architect and a corporation's building committee. An intimate bond with an enlightened patron who would agree with him that a building was primarily a work of art and that its main reason for existence was to convey an idea as importantly as a sonata, a poem, or a picture can was much more in keeping with his personality.

His intolerance of ideas departing from his own transcendentalist doctrine was so formidable that one imagines that his times would have

had to be completely different than they were—that romanticism would have had to continue through the remainder of the century as it had been during the 1830s and 40s—for his own generation to have accepted his ideas as anything but impractical and old-fashioned. Instead of appearing opinionated to his contemporaries, he might then have been acknowledged as an important spokesman of the times, more or less like Ruskin a few years before him. Only then would he have been the "prophet of modern architecture" in his own time and his work hailed as "the shaping of American architecture." Perhaps even his inadequacies as a planner would have seemed unimportant to his clients, who would have been willing to offset their discomfort with the pleasure of having Sullivan express their lyrical aspirations better than any other architect could. But of course, all of this is idle speculation; reality was different. He adjusted neither intellectually nor emotionally to the new ideas of his generation, and became a social misfit.

Even more than is usual in the life of an architect, Sullivan's train of thought was constantly channelled by or expanded in the direction of the expressive possibilities of his commissions. The precepts of "Characteristics and Tendencies of American Architecture" and of the "Essay on Inspiration" did not find fruition in "forceful, direct, clear and straightforward . . . virile buildings"[1] until the Auditorium commission. "Intuitive sympathy, tact, suavity and grace"[2] were later explored in a woman's tomb. At the same exact time that he was designing Eliza Getty's mausoleum, in October of 1890, he was compelled to look at other design possibilities. His first skyscraper had moved him to look upon that building type as the symbol of the heroic power of trade that would lead American civilization towards a dream of perfection. Such power was not to be portrayed as the potential energy bound up in the Auditorium but as the dynamism of an acting force. Anthropomorphism was now more important than before. In his new buildings, subjective tension reacted against objective compression to represent not only power but also that superior rhythm from which it derived. To use a Michelangelesque metaphor, the passive Adam of the *Creation of Man*, which is the Auditorium, had become in the skyscrapers as active as his Creator. In time, these experiments led to the pronouncements of "The Tall Office Building Artistically Considered," of 1896.

Events continued to shape Sullivan's life. If a number of young people had not been active in the Chicago Architectural Club and subsequently in the Architectural League, *Kindergarten Chats* and its sequel *Democracy: A Man-Search* might not have come to light. Maeterlinck and Debussy left their mark in Owatonna as strongly as Taine and Swedenborg had left theirs on the Auditorium and the Getty Tomb. *The*

Autobiography of an Idea and *A System of Architectural Ornament* exist because they were commissioned largely out of pity to someone who had once been important. And if it had not been for Adler, Sullivan might not have been a major figure in American architecture.

But beyond as well as under these accidental circumstances pushing him in one direction or another was the concentrating element of his passion, which made his esthetic as straitly bound as his concept of architecture. The intensity of his artistic vision was a consequence of his making only one thought manifest in his work. Democracy, as he understood it, was the final utopia prescribed for man by nature. Architecture was to express that perfect state by evoking the essential rhythm of the universe. Lyricism, rationalism, and heroism, the three elements with which humanity may comprehend its own participation in nature, are revealed in the beauty, method of design, and expressive purpose of Sullivan's buildings. In that respect, the teachings of Herbert Spencer, whom he revered,[3] explain much of Sullivan's thinking.

To Spencer, matter, motion, and force were the constants of a universe mechanically conceived. He believed that force produced motion, that motion determined the diffusion of matter, and that conversely, concentration of matter slowed down motion. Fundamental cycles of evolution and dissolution grew out of each other, and this continuous creation of the universe was "the law that transcends proof."[4] These were concepts that Sullivan extolled with fanatical zeal because he believed that they brought objective validity and scientific verification to ideas that, in reality, came from the transcendentalism that suffused his romanticism. To him, Spencer's philosophy sanctioned the belief, for instance, that the subjective and the objective evolve into each other and are interchangeable because they are both reflections of the same transcendent rhythm. Such romantic interpretations point to the fact that Sullivan made use of Spencer's theories arbitrarily, making them fit his own. Yet, totally by accident, Sullivan's esthetic progress followed Spencer's categories of matter, motion, and force. The static tectonicism of the Auditorium corresponds to matter, the dynamic anthropomorphism of the skyscrapers to motion, and the integration of color and light in the banks suggests a transcendent force. In Spencerian terms, Sullivan's esthetic evolution could be seen as an image of cosmic evolution.

Sullivan needed but few elements to achieve his artistic intentions. Common to all his periods was the Ruskinian idea that architecture consisted exclusively of the articulation of surfaces and the decoration of key points. Stenciled ornamentation; reliefs in plaster, terra cotta, and cast iron; clusters of organic motifs placed on capitals and other

prominent places, structural members attached to facades and becoming constituents of anthropomorphic programs; and later, tapestry brick and stained glass—these in his opinion were sufficient components for achieving his esthetic purposes. As a result, not only John Root, Daniel Burnham, and Montgomery Schuyler considered him mainly a decorator, but also Frank Lloyd Wright, who in 1935 in reviewing Hugh Morrison's book wrote about Sullivan, "[He] is essentially a lyric poet-philosopher interested in the sensuous experience of expressing inner rhythms evolving a language of his own—his ornament—in which to utter himself: unique among mankind."[5] Sullivan, to Wright, was an ornamentalist expressing a longing for integration with nature through decoration.

Because of the strength of his vocation, Sullivan never stopped to reflect that decoration and architectural composition were too limited to state ideas as important as those he wished to express. Indeed, if he had not written so extensively about his beliefs it would have been very difficult, perhaps impossible, to deduce his transcendentalist message. On the other hand, his belief that composition and ornamentation could communicate such concepts makes him a participant in that nineteenth-century tradition which strained the expressive capacity of those two elements and made them the most important features in architecture. In keeping with the period's fascination with taxonomy as the groundwork of knowledge, the classification of ornamental characteristics and methods of facade composition came to be considered the clearest and most profitable system for studying architecture. Both Sullivan's work and Art Nouveau, having specific ornamental features that can be listed and described as different from those of any other period, rank among the late-nineteenth-century styles that were a culmination of the era's quest for a new and characteristic architectural expression, as the idea was then understood. There are differences between the two, however. William Jordy has rightly pointed out that Art Nouveau ornamentation is structured towards spatial composition more than is Sullivan's, which concerns itself mainly with the decoration of surfaces.[6] Articulating space by means of structural elements conceived as sculpture in the round—as Horta, for instance, did—seems to have never entered his mind. Much less did he even consider, as did Gaudí, that nature could be evoked by molding space into effects of flowing plasticity.

Sullivan's romanticism is finally being recognized as the true cause for both his failure in life and the posthumous success that is his due. An important reason for this delay in recognizing the importance of his romanticism is that his architecture was misunderstood for so long. Shortly after his death in 1924, European critics began citing Adler and Sulli-

van skyscrapers as important antecedents to avant-garde constructional ideas of the interwar period. Studying the buildings but not Sullivan's writings (which are more accessible now than then), and mistaking Adler's work for Sullivan's, Europeans noted with interest what they incorrectly saw as Sullivan's relation of form and structure in architecture. Ironically, they disregarded his ornamentation, and did not realize that at the end of his life Sullivan endorsed only Frank Lloyd Wright and Eliel Saarinen, because he considered that their concepts of design were as romantic as his own. Neither did Europeans seem to know that in a 1923 article entitled "The Chicago Tribune Competition" Sullivan made no mention whatsoever of Gropius's entry.[7] Erich Mendelsohn's summarizing comment of 1928 on the Schiller Building is a good example of misguided European attitudes. "Much as yet depends on tradition," Mendelsohn wrote, "but much is an honest attempt to develop the proper forms according to new conditions."[8] European scholars moving to America after 1933 did not alter their views on Sullivan. That was an age of universal belief in machines, efficiency, and technocracy; the romantic aspects of Sullivan's architecture were outside the interest of the Europeans who spoke and the Americans who listened.

American contributions to a more rounded understanding of Sullivan's architectural and literary work are innately broader and deeper than the European. In 1931 Lewis Mumford, in *The Brown Decades*, was the first historian to recognize Sullivan's position in American architecture. Hugh Morrison's seminal *Louis Sullivan, Prophet of Modern Architecture* came out four years later. Yet in spite of the broad avenue of research Morrison opened, a canvass of the architectural press of the late thirties and early forties reveals that Sullivan's architecture received little attention during that period. This lack of popularity can be explained partly by the self-consciousness with which eclectics and early Internationalists of the time disregarded "the ornamental vagaries" of late-nineteenth-century architecture.

Interest in Sullivan increased after World War II, beginning with an article by Henry Hope in 1947. Hope was the first person outside Sullivan's immediate circle, besides Morrison, to study Sullivan's ornament as an element integral to his buildings, and to see him as a man of his times and not as a precursor to the new architecture. Also during these immediate postwar years, Isabella Athey brought out her edition of important writings by Sullivan, Frank Lloyd Wright published *Genius and the Mobocracy*, and James Marston Fitch, in his *American Building: The Forces That Shape It*, reinforced the more recent view of Sullivan as an architect with significantly American roots. A few articles on Sullivan also appeared here and there. Yet these efforts did not make

him popular; the 1956 show at the Art Institute of Chicago honoring his centennial was very poorly attended.[9] He was still unknown to many, and was considered "old fashioned" by others. In the last two decades, however, his name has come to be widely recognized. Some of his works have been reprinted, others have been published for the first time, and several important books and dissertations such as Paul Sprague's, as well as valuable articles, have been written about him. The idea of Louis Sullivan as an antecedent of the *neue Sachlichkeit* is now a thing of the past. Sherman Paul's *Louis Sullivan, An Architect in American Thought* and Vincent Scully's article "Louis Sullivan's Architectural Ornament," two truly important landmarks in the study of his work, have contributed much to a more accurate perception of his style as an outgrowth of earlier American romantic notions.[10]

Now, more than half a century after his death, one can see Sullivan in sharper focus. In his romanticism he believed that when humanity came to realize what his architecture expressed, man would want to adopt a mode of living befitting such buildings and the millennium would be established. He was also confident that he had found a style of everlasting modernity. Building types would come and go with the development of material progress, but his method of raising them to the dignity of architecture through decoration and composition would remain unchanged. His style, for him, had the timelessness of a work of nature—of foliage in spring, or fields in autumn. It was such ornament and sense of composition that would evoke the eternal rhythm that sustained the universe, helping man to realize that the reward of communion with nature would be a life of constant esthetic pleasure. The beauty of a Sullivan design, in the last analysis, depends upon how faithfully he sought to express his "Idea" in it, and how well he united lyricism and rationalism to express heroism through architectural composition and ornamentation. Now that questions of turn-of-the-century taste are the subject of history and he is no longer brought into the polemics of the day, the esthetic aspects of his buildings are coming under sharper scrutiny than their better-known structural characteristics, and his true position in American architecture can be assessed.

A strong correspondence between his poetic idea of America and his practice—that remarkable bond between his concept of architecture and his architectural conceptions—is perhaps the most salient of Sullivan's achievements and places him in a category almost his own. Neither a rationalist like Viollet-le-Duc nor a romantic revivalist like Ruskin nor a classical one for the sake of order and propriety like Gaudet, he followed a line of thought much neglected in nineteenth-century architectural studies, a transcendentalist-romantic one. This he

did in a typically American way, by identifying democracy as the dictate of a nature which had created all men as equal specimens of the same race. The dignity of man resided in his fulfilling his potential for perfection by allowing his actions and his appearance to suggest his essence effortlessly, naturally, and continuously, as do animals and trees. A society featuring "feudal consciousness," as Whitman called it, would never understand that it is an error to look upon democracy merely as the best socio-political system devised by man; far more important than that, it is a creation of nature. But not even in America was this relationship between nature and democracy clearly understood. Sullivan, to redress that condition, gave his buildings a didactic function to perform. Like creations of nature, they would each rejoice in their uniqueness, while at the same time expressing the general characteristics of their types. It is this insistence upon individuality, as opposed to a corporate conception of typology, that makes Sullivan so eminently American. But his designs—and ironically, this is where they fail—cannot by themselves broadcast the message entrusted to them. Sullivan's intentions are understood only when his work is taken as a whole, literary as well as architectural, and one area explains the other. Hence the reason that his architecture was misunderstood by people who had not read his writings carefully.

Exploring Sullivan's thought to understand his buildings yields its own reward: one encounters his superb passion. Important as his accomplishments as an architect are, it is the force of his passion seeking an outlet through architecture that is most astonishing about him. He found exhilaration in the belief that he was acting like the creative principle of nature and that he could raise humanity to a permanent manic god-like feeling, because the purpose of human consciousness is to attain to constant and exquisite esthetic pleasure. For him, it was this existential capacity for understanding delight, above all, that raised humanity far above the rest of creation. His identification of these ideas with an American libertarian myth brings him close to those earlier transcendentalists and romantics who expressed their dream of America by attempting to translate into art, and to fuse themselves with, a nature that was awesome, all-inclusive, transcendent, and, above all, utterly beautiful.

Reference Matter

Appendix A

Louis Sullivan's "Essay on Inspiration"

Although too long, difficult to read, and at times very poor in quality, Louis Sullivan's "Essay on Inspiration" deserves scrutiny because it gathers together his beliefs more compactly than any of his other writings. The work is useful for other reasons as well. It proves that by 1886 Sullivan had formulated a body of ideas from which he would never depart. It also shows that his techniques of composition in literature and architecture were similar, although results were patently different from one art form to the other. The same love of decoration pervades both; symbolism and metaphor perform tasks in the "Essay" not unlike those of ornamentation in his buildings.

After its first publication in the *Inland Architect* of December 1886, Sullivan changed the title of the "Essay" to "Inspiration," made small adjustments in the text, and inserted it in the manuscript of "Nature and the Poet," an unpublished book of poems that bears the completion date "July 1st. 1899." The fifty-five-sheet typescript was donated to the Burnham Library of the Art Institute of Chicago by George Grant Elmslie, Sullivan's literary executor. The edition presented in the pages that follow includes Sullivan's corrections of 1899. Besides the shortening of the title, the emendations consist in the addition of one phrase and one preposition, one change in punctuation, and the capitalization of certain words, all such minor changes that pointing them out is more cumbersome than useful. A typographical error in the 1886 and 1899 versions, the spelling of the words rhythm, rhythmic, and rhythmical without the first *h*, has been corrected. Two parenthetical notations by Elmslie have been retained as they appear in "Nature and the Poet."

Inspiration

PART I. GROWTH.—A SPRING SONG

When birds are caroling, and breezes swiftly fly, when large abundant nature greets the eye, clothed in fresh filigree of tender green, when all is animation and endeavor, when days are lengthening, and storm clouds smiling weep, when fresh from every nook springs forth a new life,—then does the heart awake in springtime gladness, breezy and melodious as the air, to join the swelling anthem of rejuvenated life, to mate with birds and flowers and breezes, spontaneous and jubilant as the glow of dawn, to pulsate ardently with hope, rich in desire so tremulously keen,—then wondrous joy to simply live,—and question not, to walk into the ample air, to open wide the portals of the winter-bounded soul and eagerly to hail the new-born world with voice like mountain torrent quick melted from the heart's accumulated snows,—even so eagerly and so voluminously does the song gush forth and wildly leap, tumultuous as nature's self,—to fall in gentle spray upon the misty valley far below, and there, to live bound up within the very life it sung.

O wondrous joy that this should be the springtime, and this the heart to greet it and to sing a song more wondrous still of joy within the sun-touched soul.

For such a song doth rise within me like a boundless symphony, rich chorded, and intense with lambent melodies which come unbidden from the general glow of life; a symphony whose theme is interwoven with this eager springtime life, a theme whereof the measure, caught up by the senses quick from every growing thing, doth seem to move, as all in nature here now seems to move in rhythmic cadence toward some subtile and tremendous consummation.

In tender light of dawning spring that song's incentive filters through the mists when the ardent sun, flushed and impatient, pulsates hotly toward the summit of the heavens; in urgent need the equal mounting soul too pulsates toward the crown of inspiration, while pensive nature wakening with the morn makes manifest the latent measure of her sweet and procreant rhythm. The lark floats up to vocalize the limpid atmosphere,—the shadows shorten with her tense refrain. Abounding joy starts nimbly forth from hidden sources; vibrant, the heart, filled to the quick, o'erflows, the tongue unloosens, and the inhaled breezes sing thus, respirant, anew:—

(O, soft, melodious springtime! First-born of life and love!)* How endearingly the thrilling voice of destiny hath called thee, and with what devotion thou hast come! And thou thyself hast taken up that call, made doubly potent by thy sweet embrace, and thou hast wrought the self-same magic on my slumbering soul.

Joy of the radiant day, joy of the sun-kissed verdure, joy of the radiant soul! The instant power of sympathy girdles and binds them together with bands sufficient as the ethereal sympathy of the planets coursing around the central virtue of the sun. So, orbital and responsive, colored to its rise, high noon and twilight, revolves the planetary spread of nature round the attracting and illuminating

*The parentheses were added by Elmslie with a note that reads "Auditorium mural caption."

soul. By that soul's effulgent light look I out again upon thee, wondrous spring-time, casting on thee brilliant high lights, and beyond thee changing shadows.

Now do I know thee as thou art, look on thee, through thee, and beyond thee toward a far off source whence thy joy has come.

Surge and surge through thee to me, the hugely undulating waves from distant raging joy within the vast expanse, that now break on our shores in foaming and majestic surf of springtime life.

Abysmal spring! The myriad nebulae were surf upon your cosmic shores. Stu-pendous winter passed away, the dawn mists parted in primeval splendor, and through your vistas floating rose the lark, the world, uttering as a morning song of promise the melodious succession of the races.

Of such are we; and high above our struggling, joyous verdure, our parting mists, our urgent and propulsive dawn, poised serenely, soaring ever toward the azure heights rises the immortal spirit of man, showering tones exalted, pro-phetic, volatile, spontaneous—a spring song to the waiting soul, a hymn of praise to nature's bounty, a sweet and unnamed outburst of itself.

Of such melodious origin are all our hopes, our sympathies, our desires; whence here, among us, coming daily, hourly into being, are great and lesser springtimes—each with its dawn, its urgent ruddy sun, its trailing mists, its aro-matic sprouting verdure—its trilling songster in the sky.

Of such come likewise protean thought and action, roused and sustained in eagerness by the touch and impulse of desire. Far transmitted yet ever present the creative call of nature sounds inspiring, jubilant and sweet. Responsive, imagi-nation rising quickly to the heights makes thoughtful action magically vocal and complete.

Through lesser springtime expanding, merging, completing, courses mysteri-ous life, unfolding toward greater, ever greater, ever broadening springtimes, successively through these, and through each intermediary winter sleep, at each renewed adjustment both farther removed yet more intrinsically here than be-fore, ever jocund and agile, ever onward impelled by the rapidly surging and in-flowing currents, comprehending and so transmitting the past, fulfilling the present, gestating the future—ever fecund and joyous.

And all this while the dawn-bird singing! On the wings of spring he ever rises, looking down on the lesser springtime growth; looking down on the meadows, the forests deep, ever rising, unfolding and blending in song looks down on the wide spreading plains, on the curving sea, on the shifting clouds that brood over all; alone, from the greater heights looks down on the distant enveloping haze of the swiftly receding world; and transmuted on high, now faintly heard, serenely attuning aloft it floats as the mellow companion the moon chanting softly.

In the stillness intent it now looks down on the balancing swing of the deep brooding world,—ever dawning; singing a hymn to its greater springtime, as I hear, floating high, sing a hymn to the perfect and spherical soul renascent of many a heaving springtime;—consorted still by a voicing spirit, the spirit of un-ending spring;—the desire, the appeasement, the joy of the world.

Effusing from such wonders interblended all around, has come to me thus, in soft pulsations, the elemental voice of Nature yearning. Whereby deeply do I know, thou generous and kindly Springtime, why I was touched, O, Prodigal! and captivated by thy presence. Now, nevermore to cease in its crescendo, has the lark's refrain returned in part to thee, a rhapsody of echoes from my soul.

INTERLUDE

And now the day is done. The trailing splendor in the west fills me with peace. The beckoning twilight leads me toward the cool and placid night. Shadows and the dusk surround me, while here, companioned by a cherished memory, soothed and lulled by the mystic moonlight, I meditate in swiftly deepening strain,— touched by a hint or weird suggestion, a premonition and uncertainty: whence comes it, I must know: wherefore, abiding here in gloom, residuary, musing, ineffably sequestered, do I follow hence the rich suggestive indirections of thy theme, thou softly dimming shade of springtime; undulating with it through the swell of ample summer, gliding detached and phantom-like athwart its mellowing term, to pass away in transcendental twilight, and coalesce with star-lit thoughts beyond.

PART II. DECADENCE.—AUTUMN REVERIE

In pathless wilds, in gray subsiding autumn, where brown leaves settle through the air, descending one by one to join the dead, while winds, adagio, breathe shrill funeral lamentations, tired Nature, there, her task performed, divested of her lovely many-colored garment, withdraws, behind a falling veil, and sinks to sleep.

Like sentinels standing, like spectres, bare and fantastic the trees rattle their dry hard branches.

The migratory birds have gone.

The faded hills squatting grimly together, commune with wind and sky, echoing their miserere.

The sap has sunk into the ground. There is no life but in root, and precarious broadcast seed.

A summer has departed:—never that summer to return; (a great life has passed into the tomb, and there, awaits the requiem of winter's snows.)*

And we, the living, in sympathy, view, ponder and speculate; take up the melancholy theme within our hearts, and through the sad attuning of the mind look out again upon the endless spread of life and dissolution—the fatal chance and certainty of change;—nor think to contravene the destined action and reaction.

The coupled opposites which we call light and darkness, good and evil, fortune and failure, growth and decay, sound and silence, harmony and discord, love and indifference, hope and disappointment, life and death, law and chaos, and their quick engendered brood pass in crowded processional through the deepening twilight of our inclination.

Sombre through the gloom come the impassioned ear the diminished strains of

*Parentheses added by Elmslie with a note "Auditorium mural caption."

promise unfulfilled, melting the soul to overflowing languorous compassion.

Now darkness holds full sway: the heart, in anguish, sinks upon the bosom of the deep. The haggard winds moan to the faint-appearing stars; the answering voice of Night, sitting in the heavens, the crescent moon a gem upon her finger, her velvet gown spread about the unhappy spirit, speaks rest to the disconsolate. A hoar frost gathers, glimmering in the mild light; the wanderer, chilled to resignation, moves into the deep valley of negation, to garner up the lineaments of phantom souls.

Slowly the tenebre unfolds its content; the darkness separates, taking visible shapes—shadows within the soul, that are revealed as blighted lilies, and the trampled violet, the shattered oak, disintegrated rock, the parched air, the storm's destruction, the jetsam of the sea; the ashes of a city; the fallen bridge; impeded traffic; broken fortunes.

The shadows multiply,—a host of wraiths:—day dying in the twilight, the waning moon, the fading of yesterday within the sense. Their still, subjective voices spectrally recall our fleeting states:—the departed joyousness of childhood, vanished youth, faded illusions; bespeak the mind's indulgence toward the slow decay of once fresh spontaneity; plead with the heart to feel in sympathy and comprehend the sorrow of unrequited love: golden-warp-dimming shuttle, and so, in turn, to know the language of the silent cot, the footfall heard no more, the touching voice of reminiscence.

Then flock about erroneous judgments, aborted projects, failures of all kinds; as a multitude of seeds fallen upon barren soil, a multitude of seedlings nipped by the frost, a multitude of saplings stricken by adversity, a multitude of bearers shriveled by drouth or worm, a multitude of the gnarled and moss-grown vigorously dying, a multitude of rotting stumps,—a multitude of vanished lives.

In extremity of woe, the hapless wanderer seeks to turn, but there is no turning, and but one result: a lonely, yearning thing of sorrow, with whose last sigh the departing spirit wafted, settles slowly, as a leaf, into the Nirvana.

A great soul is thus swallowed up by deepest gloom within this sepulchre, and can nevermore, the same soul, unregenerate, return. Without alternative it yielded up its life, through overwhelming sympathy with death.

So he who with compassionate solicitude looks on the actual face of dissolution, must surely die in sympathy forthwith. Yet is this not the end; for when in its predestined course the world of hope moves past another vernal equinox, in springtime ecstasy, mid the soft, persuasive rays of fixed serenity of purpose he will emerge from this abode of gloom, and greeting the warm air, will rise again into a nobler, greater life, to bear as rich fruition, a more complex sympathy, a metamorphosed insight, a profoundly changed belief.

And so, as wild flowers spring from manifold remains, do sympathies arise from regions of the dead, sending upward wondrous longings. As the plant grows, so thought grows, by what it feeds upon, its delicate chemistry changing poison into vital sap, to nourish growing sympathy, to the end that leaves and branches spread out in the generous, vivifying air, take on color, and firm visible growth heralding the bud that shall unfold with time its choicest worth:—the lovely flower at once of life and death, which here, hanging in fragrant equilib-

rium within the present joyous certainty of life and the imminent surroundings nearness, though remoter certainty of coming death, must need exhale its soul in rapture till such moment when the latter force shall prove ascendant; then does it softly yield its trusted heritage of vital wealth, and sink again into the realms of night.

And so the living present, firm-rooted in the past, grows within its atmosphere, takes on local coloring of identity, fulfills its ordained rhythm of growth, condenses its results, and, waning hour by hour in all that marks its physical, mesmeric presence, fading in the inevitable twilight, it too becomes in turn a stratum of the fertile past.

And so does the individual enterprise, the individual far-reaching purpose, the individual transitory emotion, the individual triviality and incidental, fulfill each its rhythmical alloted part, and pass away.

By how much and in what way the penetrating roots spread through the soil, grasp and absorb from it, by so much, and in correspondence, will the topmost branches tower, move with individual peculiar sway in the storm, rustle likewise in the breezes, or stand superbly, calmly silent.

By such virtue of limitation the lily nods in aromatic luxury, a proud weed overtops the timid violet.

How grand and self-sufficient seems the forest monarch, how fair the lily; how ardent is living personal desire, how lily-sweet true sympathy; yet the subsidence and withdrawal of vital sustaining elements comes not more surely to one of these than to the others; unto each in normal time comes the ineffable serenity of dissolution, whose outward sign and garment is decadence.

When brewing tempests sound a knell, who shall survive? The destroyer comes! Fearful its fury!

Afar at sea the angry waves engulf a bunch of pallid mortal specks. They are gone! with all their tiny hopes and fears. What are hopes and fears amid the raging elements, more than fantastic and circuitous sparks blown by the night storm from the chimney's throat to glow a troubled instant and vanish into black oblivion?

And in the surging forest, the tortured giants roar in such frenzied chorus that the exalted soul quakes at their awful music. In the intermittent glare the eye gloats on their huge resistance. A blinding flash! The instant deafening rattle and malodorous sizzling air. A hush! a frantic shattering roar, a prostrate growth of centuries, a mighty one laid low. Yet what is the forest, the labored and accumulated growth of years, but the plaything of the storm? And what is the total life of the forest more than the life of the human speck, or the spark, or the race, or the flitting smile? Each and all playthings of fate, momentary justifications, transitory trifles, great and wondrous only to the great and wondrous heart of man whose sympathetic soul envelopes them and draws them nigh, and interweaves them with its own catastrophe and bliss.

And when that heart, that soul, shall sing in duo, shall find a full, eventual expression, bursting into full-blown ecstasy of metaphor their rich and varied language shall tell a thousand thousand tales wherein the blended themes of life and

death shall intermingle with our smiles and tears, wherein the limitless reality of nature and the limitless illusion of the heart shall coalesce, wherein the soul of man shall tell of Nature's soul in hymns of life, and yet wherein shall sound, responsive, murmuring in a gentle undertone, the constant, solvent song of death.

To death then, hear a hymn:—

Now crafty and concealed, now open jawed and furious, now bland and sophistical, void of form yet multitudinous in seeming aspect, patient of opportunity, certain of the final outcome, present everywhere, pressing against each individual life—testing it always and everywhere, gaining a little, losing a little, utilizing every means, missing no opportunity, pressing the whole surface and interior of all life, thy active resistance continually meets that ceaseless, aspiring force, while in tranquil depth thou dost simulate the soft, preliminary sleep of every germ.

Of many moods, all-devouring, insatiable, enormous and sinister, sublime, vast and terrible, to Thee, alike the vanished morning mist, the holocaust, the gurgling rale, and endless series of forgotten years, unnumbered longings, individual twinklings—Thou, Great Denier, hast gathered them in—and they are not!

Before the soul, comes pleading, self-justified in innocence, soft voiced and heartful, a beauteous bewitching form claiming, open-armed, expostulate, its individual dower of life. The soul, attentive, entranced, ecstatic, would overflow in plentitude of instant, ardent love, but Thy inexorable form arises, and with unspeakable gesture Thou dost spread an answering darkness that envelopes all.

And Thou dost ride upon the agitating storm, Thou sett'st a brake upon the coursing planets, Thou art with the glorious meteors erratic through interstellar space, Thou hast touched the burning suns and they are cooling; Thou art with the microscopic crawling mite—following inseparably its earnest quest, looking through its minute eyes; Thou speak'st with every mortal breath, and art resident in brightest smiles; Thou art within thyself, Thou fearful shade, and hast thine own great death.

More tenuous than air, more steadfast than the stars, harder than granite rocks, more mobile than running waters, variable and elusive as the winds, Thou art beyond our touch, imponderable, yet definite and real as shadows.

Thou art the reactionary cause of every change, without Thee there can be no palpable or seeming growth, no sentient being; Thou art the everlasting and sublime companion of all life; Thou art the eternal shadow cast from things mortal by the eternal light.

In catastrophe, O power sublime, we know Thee dread, yet in solitude of meditation I view its fury as thy comedy and by-play; but in decadence, in peaceful subsidence and dissolution Thou art so tragic that the soul spontaneously believes Thee friendly, adorns Thee with a name, and holds Thee precious in its sight.—O, Death!

INTERLUDE

When from well-springs bubbling to the light in mystic dell, there flows a crystal rivulet gladsome and free, cradled by fresh mossy banks so lovingly tender,

lulled by the twitter of birdlings and murmurous balsamic breezes, the sunbeams curiously peer through the leaves at its smiling, innocent face, and wish it joy.

Soon joined by rippling little ones who sweetly give it their all, it welcomes their tribute, and wantonly runs to the open meadows and alternate wooded reach.

Here sequestered 'mid high grass and shrubs, it gurgles, and crows, and fattens; then turns hither and there with sinuous curve, sings soft cadenzas to the intercepting stones, and hastens on to leap in burnished cascade from the ledge.

Anon it grows in dignity with each succeeding token from the confluent streams which, mingling with its genial flow, add their qualifying mites of tender power, abstracted from perhaps desolate or, it may be, verdure-laden hills, the porous strata, overhanging rocks;—and wrought on by the alternating influence of storm and sunshine.

With mingled persiflage and serious undertone, growing ever in earnestness it flows through rich diversity of landscape, spreading out at times to rest, in quiet sombre pool or solitary lake.

Thus grown and quieted it now moves between yon tacit banks which slowly individualize at each encountered bend and seem to hold their counsel.

One by one the larger tributaries in turn converge upon this widening stream and pour their inflow of rich abdundant waters—slow-moving messages from many lands.

The banks widen apart, become serious and broad of aspect, assuming each unto itself a separated and less kindly mien:—sandy bluffs rising to beetling cliffs, severely wooded hills, the austere forest coming to the water's edge:—whence all cast images of their restraining will and purpose on the receptive breadth of the current moving now in affluence and majestic ease.

The river-bed diversifies, shoals, snags, islands, soon irritate the current which sullenly yields to corrode the opposing shore.

The channel deepens, is fugitive, tortuous, lurking with engendered passions, and ever less friendly to the less friendly and receding shores.

Grown avaricious of power, tributaries large and small are swallowed up. Jealously the banks multiply their strength, each one for itself, grim, determined, serious. Alike to all are storm and sunshine, the slow succession of the seasons, moon and stars, the grand each day arrival and departure of the sun; they but take on a fleeting color from these things, and remain, themselves, preoccupied of their own destiny.

Increase and sombre intensity, culmination close by the limit; deep, broad, and still; high, firm and still; divided, inimical, one and inseparable, great river, great banks— Behold here the delta! disdainful, fierce, haughty, descend to the sea, and with measureless pride are lost in the depths.

PART III. THE INFINITE.—A SONG OF THE DEPTHS

Many a thought lies dormant in the sea.—Exchanging secrets with fortuitous winds, free with the driftwood and the birds, yet sealing close its thoughts to thought-proud man, the vast sea broods and effuses ever, yet as I know, unspeak-

ably, imparts with freedom only to the native one who equals it in elemental turbulence and in serenity.

Deep throated sea! sing to me now in occult murmurs, in rushing tumultuous plunging cadenzas, a song, an entrancing song of the Great Spirit; for here I sit impressionable, super-intent, and wholly given up to thee, to listen and to ponder.

The morning sun, young and blushing, o'erhangs thee, glancing ardently. I see his image pictured broken and glittering on the waves. So do I o'erhang thee, mighty one, yet where may I find the image of my ardent soul, where may I hear the arcanum unfolded:—the song of the depths, the song that shall attune harmonious and amplifying to the song within,—the questioning song, the unsatisfied song of the twilight.

The salt breeze, quickening, moves swiftly as the passing sea-gulls. Harshly they scream. Yet shall my thoughts ever circle and swiftly wheel in hunger over thee when the sea-gulls are fed?

In vain I sang with the jubilant springtime, inhaling balsam with the flower-laden air. It departed in sweetness, leaving me perplexed.

In vain I shuddered through the rustling depths of autumn's slow decay. That which I sought eluded me as before!

Here, then, in the simple air and by the simple water lies my refuge and my hope. Deny me not, for I am come as one nearing his journey's end; as a traveler at eventide, here must I seek final nourishment and rest.

For there must somewhere lie beyond this complex phantasm, beneath this eagerness of growth, this upheaval and fatuous endeavor, beneath this sorrow-laden, inextricable fatality of subsidence and decay, that which stands to them as water to the waves: deep, fluid, comprehending all:—bearing quiescent and passionless this endless agitation, this fascinating to to-and-fro. Else why, as I tarry here expectant, am I so persuaded by the heavy rolling roar and subsequent gurgling thin-spreading swash and laconic return of the green transparent waves? How exultingly they rear and curve, how they plunge impulsively upon the sloping sands! Yet in a moment they return—inevitably and swiftly they return.

Clear blue and crystalline the firm sky arches overhead. My buoyant craving darts vividly upward, in instant search: to instantly return: resolved to learn all from the friendly sea, so tangible, so near at hand.

Sing jubilate, turbulent sea! Of all things that the crowded universe contains thou art nearest like the human soul. For in thy very self, thy liquid depths and shallows, thy lightless and unfathomable depths, thy restless surface waves and currents, impressionable, incontinently shifting and changing, in thy very self unquestionably I see, with wonder and amazement I see near by and luminous my soul's inspiring image which I sought.

And as my soul with joyous ardor gazes on that image pictures softly in thy depths, so thou seem'st to rest, in secret stillness, brooding o'er a wondrously reflected image—image mobile and serene beyond compare.

Yet, alas! though fervently I conjure thee, still remains inscrutable that rare reflection, hiding which, thou smilest calmly toward me, evanescent smiles of billowy waves.

My backward turning thoughts recall the sorrow and illusion of my days:—
How, earnestly, Inscrutable, I struggled through entanglements unending,
searching deviously amid perplexities to find thy abode; prying with sharp-
pointed thoughts, testing with the delicate touch of the heart, yet heeding not
sufficiently, trusting not at all the simple promptings of the soul which spoke to
me often as the sea now murmurs; but it spoke not in a language that I knew,
therefore I heeded not its tender voice, which died away 'mid the rising clamor
of random words, to lie, over-ridden and hushed—dormant for many a year.

Patiently I sought thee, yet preoccupied I passed thee by in my haste, believing
I would find thee yonder, where the alluring rainbow of my thoughts so grace-
fully ascended.

Where I saw power I looked beyond for greater power; where there was storm
and stress, I peered out anxiously toward turbulence sublime; when in dismay I
gazed on death in many forms I questioned closely if beyond this lay an answer:
—yet all these disconnectedly, with manifold obliquities of view.

Once, after hot pursuit along a sinuous trail, I called thee long and loud by
many names: thou didst answer, but I, alas, mistook the murmur of the winds
for commonplace, I heeded not the drifting odor of the woods, nor marveled at
the nearness of the mossy bank whereon I lay me down to rest:—prostrate that
my labor should remain without reward:—drawing over me as I sank in fitful
sleep, a coverlet ingeniously contrived of self-spun gossamer, subtly shuttled
through and through by dexterous guesses, consummately resplendent with the
dazzling embroidery of long transmitted thoughts.

In pride of thought I sought to seize thee deftly, as one seizes with an instru-
ment; I sought to snare thee with a loop of words; to trap thee in arctic zones, as a
trapper setting his falls on the bleak and lonely winter wilds. Yet all in vain.

Furious, I went by night, malignant, to glean an answer from the storm o'er-
shadowed sea. Foreboding winds were shrill with angry warnings. The ancient
bowlders, heavy with odorous wet weeds, gloomily offered their support.
Athwart the overcast and threatening sky the moon pushed rapidly from cloud to
cloud, fitfully pouring her clear fresh light between, flooding the mysteriously
approaching waves with shifting throes of shine and dark:—whence equal light
and gloom within, sullenly revealing and obscuring dim far off undulating hints
of unison, mysteriously approaching harmonies, modulating weirdly through
the swell and subsidence toward tangible identity of sea and soul:—identity
trembling here, now, in the awful hush before the storm, trembling in sup-
pressed and vaguely lurking throes of consummation.

Lurking and trembling the lurid distant lightnings waver on the edge of the
sea. In vain! In vain! The soft light disappears in murky night. No moon, no
peaceful star. Hoarsely the wind-driven sea plunges furiously on the rocks. En-
raged, and flashing through the sky, deliriously sweeps the fearful hurricane,
swirling the rain-sheets, unloosening the thunder.

Elohim! Elohim! In utter darkness I! In vain, Inscrutable! Thou wert more
near than my unhappy soul's desire was to itself, yet art Thou far off and un-
reachable as Thyself alone.

So fares the sea in rocking storm. So, tempest-tossed, I too abate, and balance with the measured swell, while storm clouds drift away, and heartsease, storm-abandoned, rests beneath the glory of the breaking day.

Clear morning light, refreshing air made vocal by the dashing spray, the neighboring beach low-spreading and withdrawn, compose my thoughts in strains akin to theirs which issue from the surf as jetsam from the wreckage of my hopes.

Deny me not, O sea, for I indeed am come to thee as one aweary with long journeying returns at last, expectant, to his native land.

Deny me not that I should garner now among the drifted jetsam on this storm-washed shore, a fragmentary token of serenity divine. For I have been, long-wistful, sitting here beside thee, my one desire floating afar on meditation deep, as the helpless driftwood floats, and is slowly borne by thee to the land.

Deny me not that now, awakening, as the spring awakes from mystic fleeting winter sleep, that I too may sing in tones rejuvenant yet softened by autumnal memories, in tones that shall have deep within them the thrill and intent of thine own native song, that I too may sing, as thou singest ever, a song of the depths, a wordless song of the near at hand, a song of the ardent present, a song of the vanished past, an inspiring song of the future:—the gladsome song of the soul at one with Inscrutable Serenity.

All hail, sublime serenity! Thou answerest the questioning heart, thou sendest peace and guidance to the striving soul. Thou art the voice of the morning lark, thou art the power whereof it sings, whereof we also sing and dream.

Wondrous thou wearest springtime-life and ecstasy upon thy brow, while watching, tranquil, by the grave.

Thou art the lark, thou art the falling leaf; thy breath is the breath of flowers, thy voice is sweeter than the zephyr, deep, below the rumbling storm.

Thou floatest with the swallow at evening skimming the surface of quiet waters:—over the placid soul thou likewise comest as a delicately fleeting thought at the hush of day.

Raging catastrophe is now as a silence wherein the hungry voice of fate is heard as wolves are heard at night in the depths of the forest.

Whence the wail of decadence is to me as the silence of caves, wherein thy voice is heard resembling the dripping of waterdrops in the stillness.

Thou speedest thy rays to the sun, thou art dawn and twilight to the universe.

Life and death are as dreams of thy slumber; thou breathest and the seasons come and go.

Yet thou art near as the flowers of the field. To their lovely companions within the heart thou comest as storm and sunshine interblended with the melodies of spring.

I am sure that thou art very far and very near and round and about me, yet all that I may know of thee comes of the fragmentary token which I gathered on the sands by the sea.

But I know, best of all, that this token, once found, takes root in the soul as a seed that is dropped into virgin soil.

Through lesser springtime expanding its course doth lie to unfold 'mid the greater unfolding growths, to become in turn of nature's chosen, bearing joyous flowers and labored fruits in its onward course, impelled by the steadily inflowing currents of rotating seasons:—And I know 'tis by these fruits alone that the token is transmitted.

From this summit and consummation hence to decline as the sun declines in splendor from the zenith, merging with the roseate and gathering clouds, sinking tranquil through their midst, I know indeed that to thus depart in splendor as the sun departs is the final announcement of this token of serenity:—announcement echoed in the twilight by soft evening chimes from remaining hearts, denoting peace in the realms of night.

Over all, as a beautiful memory following deeds, arises 'mid soft refulgence the mellow companion, the moon, chanting softly a song of endearment, a token-song to the great departed, a song of the depths, a song near at hand, harmonious and amplifying to the song gone hence, a song of inspiration.

And thus my song, declining, now sinks to its rest through the peaceful sky. Whereafter prolonging thought arises, following close, as a harvest moon, shining with milder, reflected light.

The thought that dawn, noon and twilight are ever linked with the coursing sun; that invisible tomorrow is even now its gliding companion, and will appear with it anon, dawning our day in urgency.

Whence I believe that action thus ever attends on flushed and procreant purpose, continually mounting with it toward the shifting summit of desire.

Without the sun, no dawn; without sustained desire, no fruitful or efficient action.

The thought that from such desire emerges art as action.

The thought that tallying such desire, (native, widespread, and unawares), appears the art of a nation: dispelling the gloom in its dawn:—whence works awaken imperceptibly, like a tinge of green upon the land, rejoicing in their lesser springtime gladness.

Through speedy decadence the weak are denied; surely the autumn nipping winds dispose of the loose and tremulous, leaving the hardy sound.

How quickly the lesser seasons change! How, manifold and numerous, they ever turn involved in the greater and broadening rotation of growth and decay. Yet how tranquilly beneath the tumult and silence persists a hidden power, mysterious, inscrutable and serene, qualifying imperceptibly both growth and decadence, leading both, sustaining both, denying none, while through the lesser and greater unfolding springtimes, the tide of destiny ebbs and flows with mysterious undulations, working freely, through marvelous rhythms, toward subtle and tremendous consummations—consummations balanced in the end by a noble decay, and the sweet oblivion of death. Whence comes the strangely complex thought of rhythm—for all is rhythm.

The thought of attuning the rhythmic song of art harmonious and amplifying

to the rhythms of nature as these are interpreted by the sympathetic soul: that herein lies a vital purpose and significance of art.

That to arrest and typify in materials the harmoniously interblended rhythms of nature and humanity, sustained and permeated by an essence wholly inscrutable, yet manifest as wondrously elusive mobility and abiding serenity, indicates the deepest inspiration and the most exalted reach of art.

The thought, that to perceive the material workings of this mysterious essence as the power underlying all gowth and decadence, requires that the senses be highly spiritualized by the mobile, serene and sustaining influence of the soul.

That to attempt in cynical pride to seize this essence deftly with the mind as with a delicate instrument, or by conscious strategic methods whatsoever, is illusory and utterly in vain.

That a reverent attitude of the mind is equally in vain.

That it is not at all an essence for the mind to deal with, but for the soul to deal with; and this alone with the help of exquisitely vital sympathy.

That the mind speaks in terms of logic, which is vital, yet conscious and secondary; but that the soul speaks in terms of inscrutable intuition which is involuntary, vital and primary.

Whence the thought that the greatest art is at once the most and the least thoughtful—that logic and intuition are therein marvelously interblended.

That moments when the soul loses the identity of conscious mind and merges with the infinite, are moments of inspiration.

In tranquillity of meditation the soul unites with nature as rain drops unite with the sea; whence are exhaled vapors, under the hot and splendid sun of inspired imagination, vapors rising through the atmosphere of high endeavor to drift away in beauteous clouds borne upon the imponderable winds of purpose, to condense and descend at last as tangible realities—sometimes in gentleness, sometimes in sombre fury, as the rotating seasons call. Here they nourish and refresh, and amid untold vicissitudes and metamorphoses, return at last to the great sea of Nature.

Whence the dominant, all-pervading thought that a spontaneous and vital art must come fresh from nature, and can only thus come.

That the specters of departed and once spontaneous art growths, which arise from their natural graves and walk abroad clad in tenuous garbs, like other .phantoms and mock realities, must vanish with the dawn of artistic vitality.

That such a dawning is close upon this land there can no longer be any doubt. In the paling gloom the phantoms flit about, uneasy and restless, losing identity. The heavens are faint with the glow of a new desire; and with overflowing heart I rise through the mists, aloft, to catch a glimpse of the coming sun, and carol this prophetic song of spring.

Appendix B

A *Chronology of the Construction of the Schlesinger and Mayer Building (Carson-Pirie-Scott)*

The Chicago dry-goods firm of Schlesinger and Mayer, established in 1872 by Leopold Schlesinger and Daniel Mayer, leased in 1873 a then recently constructed six-story white building with a corner tower, designed by W. W. Boyington. Located on the same southeast corner occupied by Carson-Pirie-Scott to this day, that property fronted 60 feet on State Street and 80 on Madison. In 1886 Schlesinger and Mayer purchased the building and also leased the adjoining four-story structure on State Street, which brought their total floor space to 60,000 square feet. The store was enlarged again in 1890 by leasing 137–139 State Street, a four-story building. A heating plant was installed at this time at a cost of $50,000. A year later the next two properties on State Street, numbers 141 and 143, were leased. At this point Schlesinger and Mayer considered the possibility of removing all interior partitions in all buildings and adding two floors to the State Street structures they had leased, to make all the buildings the height of Boyington's six-story corner building. Adler and Sullivan were consulted for this project, but it was not carried out.

Information for this appendix has been extracted from the following sources: "Schlesinger and Mayer Leases," *Chicago Tribune* 51 (26 July 1891): 10; "Schlesinger and Mayer Lease the Barker Property," *Economist* (Chicago) 15 (30 May 1896): 666–67; "A Big House Still Growing," ibid. 18 (18 September 1897): 319–20; "Architecture in the Shopping District," *Inland Architect* 34 (January 1900): 46–47; Sullivan, "Sub-Structure at the New Schlesinger and Mayer Store Building, Chicago," *Engineering Record* 47 (21 February 1903): 194–95; "The New Schlesinger and Mayer Building, Chicago," *Brickbuilder* 12 (May 1903): 101–4; Louis J. Millet and Henry W. Desmond, "The Schlesinger and Mayer Building," *Architectural Record* 16 (July 1904): 53–67; Claude Bragdon, "Letters from Louis Sullivan," *Architecture* 44 (July 1931): 7–10; Hugh Morrison, *Louis Sullivan, Prophet of Modern Architecture*, p. 198; and Commission on Chicago Historical and Architectural Landmarks, *Carson, Pirie, Scott and Company Building* (Chicago: City of Chicago, 1978).

In 1896, with the impending completion of the elevated railway along Wabash Avenue, Schlesinger and Mayer decided on a program of expansion and renovation. They leased structures on 141-147 Wabash. These had a total frontage of 80 feet, a depth of 171 feet, and were back to back with the properties the firm controlled on State Street. Around the month of June, Sullivan, who by then was working alone, designed a plate glass and metal storefront for the Wabash Avenue buildings, as well as a metal bridge linking the elevated railway with that section of the store. Construction of these projects was finished the following summer. That bridge, no longer in existence, was not unlike the one Juste-Gustave Lisch erected in Paris between 1886 and 1889 across the rue de la Pépinière to link the Gare Saint-Lazare with the Hôtel Terminus (plates 77–78). Also during the summer of 1896, Sullivan added the two floors to 137–143 State Street that had been proposed in 1892-93. A "French café was introduced in this addition for the accommodation of the customers," a contemporary account says. No expense seems to have been spared either in construction or decoration; the kitchen was "probably the most perfect in the city."

In spite of these expenditures, the firm decided early in 1898 to erect a large twelve-story building on their corner property at State and Madison (plate 79). Sullivan produced a design around May and June. Ignoring the possibility of an uncomfortable tension between the two former partners, Schlesinger and Mayer commissioned Dankmar Adler to design the powerhouse. In July, all properties heretofore leased were purchased, and in August it was announced that erection of the new building would begin in a year. This project, however, was never realized.

Later in that same summer of 1898, Schlesinger and Mayer decided to reduce the project from twelve to nine floors and to begin construction by erecting only the three easternmost bays along Madison. Sullivan complied with these changes, designed a nine-story building with neither an entrance pavilion nor ornamented awnings around the month of October, and those three bays intended to be built first were erected by late 1899 (plate 80). Press coverage of it was both ample and highly favorable.

Soon thereafter, Schlesinger and Mayer changed their minds once more and decided to build the rest of the project not nine but twelve stories tall, as they had originally intended. They now wanted, also, to make the building much larger than they had first meant it to be. Instead of covering only the corner lot, it was to be extended onto their newly acquired properties on State Street. In addition, they asked Sullivan to raise the existing nine-story structure on Madison to twelve stories so that all parts of the building would be the same height. This second idea, however, could not be carried out; the foundations had not been constructed for such a heavy load.

Sullivan designed the new building in August 1902, and its construction was carried out in three campaigns: one from October 6, 1902, through January 1, 1903, another from January 6 through May 11, 1903, and a third from May 11 through October 12, 1903 (plate 81).

All foundations were completed during the first stage, with a remarkable method of construction. Schlesinger and Mayer had told Sullivan that they

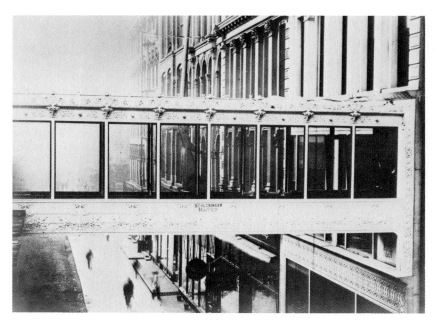

77. Schlesinger and Mayer Store, Chicago, bridge, 1896–97

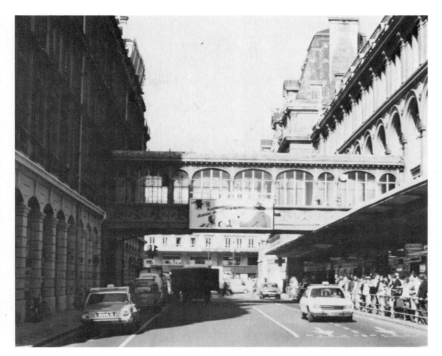

78. Gare Saint-Lazare, Paris, bridge, Juste-Gustave Lisch, 1886–89

79. Schlesinger and Mayer Shop, first twelve-story project, 1898

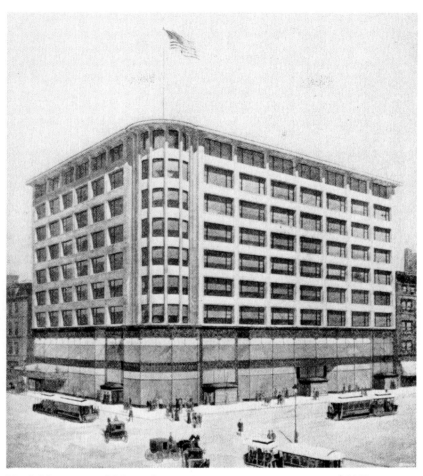

80. Schlesinger and Mayer Store, nine-story project, summer of 1898

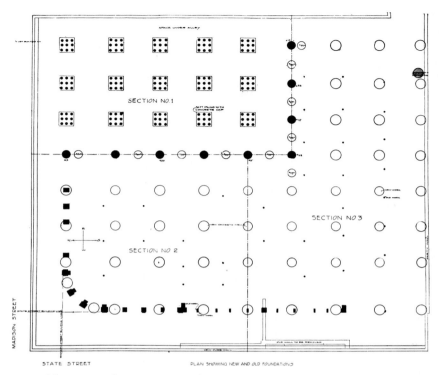

81. Schlesinger and Mayer Store, plan

174

wanted to use the existing buildings through the 1902 Christmas season while the fifty-nine piers for the new store were being laid in wells underneath. It was decided to conceal building activities as much as possible in order to avoid interfering with the business being carried on above. Moreover, no materials could be piled on the street, because of the importance of holiday displays in the show windows. The new basement, which was deeper than the old one, caused further complications. Two towers with elevators had to be built on the sidewalk to take out all excavated dirt and surplus material. Whatever could be crushed in the cellar to be poured as aggregate in the concrete of the piers was thus used not so much for the sake of economy as to have the less to take out. But since there was not enough of this material, pebble gravel, rather than the less expensive crushed stone, was brought in through the elevator towers to make up for the deficiency.

Once the holiday season was over, the corner building was torn down. Beginning on January 6, 1903, the wrecking was completed in nine days of sixteen hours each, including night work under electric lights. The main portion of the building—the corner tower and the three bays on each side of it—was begun on January 15, 1903. In the meantime, Schlesinger and Mayer continued conducting their business in the three-bay nine-story section on Madison Street that had been finished in 1899, as well as in the buildings on State Street that Sullivan had increased to six floors in 1896 (plate 82). These structures were connected internally and formed in plan an L around the corner lot, where construction was then taking place. The part of the store fronting on Wabash Avenue also remained in use during this period. The four southernmost bays on State Street were the last to be built. Demolition of the buildings standing on the site began on May 11, 1903, the very day the section on the corner lot was finished. All work was finally completed on October 12, 1903, in time for the new Christmas season (plate 41).

Sullivan had planned on an all-steel structure, but when figuring out a time schedule in August of 1902, he found out that although steel girders and floor beams could be obtained by January 1, 1903, it would be impossible to procure steel columns by that time. Consequently cast-iron columns were used in the corner portion of the building and Z-bar columns in the section subsequently built on State Street. Fireproofing consisted throughout of terra-cotta casings for all metallic members. With very few exceptions, terra-cotta segment arches supported all floors and served as fire stops between stories. All suspended flat ceilings were incombustible, because they were constructed of plaster and metal lath on a steel framework. They were not given the task of acting as fire deterrents protecting structural members, however—the practice of many architects of the time, who saved their clients money at the expense of their buildings' safety.

Presumably Schlesinger and Mayer spent more on their building ventures than they should have. During the summer of 1903, while the last part of the store was under construction, they sold the building to Carson-Pirie-Scott and Company, but transfer of the property was delayed until the summer of 1904.

Carson-Pirie-Scott added 105 feet of frontage on five bays extending south on State Street in 1906. The commission was not given to Sullivan but to D. H. Burnham and Company, who followed Sullivan's design of the original building

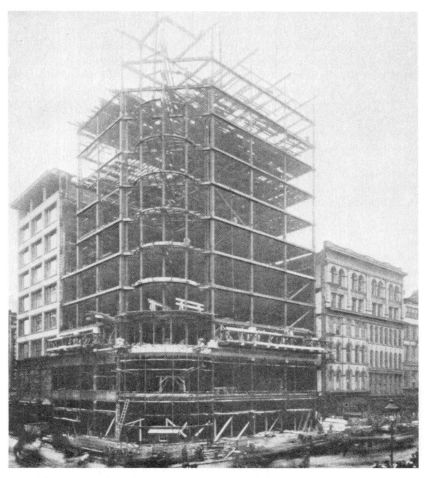

82. Schlesinger and Mayer Store, photographed March 23, 1903. At right are 137–143 State Street with the two top floors added by Sullivan in the summer of 1896

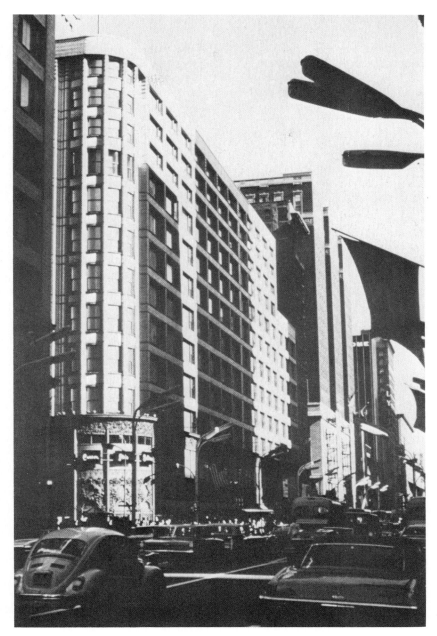

83. Carson-Pirie-Scott (formerly Schlesinger and Mayer Store), present appearance

except in the attic story. In 1948, the twelfth-story windows, which Sullivan had designed as recessed, were altered to make them look like the ones below, and a flat parapet replaced the original projecting cornice. This "modernization," along with the removal of most of the ornamented cast-iron awnings above the shop windows, has greatly altered the original appearance of the building. The last expansion of the property occurred in 1960, when the firm of Holabird and Root added three bays on State Street (plate 83).

Appendix C

Two Letters concerning the Bradley House, Madison, Wisconsin

October 14, '65
Harold C. Bradley
2639 Durant Avenue
Berkeley 4, California

Dear Jim [James S. Watrous]:

Your inquiry about the Prospect Ave. house has just come in and warrants immediate treatment. So I shall not start by saying the usual alibi for delayed answers.

I was of course astounded that the time had arrived when the shacks of yesteryear must be down in the name of "redevelopment" by means of which a mammoth apartment is added to the scene, while the former shack owners, finding the apartment rents much too high, must look around on the outskirts of the city for old and decrepit farm houses or more likely new ply-wood boxes, all alike except for color, which will automatically fall apart in ten years.

I did not like the Prospect house, ever! It was not at all what we had expected as a home for a small family, planned to be considerably larger some day, to supply Josephine with a long lasting career and happiness. I was sure however it was not only expensively built, but also very well built—a place that would last like the churches of Maine and New Hampshire where a couple of hundred years is young, and a new coat of paint the only change required!

The story of the house is unfortunately a long one, and complicated by the personalities involved. Quite recently I wrote it to a Mr. Buschke in Madison, who is doing a paper on Sullivan, Wright, Elmslie, Purcell and Feick, and enclosed a copy of "The Prairie School Review" in which are photos illustrating some of the work of these men, including our Shorewood home, and the Bungalow at Woods

I am grateful to Dr. Bradley's heirs for permission to publish these documents.

179

Hole where we spent many summers—and which was not our house of course, though Josephine had worked over it with Elmslie and Purcell. The result was a rare combination I think—functionally perfect for our large family, and beautiful in its sea-shore setting.

I shall send you, Jim, my only carbon of the Buschke letter if you wish it and cannot locate Jon Phillip Buschke. More briefly I shall attempt to answer your three questions—always allowing for the tricks memory is likely to play.

a. It was designed by Louis Sullivan. However Elmslie was his skilled right-hand man with the artist's gift. I would say he was much more than a "project assistant." He was under orders of course from the boss—who was far from a well man. As the work progressed I am sure Elmslie was more and more responsible, but no question it was a Sullivan house.

b. I have no recollection of an original design later supplanted by one of Elmslie's. For economic reasons I assume, Sullivan made it a *big house*, and because he was responsible to Mr. Crane, we could not change that.

c. So far as I know the over-all design was Sullivan's. I think Elmslie had a good deal to do with interior arrangements to make the house more like what we had hoped, and with all the decorative items, design of tables, etc. and the leaded window designs, and exterior decorations. . . . Ruth joins me in all good wishes. . . .

/s/ Harold

September 30, '65
Harold C. Bradley
2639 Durant Avenue
Berkeley 4, California

Dear Mr. [Jon Phillip] Buschke:

Apologies for this late attempt to answer your queries of July 15! I was away in the east for a couple of months, and am just now digging myself out of the pile of awaiting material. This may be too late to be of use to you. Also the information is blurred by the nearly sixty years that have passed since the story began. For you to understand it at all means that much of it is intimate gossip which deserves almost the label of "confidential." I am sorry we cannot just talk it over.

As a Yale graduate student and instructor in the Yale Medical School for a year, I accepted a call to Madison, Wisconsin, as Assistant Prof. in the just developing U. W. Medical School, and arrived in Oct. '06 to help get the laboratories built and stocked. Among my first students was a young lady from Chicago, Josephine Crane, who was totally deaf, but very sharp in reading lips, and with a well modulated voice, and who had already covered two years of college with little difficulty. My interest was of course immediate, and turned into admiration as I became better acquainted. In the summer of 1908 we were married—

but not until I was sure that I had the answer as to how to provide a long happy career for a girl without hearing in a hearing world. A large family, well spaced seemed the ideal answer—and in time this proved to be correct.

When we were married I had stipulated to Charles Crane, my father-in-law, that we wanted to live the life of the average professor's family, on what salary would provide, with no outside help. He agreed and I think liked our plan for both independence and a large family, should that prove possible. We lived for the next few years in small rented houses. The first child arrived a year later, a girl, and about two and a half years later we added a boy. In the meantime I had invested some savings in an oak covered hill top, where land was cheap, well outside Madison, along Prospect Ave.

At about this time Mr. Crane visited us and suggested that he would like to build us a house of our own, suitable to our expanding needs, but not out of line with the size of my pay check. He told us his old friend Louis Sullivan was having a hard time just then, and he would like to help him without hurting his feelings or pride. He would like to assign Sullivan the job, so no evidence of charity would appear. We could hardly refuse so generous an offer done in such a sensitive way. It would be a favor to him, Mr. Crane—if it could be done. Mr. Sullivan came up to look over the land and to learn our wants before any tentative drafts were made. At about this time Mr. Crane took off on one of his long journeys—roughly a year. But Mr. Sullivan understood our situation and would follow our wishes.

Eventually Mr. Sullivan came up with the drawings. We liked Mr. Sullivan personally. He was a courtly gentleman, considerate, entertaining, well read, and a persuasive talker. When we saw the plans we were astounded! We wanted no mansion—but a modest academic-sized family home, with enough space to permit expansion as our program progressed. However Sullivan was not to be changed. He said he was building the house for Mr. Crane and was responsible only to him. We could manipulate the interior spaces to some extent, and the interior decor and furnishings would be constructed as we desire. He was sure the house would please Mr. Crane. So eventually it was built. It seemed impossible to stop the project without disappointing Mr. Crane. It was a beautiful house; much too fine and imposing for us, and much too costly to maintain. Before it was completed we had a family of three children, and Madison was rapidly surrounding our hill with new homes.

We were already working on plans for altering the interior so as to make more rooms. The space units of the house were larger than we needed, but also were hard to cut up into smaller units. At this point, John McKenna was laying out a new development just west of the Lake [Mendota] to be called Shorewood Hills. How would we like to relocate out there, if he could sell the Prospect Ave. place? The idea of getting out of the enveloping city into open, hills, and wooded country, near the lake, was attractive. McKenna had a wealthy fraternity looking for a new home. Their alumni looked the Prospect Ave. place over and decided right away they would like to get it. So eventually that happened. We moved into McKenna's house in Shorewood temporarily, while the new home was being planned and eventually built. We talked it over with Elmslie and Purcell, later also

Feick, who seemed to be the engineering expert of the group, and eventually the plans evolved with Mrs. Bradley playing the leading role.

To go back a bit. Sullivan, who was to begin with the polished courtly gentleman, whom we enjoyed in spite of his insistense on dominating the plans, seemed to deteriorate. He was obviously and often under the influence of liquor—not drunk, but somewhat tipsy, sometimes vague or sleepy. He was evidently cashing in on his commission and turning things over more and more to George Elmslie—whom we liked very much, and who seemed to understand our problems perfectly. Elmslie eventually came up for all the conferences, worked with Mrs. B. on furniture design, decorations, etc. We saw little or nothing of Sullivan any more. I always thought of him as the originator of a type of architecture reflected in the work of men who had worked under him in his office—Elmslie, Purcell, Wright, possibly Feick. The wire-cut brick; horizontal lines emphasized by the horizontal raked joints; the lovely leaded glass windows; the sawed decorations, and sometimes the decorative designs to high-light the structure outside, the use of cantilever construction, etc.

Wright I met while the Prospect Ave. house was new and occupied I think. He built the Gilmore house a couple of blocks away; later it was the Weiss home. He had designed a porte-cochere for the building which stuck way out over the front entrance with no visible support. It made to my untutored eyes, an insecure-looking structure. I talked to Wright about it—and he was very curt and contemptuous. Of course it would not be disturbed by the heavy winds that now and then came to our hill-top area. It was anchored securely by cantilevers. Nevertheless I disliked it—because it gave to me the sense of fragility in a storm. Then soon after a storm came along and the long visor began to move and flap! I understand it had begun to pry apart some of the inside structures and would have wrecked the place in time. It was quickly tied down at the outer corners—and my sense of insecurity of course disappeared. My dislike of Wright as a person however remained—dogmatic, contemptuous of anyone failing to appreciate the Master—with little time for the untutored man-in-the-street. Many of Wright's houses and buildings I liked. Some I continue to dislike. His highly demanding ego and studied gaucherie were in absolute contrast to the modesty and artistic skill of Elmslie (in my estimation). Also he never mentioned his beginnings under Sullivan so far as I know.

The Shorewood house plans went forward with Elmslie working often and long hours with Mrs. Bradley. I think they were an ideal pair—and Elmslie was picking up our family needs from a very competent presentation and exponent of them. He was highly perceptive, and would come back later with what we thought were ideal solutions and arrangements. Also our general philosophy of a home for rearing quite a sizeable family had become well established, and he seemed to agree and approve and proceeded to fit the shell to the family life inside, in a sensitive and imaginative way. We three became warm friends in the process—something we obviously could not achieve with Sullivan, though we greatly admired his genius of the past.

My impression was that Elmslie was the real genius of the firm. Purcell we did not see often, and I thought of him as the business man, of the firm. Feick, whom

we met only a few times, I thought was the engineering specialist.* We liked all three—but George we loved!

The first War came along soon after we had moved to the Shorewood home, and when I got a call to Washington in what became the Chemical Warfare Service, we took the whole family, and staid there until I was discharged about 1919–'20.

In the meantime it had been our custom to go to Woods Hole, Mass., where I could work summers on my own lines of research, while staying in The Big House—as it was called, which the Cranes had purchased as a summer home. At that time Mr. Crane wanted to build another house out on the tip of Juniper Point, and Mrs. Bradley went to work again with Elmslie, Purcell and Feick (I think), in designing it. Like the Shorewood house it made much of sleeping porches. I think myself it was one of the nicest homes to live—in summer—that I have seen! Again, I think it really represented George Elmslie and Josephine Bradley in achieving a design that was functionally perfect, and at the same time beautiful. Purcell and Feick undoubtedly contributed—but just how much I do not know. If you have not seen this house, I think you should do so! The views from the great curve of the living room windows. The sheltered but wide open dining porch. The opposite porch which regularly housed four boys as their sleeping room, with its curtains for stormy weather, lashed down. The sights of sea and land from south toward Vineyard Haven and Martha's Vineyard, westward to the Elizabeth Islands, the Hole, and north-west to Buzzard's Bay. And on stormy nights, the clanging of the bell buoys, the regular fog horns on the Vineyard, with the steamers plying east and west through Vineyard Sound! And all to the background music of the heavy waves crashing against the Point! We continued to use the M. B. L. Lab'y facilities about every other year until the 2nd War, when the accelerated program made it necessary to stick close to Madison. I think we made one more trip about '46 to Woods Hole. In '48 I retired and we moved to California—where Mrs. Bradley again jumped into the job of making alterations on the old home here, where I grew up, and which my parents built in '93. In '52 we lost Josephine—and I have never wished to return to see Woods Hole, although John Crane, son of Chas. makes The Big House his home quite regularly in summer. The Bungalow of course was sold as part of the liquidations of the Crane estate.

I should add that as time went on at Madison and our family grew, we made some additions and changes. The original garage, next the front door became the work shop. We added a small apartment to house a man and wife, who were the cook and the general helper and who lived there when we were away. We were away either at Woods Hole or west in the Sierra camping, or canoe camping in the Quetico country. I have forgotten whether George Elmslie designed the addition or whether it was done by Mrs. Bradley and a local architect. In any event I think it adds to the beauty of the Shorewood house as much as it added to its functional perfection.

*George Feick, Jr. (1881-1945), an engineer associated first with William Purcell and then with Purcell and Elmslie. He left the firm in 1913.

I think you will understand better our large family program, which really determined both the Shorewood house and the W. H. Bungalow, if I send you also a talk given to a large group of young married people and others about to be married. Except for the Prospect house—which was a mistake—the other two were designed around function, present or expected. . . .

Sincerely yours,
/s/ Harold Bradley

NOTES

1 The Autobiography of an Idea

1 For the story of the publishing of *The Autobiography of an Idea*, see George E. Pettengill, "The Biography of a Book: Correspondence between Sullivan and *The Journal*," *AIA Journal* 63 (June 1975): 42–45. Of the several editions of *The Autobiography of an Idea*, the one I follow is the Dover (New York, 1956).

2 Sherman Paul, *Louis Sullivan: An Architect in American Thought* (Englewood Cliffs, N.J.: Prentice-Hall, 1962), p. 132.

3 Charles Whitaker to Louis Sullivan, September 26, 1923, Burnham Library, Chicago.

4 For a more-detailed account of Sullivan's childhood and youth, see Willard Connely, *Louis Sullivan as He Lived: The Shaping of an American Architecture* (New York: Horizon, 1960) pp. 23–94.

5 Sullivan, *Autobiography*, pp. 14, 36.

6 Ibid., p. 36.

7 Ibid., pp. 28–29 ("Great Friend"), 65–68 ("domain").

8 Ibid., pp. 171–72.

9 Ibid., pp. 11–12, 42–46, 60 (Grandfather).

10 Ibid., pp. 157–69, 173–74 (Woolson).

11 Ibid., pp. 220–21 (Clopet).

12 Ibid., p. 272.

13 Ibid., p. 248.

14 Ibid., p. 79.

15 Ibid., p. 85.

16 Ibid., pp. 86–87.

17 Ibid., p. 201.

18 The "Lotos Club Notebook," Avery Library, New York, shows sketches— probably drawn by Edelmann—of nude men wrestling and swimming (pp. 94, 97, and 217). For Eakins, see Gordon Hendricks, *The Photography of Thomas Eakins* (New York: Grossman, 1972).

19 Sullivan, *Autobiography*, p. 211.

2 Exploration and Assimilation

1 For the minutes of the meeting, see *Inland Architect* 9 (March 1887): 23–26; Sullivan's participation, p. 26.

2 *Inland Architect* 6 (November 1885): 58–59. Reprinted in Louis Sullivan, *Kindergarten Chats and Other Writings*, ed. Isabella Athey (1947; New York: Wittenborn, 1968), pp. 177–81; this quotation, p. 177.

3 See the 3d American ed., trans. John Durand (New York: Henry Holt, 1889), p. 162. This volume, standard in America at the time, comprises both *The Philosophy of Art* and *The Ideal in Art*.

4 Sullivan, *Autobiography*, pp. 167, 233. For a further discussion of Taine's influence on Sullivan's thought, see Paul, *Louis Sullivan*, pp. 20, 41–42, 77.

5 Taine, *Lectures*, p. 76.

6 Ibid., pp. 87, 222–23. The quotation loses in translation. The original text reads "L'oeuvre d'art est determinée par un ensemble que c'est l'état général de l'esprit et de moeurs environnantes" (16th French ed. [Paris: Hachette, 1918], 1:49).

7 Herbert Spencer, *First Principles of a New System of Philosophy*, 2d ed. (New York: Appleton, 1872), p. 555. According to Frank Lloyd Wright, Sullivan held Herbert Spencer in high regard (*Genius and the Mobocracy* [1949; reprint ed., New York: Horizon, 1971], p. 70).

8 The text of the "Essay on Inspiration" is given in full in appendix A.

9 Taine, *Lectures*, pp. 210–25; Spencer, *First Principles*, pp. 545–46.

10 See appendix A.

11 J. H. Fichte, *Johann Gottlieb Fichte's Sämmtliche Werke Herausgegeben J. H. Fichte*, 8 vols. (Berlin: Veit und Comp., 1845–46), 5:182 ff., 210 ff. Friedrich Schiller, *Werke*, 6 vols. (Zurich: Stauffacher, 1967), I:195–207 ("Die Künstler"); 341 ff. ("Über die Ästhetische Erziehung des Menschen"); 433 ff. ("Über das Patetische"). Immanuel Kant, *Kant on the Foundation of Morality: A Modern Version of the Grundlegung*, trans. and ed. B. E. A. Liddel (Bloomington: Indiana University Press, 1970), chaps. 6–7.

12 Very little is known about Edelmann. The only bibliographical item on him, and one that is avowedly incomplete, is Donald D. Egbert and Paul E. Sprague, "In Search of John Edelmann," *JAIA* 45 (February 1966): 35–41. See also Connely, *Louis Sullivan*, chaps. 5–6.

13 Sullivan, *Autobiography*, p. 206.

14 For the full text of the letter, see Paul, *Louis Sullivan*, pp. 1–3. Paul's treatment of the relationship between Sullivan's ideas and Whitman's is the best that has been written on the subject.

15 Published in *Inland Architect* 14 (Octobert 1889): 38–39.

16 Sullivan, *Autobiography*, p. 79. The idea of trade as a major determinant of progress was widely accepted at the time. See Richard Hofstadter, *The American Political Tradition and the Men Who Made It* (New York: Knopf, 1948), chap. 7.

17 Sullivan, *Kindergarten Chats*, in *Kindergarten Chats and Other Writings*, p. 30.

18 Sullivan, "Characteristics and Tendencies of American Architecture," in *Kindergarten Chats and Other Writings*, pp. 178–79.

19 Sullivan, *Autobiography*, pp. 233–35.

20 Sullivan, *Autobiography*, p. 236.

21 Sullivan, *Kindergarten Chats*, pp. 29–30.

22 For the story of the Auditorium Building, see Sullivan, *Autobiography*, pp. 292–94; Hugh Morrison, *Louis Sullivan, Prophet of Modern Architecture* (1935; reprint ed., New York: Norton, 1962), chap. 3; Connely, *Louis Sullivan*, chap. 8; and Daniel H. Pearlman, *The Auditorium Building: Its History and Architectural Significance* (Chicago: Roosevelt University, 1976).

23 Sullivan, "Ornament in Architecture," *Kindergarten Chats and Other Writings*, p. 187.

24 Paul E. Sprague, "The Architectural Ornament of Louis Sullivan and His Chief Draftsmen," (Ph.D. diss., Princeton University, 1969), pp. 167–81.

25 Several works by Viollet-le-Duc are listed in the *Auction Catalogue of the Household Effects, Library, Oriental Rugs, Paintings, etc. of Mr. Louis Sullivan, the Well-Known Chicago Architect, November 29, 1909* (Chicago: Williams, Barker and Severn Company), of which the Burnham Library holds the only known copy. Theodore Turak, "A Celt Among Slavs: Louis Sullivan's Holy Trinity Cathedral," *Prairie School Review* 9 (Fourth Quarter 1972): 5–23, gives visual evidence supporting the author's suggestion that the design of several stencils in the Auditorium were adapted from Viollet-le-Duc's *L'Art russe* (Paris, 1877).

26 Sullivan, "What is the Just Subordination, in Architectural Design, of Details to Mass?" *Kindergarten Chats and Other Writings*, p. 184.

27 Sullivan, *Autobiography*, p. 42.

28 Donald Hoffmann, *The Architecture of John Wellborn Root* (Baltimore: Johns Hopkins University Press, 1973), p. 13.

29 Thomas S. Hines, *Burnham of Chicago: Architect and Planner* (New York: Oxford University Press, 1974), pp. 3–5, 135, 326.

30 The Swedenborg Publishing Association, of Philadelphia, distributed free of charge a twelve-volume *Swedenborg Library*, a compendium of Swedenborg's writings. There were also shorter anthologies, such as the one-volume *Compendium of the Writings of Emanuel Swedenborg* (New York: Lippincott, 1879). The New Jerusalem Tract Society, of Manchester, England, translated and published Swedenborg's *Complete Works*. These were re-edited in New York from 1850 on by the American Swedenborg Printing and Publishing Society. There were, moreover, such introductory surveys as T. Parsons, *Outlines of the Religion and Philosophy of Swedenborg* (Boston: Roberts Brothers, 1876), and W. White, *Life of Emanuel Swedenborg, together with a Brief Synopsis of His Writings Both Philosophical and Theological* (Philadelphia: Lippincott, 1877).

31 See mainly in this respect Emanuel Swedenborg, *Angelic Wisdom: Concerning the Divine Love and the Divine Wisdom* (New York: American Swedenborg Printing and Publishing Society, 1875), pars. 1–60; and *Mar-*

riage and the Sexes in Both Worlds: From the Writings of Emanuel Sweden-borg, ed. B. F. Barrett, vol. 9 of the Swedenborg Library (Philadelphia: Claxton, 1881), pp. 61–63. Other works in which Swedenborg expounded on his "correspondences" were *The Apocalypse Explained* (3 vols.); *The Heavenly Arcana* (2 vols.); *A Dictionary of Correspondences, Respresentatives and Significatives Derived from the World of the Lord: The Divine Attributes Including also the Divine Trinity*; and above all, *Heaven and Its Wonders and Hell: From Things Heard and Seen*, where Swedenborg gives a first-hand account of his visits to Heaven and Hell.

32 See appendix A.

33 Sullivan, "Ornament in Architecture," *Kindergarten Chats and Other Writings*, p. 187.

34 Ibid.

35 Wright, *Genius and the Mobocracy*, p. 95.

36 Sullivan had been interested in Moorish ornament since 1873 at least. See Allison Owen, "Remembering Louis Sullivan," *JAIA* 6 (August 1946): 90. Moreoever, Adler and Sullivan had worked on a number of synagogues at the time when, because of its association with the golden period of Jewish culture in Medieval Spain, a Moorish expression was favored for these buildings. See Lauren Weingarden Rader, "Synagogue Architecture in Illinois," in Maurice Spertus Museum of Judaica, ed., *Faith and Form* (Chicago: Spertus College Press, 1976), pp. 37–80. A few months before working on the Getty Tomb, Sullivan had been engaged with the interior design of the Anshe Ma'ariv Synagogue.

37 I am grateful to Professor Jan Vansina for sharing with me his knowledge of Sa'adian tombs.

38 Dimitri Tselos, "The Chicago Fair and the Myth of the 'Lost Cause,'" *JSAH* 26 (December 1967): 264.

39 I am grateful to my wife for the original observation linking the Transportation Building and the École des Beaux-Arts, and to David Van Zanten for informing me that the courtyard of the Palais des Études had been painted a deep red in 1873—a few months before Sullivan's arrival in Paris—by Ernest-Georges Coquart, who in Van Zanten's opinion was "one of the most violent of the young Neo-Grec's" (Van Zanten's letter to me, June 25, 1979). Coquart had become architect of the École des Beaux-Arts in 1871 after Duban's death.

40 Connely, pp. 146–47; Sprague, pp. 232–33; and Tselos, pp. 263–64.

41 Bannister Fletcher, "American Architecture through English Spectacles," *Engineering Magazine* 7 (June 1894): 321.

42 "Colour Decoration at the Chicago Exhibition," *Builder* 65 (26 August 1893): 151.

43 Morrison, pp. 189, 227; and *Révue des arts décoratifs* 14 (1893): 65–79; 16 (1895): 305–9.

44 David H. Crook, "Louis Sullivan and the Golden Doorway," *JSAH* 26 (December 1967): 251–52, argues that André Bouilhet wrote his glowing report

on Sullivan's ornamentation because he saw similarities between it and Art Nouveau, a movement his organization was fostering.

45 See, in this respect, Rochelle S. Elstein, "The Architecture of Dankmar Adler," *JSAH* 26 (December 1967): 242–49; and Charlene Stant Engel, "Dankmar Adler, Architect: Life, Theory, and Practice" (Master's thesis, University of Wisconsin–Madison, 1974). See also the following articles by Adler: "The Chicago Auditorium," *Architectural Record* 1 (April–June 1892): 415–34; "Tall Office Buildings—Past and Future," *Engineering Magazine* 3 (September 1892), 765–73; "Light in Tall Office Buildings," ibid. 4 (November 1892): 171–86; and "The Tall Business Building," *Cassier's Magazine* 12 (1897): 193–210. "The Auditorium Building and Its Architects, Recollections, July Ten, 1940," a three-page typescript by Frank Lloyd Wright in the collection of Mrs. Irving Saltzstein, Adler's granddaughter, also points to the fact that it was Adler who designed most of the buildings erected by Adler and Sullivan.

46 Sullivan's recollection (in *The Autobiography of an Idea*, pp. 252–57) of the dates of the establishment of D. Adler and Company on 1 May 1880, with his having a one-third interest, and of Adler and Sullivan on 1 May 1881, with each partner having a 50 percent interest, are incorrect. A survey of Chicago business directories reveals that from 1879 to 1881 Adler was in business by himself, with offices at 133 Lasalle up until 1880 and then at 58 Borden Block from 1881 on; and that D. Adler and Company was formed in 1882, and Adler and Sullivan in 1883.

47 Sullivan, *Autobiography*, pp. 255–56.

48 Adler, "Influence of Steel Construction and of Plate Glass upon the Development of Modern Style," *Inland Architect* 28 (November 1896): 34–37.

49 Ibid., p. 35.

50 Ibid. Root's translation of Semper, "Development of Architectural Style," was published in *Inland Architect* 14 (December 1889): 76–78, and 15 (February 1890): 5–6. For Semper, see his *Der Stil in den technischen und tektonischen Künsten oder Praktischer Ästhetik* (Munich: Bruckmann, 1863). In December 1974, a four-day symposium on Semper was held in the Eidgenössischen Technischen Hochschule of Zurich; see the proceedings, *Gottfried Semper und die Mitte des 19. Jahrhunderts* (Basel and Stuttgart: Birkhäuser Verlag, 1976). See also Nikolaus Pevsner, *Some Architectural Writers of the Nineteenth Century* (Oxford: Clarendon Press, 1972), chap. 24, "Semper."

51 George Grant Elmslie to William Gray Purcell, October 6, 1944, Northwest Architectural Archives, University of Minnesota.

52 Sullivan, "The Tall Office Building Artistically Considered," *Kindergarten Chats and Other Writings*, p. 208.

53 Sullivan, "Style," *Inland Architect* 11 (May 1888): 59–60.

54 "All things in nature," he wrote in "The Tall Office Building Artistically Considered," "have a shape, that is to say, a form, an outward semblance, that tells us what they are, that distinguishes them from ourselves and from each other" (*Kindergarten Chats and Other Writings*, p. 207).

55 Sullivan, *Autobiography*, pp. 313–14.

56 Sullivan, "The Tall Office Building," p. 208.

57 Ibid., p. 203.

58 For this interpretation, see mainly Henry-Russell Hitchcock, *Architecture, Nineteenth and Twentieth Centuries*, 2d ed. (Baltimore: Penguin, 1963), chap. 14.

59 The terms in which Sullivan described the skyscraper as a building type. See "The Tall Office Building," p. 206.

60 Sullivan to Claude Bragdon, November 8, 1903, in Claude Bragdon, "Letters from Louis Sullivan," *Architecture* 64 (July 1931): 9. Wright, *Genius and the Mobocracy*, p. 75, corroborates this information. Elmslie does too; see his undated draft of a letter to William Gray Purcell, marked "Revision No. 1," in the Northwest Architectural Archives, University of Minnesota.

61 Tselos, "The Chicago Fair," p. 263.

62 Winston Weisman, "Philadelphia Functionalism and Sullivan," *JSAH* 20 (March 1961): 3–19. Weisman states that the idea for his article came from observations on the resemblance between the Jayne and Wainwright buildings Charles Peterson had made in 1951. However, much earlier, Everard M. Upjohn had noticed a stylistic resemblance between mid-century Gothic commercial buildings and Sullivan's skyscrapers (*Richard Upjohn, Architect and Churchman* [New York: Columbia University Press, 1939], p. 190).

63 Whether the winged figures on the Bayard Building were part of Sullivan's original conception or not has been questioned. According to Norval White and Elliot Willensky, *AIA Guide to New York City*, "The sextet of angels supporting the cornice were added, over Sullivan's objections but still by his hand, at the request of his client, Silas Alden Condict" (rev. ed. [New York: Macmillan, 1978], p. 94). Presumably this information was first issued by Alden S. Condict, Silas's son, who related it to Meyer Berger, who in turn published it in his "About New York" column in the *New York Times* (May 15, 1957). The column stated that according to Condict, it had been he who had commissioned the building from Sullivan and who at that time had requested that the architect design "the six angels." This is not true. The building was commissioned by the United Loan and Investment Company, and the person dealing with Sullivan was its president, Robert Avery. The design, according to documents on file in the City of New York, was ready by September 21, 1897. A year and nine months after that and only six months before completion, the mortgage on the building was recalled by the Bank for Savings. It was from that institution, well after the design had been set and the building almost finished, that Silas Alden Condict and his wife Emmeline acquired half an interest. Reinforcing the opinion that the winged figures were indeed part of Sullivan's original design is the fact that before designing the Bayard Building he had placed similar winged figures on the facades of a preliminary design for the Victoria Hotel in Chicago Heights, the Transportation Building for the Columbian Exposition, and the project for the Trust and Savings Bank Building in St. Louis.

64 Sullivan, *Kindergarten Chats*, p. 121. According to Arthur O. Lovejoy, *Es-*

says in the History of Ideas (Baltimore: Johns Hopkins Press, 1948), p. 153, as early as 1724 William Stukely had compared the interior of Gloucester Cathedral to "a walk of trees, whose touching heads are curiously imitated by the roof." This conception was expressed by many subsequent novelists and poets, as well as by eighteenth- and early nineteenth-century architectural theorists explaining the timber origins of architecture. The idea is much older, however; it goes back to Vitruvius (IV, 2). As examples of eighteenth-century theoreticians who developed this idea, see J.-L. de Cordemoy, *Nouveau traité de l'architecture, ou l'art de bastir* (Paris, 1706); and Marc-Antoine Laugier, *Essai sur l'architecture*, 2d ed. (Paris, 1755), esp. p. 13. An early transfer of the belief of the timber origins of classical architecture to the Gothic was Sir James Hall's in a paper he presented to the Royal Society of Edinburgh on April 6, 1797, entitled "Essay on the Origin and Principles of Gothic Architecture." He later published his conclusions in a book, *Essay on the Origin, History and Principles of Gothic Architecture* (London: Murray, 1813). Early examples of columns looking like trees are in J. K. Friedrich Dauthe's reconstruction of the Nikolaikirche in Leipzig (1784–97), where the abaci shoot out naturalistic leaves which in turn become the ribs of the Gothic vaulting; the Gothic ribs in the shape of palm fronds in Schinkel's project of a Memorial to Queen Louise, of 1810, is another instance; and, of course, John Nash's kitchen in the Brighton Pavilion is the textbook case. For a view of the interior of the Nikolaikirche, see F. Landsberger, *Die Kunst der Goethezeit: Kunst und Kunstanschauung von 1750 bis 1830* (Leipzig: Insel, 1931), p. 167. Georg Germann, *Gothic Revival in Europe and Britain: Sources, Influences and Ideas* (Cambridge, Mass.: MIT Press, 1973), gives a good account of most of these facts. An early instance in America of a comparison of a Gothic church with a grove of trees is in Ralph Waldo Emerson, "Thoughts on Art," *Dial* 1 (January 1841): 376. Later, in "On Art," Emerson used the same passage. See *The Early Lectures of Ralph Waldo Emerson*, ed. Stephen E. Whicher, Robert E. Spiller, and Wallace E. Williams (Cambridge, Mass.: Harvard University Press, 1964), p. 52. It is possible that Emerson gained knowledge of this idea from his reading of Goethe.

65 Sullivan, *Kindergarten Chats*, p. 121.

66 Ibid.

67 For Hegel, see his *Philosophy of Art*, 4 vols., trans. from the German by F. P. Osmaston (London: G. Bell and Sons, 1920), especially pt. III. For Schopenhauer, see his *The World as Will and as Representation*, 2 vols., trans. from the German by C. F. J. Payne (New York: Dover, 1969), I, 214–18, and II, chap. 35. Ronald Bradbury, *The Romantic Theories of Architecture of the Nineteenth Century in Germany, England, and France* (New York: Dorothy Press, 1934), is a good handbook on the subject. For a more basic approach to the subject, see Harold Osborne, *Aesthetics and Art Theory: An Historical Introduction* (New York: Dutton, 1970).

68 See Friedrich Vischer, *Aesthetik oder Wissenschaft des Schönen*, 3 pts. in 4 vols. (Reutlingen and Leipzig: Carl Mäcken, 1846–51; Stuttgart: Carl

Mäcken, 1852–54), especially the section devoted to architecture, III₁, 173–338, and principally within that section, "Die subjectiv-objectiv Wirklichkeit des Schönen."

69 Ibid., III₁, 331–38, "Die untergeordnete Tektonik."

70 Vischer was also responsible for systematizing ideas on empathic architecture. See his *Vorträge*, published posthumously by his son (Stuttgart: J. B. Gotha, 1898), especially the section entitled "Das Schöne und Kunst." It should be emphasized, however, that Vischer was not the first proponent of the theory; he merely put together into a system ideas that had already been expressed by others. In architectural theory, for example, the tradition can be traced back to Alberti, Francesco di Giorgio, Filarete, etc. For its nineteenth-century developments, see mainly George L. Hersey, *High Victorian Gothic: A Study in Associationism* (Baltimore: Johns Hopkins University Press, 1972), especially chaps. 1 and 2. The term *Einfühlung* was first translated into English in 1912 in connection with opinions of Theodor Lipps, the psychologist (*Oxford English Dictionary*, Supplement, 1971 ed.) Before that date, the concept had been expressed with the term *sympathy*, and it is mostly in an empathic sense that Sullivan and other early writers seem to have used the word.

71 For Eidlitz, see mainly Biruta Erdmann, "Leopold Eidlitz's Architectural Theories and American Transcendentalism" (Ph.D. diss., University of Wisconsin–Madison, 1977).

72 Transcendentalist ideas on art began in America essentially with Emerson. In 1843 Horatio Greenough expanded some of Emerson's ideas in "American Architecture" (re-edited by Don Gifford in *The Literature of Architecture: The Evolution of Architectural Theory and Practice in Nineteenth-Century America* [New York: Dutton, 1966], pp. 141–51). On Greenough, see also his *Form and Function: Remarks on Art, Design, and Architecture*, ed. Harold A. Small (Berkeley and Los Angeles: University of California Press, 1966). For the correspondence between Emerson and Greenough, see Nathalia Wright, "Ralph Waldo Emerson and Horatio Greenough," *Harvard Library Bulletin* 12 (1958): 91–116. Greenough was also a friend of the Reverend William Henry Furness, Frank's father, who had, with Emerson, been a member of the 1836 group. In that year he had published his *Remarks on the Four Gospels*, an important work proposing that Christianity use a transcendentalist perspective to revise its notions on the historical Jesus. Furness, furthermore, had been a schoolmate of Emerson's at Boston Latin School, and according to Perry Miller, Emerson's lifelong and possibly only intimate friend (*The Transcendentalists* [Cambridge: Harvard University Press, 1950], p. 124). In 1870, Furness addressed the fourth annual convention of the American Institute of Architects, presenting a transcendentalist view of architecture (quoted in Gifford, pp. 391–404). Thus transcendentalism was known in American architectural circles and to a degree had an ideological influence on them.

73 Eidlitz, *Nature and Function of Art*, pp. 271–72. New York: A. C. Armstrong and Son; London: Low, Marston Searle and Rivington; 1881.

74 John Wellborn Root, "Broad Art Criticism" *Inland Architect* 11 (February 1888): 2–6.
75 Sullivan, "The Tall Office Building," p. 203; Eidlitz, *Nature and Function*, pp. 271–72.
76 Eidlitz, *Nature and Function*, p. 57.
77 Ibid., p. 72.
78 Ibid., p. 57.
79 Sullivan, "Ornament in Architecture," *Kindergarten Chats and Other Writings*, p. 189.
80 Sullivan, *Kindergarten Chats*, p. 46.
81 Eidlitz, p. 60.
82 Ibid., pp. 222–23.
83 Ibid., pp. 223, 92.
84 Ibid., p. 287.
85 Sullivan, *Kindergarten Chats*, p. 49.
86 Thomas Hope, *An Historical Essay on Architecture*, 2 vols. (London: G. Murray, 1835); Eidlitz, pp. 217–20.
87 Reported by Claude Bragdon, Sullivan's friend, to Lewis Mumford. See the latter's *Roots of Contemporary American Architecture*, 2d ed. (1952; New York: Grove Press, 1959), p. 21.
88 Vincent Scully, "Louis Sullivan's Architectural Ornament," *Perspecta* 5 (1959): 73–80.
89 Ibid., pp. 73–77.
90 Ibid., p. 77.
91 For the Magasins au Printemps, see Louis Hautecoeur, *Histoire de l'architecture classique en France*, 7 (Paris: Picard, 1957), pp. 333–35; for a chronology of the construction of the Schlesinger and Mayer Store, see appendix B.

3 Indian Summer

1 Ralph Waldo Emerson, *Complete Works*, 12 vols. (Boston and New York: Houghton Mifflin, 1903), I, 214.
2 Sullivan, *Kindergarten Chats*, p. 44.
3 Sullivan, "Characteristics and Tendencies of American Architecture," in *Kindergarten Chats and Other Writings*, pp. 177–78.
4 Sullivan, "The Young Man in Architecture," in *Kindergarten Chats and Other Writings*, p. 214.
5 Sullivan, "An Unaffected School of Modern Architecture—Will It Come?" *Artist* 24 (January 1899): xxxiii–iv.
6 Walt Whitman, *The Complete Writings of Walt Whitman*, 10 vols. (New York and London: Putnam's, 1902), V, 51.
7 Whitman, V, 139.
8 Ibid.
9 Whitman, V, 52–53.
10 Ibid.
11 Sullivan, "An Unaffected School," p. xxxiv.

12 Harold U. Faulkner, *Politics, Reform, and Expansion, 1890–1900* (New York: Harper and Row, 1959), p. 59.

13 In 1900 there were 10,581 registered architects in the country, but in 1898 there were only nine schools of architecture with a total enrollment of 362 students. The situation changed drastically in a few years, and enrollments in architecture schools increased dramatically. See Turpin C. Bannister, ed., *The Architect at Mid-Century: Evolution and Achievement* (New York: Reinhold, 1954), tables 54 and 56, and pp. 93–104.

14 For a fuller discussion of these events, see Ralph J. Clark, ed., *The Arts and Crafts Movement in America, 1876–1916* (Princeton: Princeton University Press, 1972), pp. 58–78.

15 H. Allen Brooks, *The Prairie School* (Toronto and Buffalo: University of Toronto Press, 1972), pp. 37–38.

16 Henry Webster Tomlinson (1870–1942) was a peripheral member of the Prairie School. In 1901 he went into partnership with Frank Lloyd Wright, but the partnership soon dissolved. During this time he was a member of the Steinway Hall Group and of the Chicago Eighteen. Subsequently he moved to North Dakota and then to Joliet, Illinois. During this later stage of his career he became better known as a penal architect, although he also designed a number of commercial and residential structures in Joliet.

17 Paul E. Sprague has identified the "Unpublished Address to the Chicago Architectural Club, read at the Art Institute, Chicago, May 30, 1899, Burnham Library" noted in the "Bibliography of the Writings of Louis Sullivan" in Morrison, *Louis Sullivan, Prophet of Modern Architecture*, p. 307, as being the same read by Tomlinson at the Cleveland meeting. See Sprague, "The Architectural Ornament of Louis Sullivan and His Chief Draftsmen" (Ph.D. diss., Princeton University, 1969), p. 449.

18 George S. Dean, "Progress before Precedent," *Brickbuilder* 9 (May 1900): 92. For a full account of the events of the meeting, and the complete text of the constitution of the League, see "First National Convention of Architectural Clubs," *Inland Architect* 33 (June 1899): 41–43.

19 Sullivan, "The Modern Phase of Architecture," *Inland Architect* 33 (June 1899): 40.

20 Dean, "Progress," pp. 91–96. Dean (1864–1919) was a member of the Chicago Eighteen. After studying in Paris (1892–93), he entered the Chicago offices of Shepley, Rutan and Coolidge. He established himself in private practice in 1895.

21 Dean, p. 92.

22 Ibid., p. 96.

23 See appendix A.

24 The report of the T-Square Club of Philadelphia regarding the earlier inquest clearly reveals this. With one exception, all the architects surveyed believed that the special American conditions and requirements would result in a distinctive character in architecture. But all the faculty members except two believed the contrary, "and some of them gladly, for they hold that the

modern tendency is toward leveling of all barriers between different countries, and that all will in time exhibit nearly the same characteristics." This universal style was that of the French Beaux-Arts (*Artist* 24 [January 1899]: xxxiii). The "internationalist" view against the League's interest in the creation of "an indigenous architecture" was expressed in a paper delivered at this second convention in Chicago. See Ernest Flagg, "American Architecture as Opposed to Architecture in America," *Inland Architect* 35 (June 1900): 36.

25 The by-laws had been amended to allow the executive to serve for a two-year term instead of one and to provide that all the officers represent a single geographical area. See Brooks, *Prairie School*, p. 41.

26 *American Architect and Building News* 68 (June 1900): 224; *Inland Architect* 35 (June 1900): 42. Symptomatically, Kelsey ten years later was associated with Paul Cret in designing the Pan-American Union Building in Washington, D.C., one of the best academic buildings in the country.

27 Elmer Grey, "Indigenous and Inventive Architecture for America," *Brickbuilder* 9 (June 1900): 121–23. Grey, a native of Milwaukee, moved to Los Angeles shortly after the turn of the century. There, in 1903, he entered into partnership with Myron Hunt, a former member of Wright's circle in Steinway Hall.

28 *Inland Architect* 35 (June 1900): 42–43.

29 See *Kindergarten Chats and Other Writings*, pp. 214–23.

30 Sullivan, "The Young Man in Architecture," p. 215. Sullivan owned a copy of the first English translation of Friedrich Nietzsche's *Thus Spake Zarathustra: A Book for All and None*, trans. Alexander Tille (New York and London: Macmillan, 1896). This is vol. 8 of *The Works of Friedrich Nietzsche*, published by Macmillan. For proof of Sullivan's ownership of a copy, see item 105 in "Books," *Auction Catalogue of the Household Effects, Library, Oriental Rugs, Paintings, etc. of Mr. Louis Sullivan, the Well-Known Chicago Architect, November 29, 1909* (Chicago: Williams, Barker and Severn Company, 1909), in the Burnham Library, Chicago.

31 Sullivan, "Young Man in Architecture," pp. 216, 218.

32 Ibid., p. 220. Nietzsche's philosophy could have been a cause for Sullivan's change in position.

33 Ibid., p. 223.

34 For a comprehensive listing of manuscripts and editions of *Kindergarten Chats*, see *Kindergarten Chats and Other Writings*, appendix E, p. 251. Miss Athey made a mistake in the dates of the first publication in *The Interstate Architect and Builder*. She gives them as February 8, 1901, to February 16, 1902. The figures were transposed; they should read February 16, 1901, to February 8, 1902.

35 Sullivan to Lyndon P. Smith, 18 and 22 February 1901, *Kindergarten Chats and Other Writings*, pp. 243–44; and "Sullivan's Letters at Columbia," *American Architect and Architecture* 149 (November 1936): 100–101.

36 The letter has been published several times: in Claude Bragdon, *Architecture and Democracy* (New York: Knopf, 1918), pp. 143–45; in the preface

to the Scarab edition of *Kindergarten Chats* (1934); and in *Kindergarten Chats and Other Writings*, p. 245.

37 Sullivan, *Kindergarten Chats*, p. 57.

38 Wright's and Spencer's interest in the kindergarten method is well known. See Robert C. Spencer, "The Work of Frank Lloyd Wright," *Architectural Review* 7 (May 1900): 68–69.

39 Sullivan, *Kindergarten Chats*, p. 100. This "architectural kindergarten" Sullivan is proposing was established, according to Sherman Paul's quotation of Paul Goodman, roughly twenty years later in the Bauhaus *Vorkurs*. For a comparison of Itten's and Sullivan's methods see Paul Goodman, "A study of Modern Design," *Arts* 35 (January 1961): 21. For an excellent analysis of *Kindergarten Chats*, see Paul, *Louis Sullivan*, pp. 70–82.

40 Friedrich Froebel, *The Education of Man*, trans. from the German and annot. by W. N. Hailmann (New York: Appleton, 1897), p. 5.

41 Sullivan, *Kindergarten Chats*, p. 99.

42 Ibid., p. 91.

43 Sullivan, *The Autobiography of an Idea*, p. 207.

44 Froebel, pp. 8–9.

45 Jean-Jacques Rousseau, *Émile, or Treatise on Education*, trans. and annot. W. H. Payne (New York: Appleton, 1908), pp. 1–5.

46 Viollet-le-Duc, *Histoire d'un dessinateur, comment on apprend à dessiner* (Paris: Bibliothèque d'éducation et de récréation, 1879).

47 Much in Petit Jean and in his relationship to Monsieur Majorin probably came from Viollet-le-Duc's reminiscences of his own childhood and youth. His early education owed a great deal to his uncle, Étienne Delecluze, art critic for the *Journal des débats* and a friend of Stendhal and Mérimée. From Delecluze he received a Rousseauean upbringing, practically as a new Émile.

48 Ibid., p. 212; my translation.

49 See Whitman's 1855 preface to *Leaves of Grass*.

50 Viollet-le-Duc, *Histoire*, p. 218; my translation.

51 Sullivan, "Letter to the Editor of *The Interstate Architect* of 18 May 1901," in *Kindergarten Chats and Other Writings*, p. 246.

52 Claude Bragdon, *Architecture and Democracy* (New York: Knopf, 1918), p. 145.

53 For the text of the telegram, see *Brickbuilder* 10 (June 1901): 112.

54 Sullivan, "Education," in *Kindergarten Chats and Other Writings*, pp. 224–26.

55 Brooks, p. 41.

56 A paper read to the Chicago Architectural Club in 1905. Sullivan's typescript is in the Burnham Library, The Art Institute of Chicago. An abridged version was published in Sullivan, *The Testament of Stone: Themes of Idealism and Indignation from the Writings of Louis Sullivan*, ed. Maurice English (Evanston: Northwestern University Press, 1963), 105-23. This quotation p. 109.

57 Most of his earlier speeches had been published in *The Inland Architect*. For

years Sullivan's name, among others, had been listed among the "Special Contributors" immediately below the paper's banner. The last issue where this listing appears is that of December 1904 (vol. 44). A month earlier Robert Craik McLean, who had been the editor for a long time, had ceased to be listed in that capacity, and the name of his successor was never printed in the paper. The issue of January 1905 carried an announcement on the first page stating, "All communication intended for *The Inland Architect* should be addressed to Porter, Taylor and Company, 505 Pontiac Building, who have purchased the publication." The new owners brought in editorial changes; Beaux-Arts architecture now received preferential treatment. From time to time, however, a house by Frank Lloyd Wright or George Maher would be published.

58 Sullivan, *Testament of Stone*, 107.
59 Ibid., 108.
60 Sullivan, *Democracy: A Man-Search*, ed. and with an introduction by Elaine Hedges (Detroit: Wayne State University Press, 1961). The work remained unpublished until 1949, when the Free Public Library of Louisville, Kentucky, published a microcard edition supervised by Walter L. Creese and with an introduction by Hugh Morrison.
61 Ibid., p. 141; see also pp. 39–40 for Sullivan's ideas on political revolution. Compare these passages with G. W. Friedrich Hegel, *Philosophy of History*, trans. J. Sibree (New York: Collier, 1902), pp. 169–71.
62 Sullivan, *Democracy: A Man-Search*, pp. 59–60.
63 Ibid., p. 60.
64 Ibid., p. 97.
65 Ibid., p. 46.
66 Ibid., pp. 143–44.
67 Ibid., p. 64.
68 Ibid., p. 151.
69 Ibid., pp. 148–49, 223–24.
70 Ibid., p. 151.
71 Ibid., pp. 370–71.
72 Ibid., p. 374.
73 Ibid., pp. 379–80.
74 Ibid., p. 382.
75 Ibid., pp. 385–86.
76 Elaine Hedges, in her introduction to *Democracy: A Man-Search* (p. xxi), argues that the work should not be read as a philosophical treatise, because it is not a logical and reasoned demonstration of ideas, and that the book's worth lies in showing Sullivan's "deep affinity with an American tradition of thought [and in] recognizing the validity he found, as a consciously democratic artist, in forms both of romantic-Transcendental and pragmatic-instrumentalist philosophies." The work, she concludes, should be regarded as a manifesto. Correct as her position is from a critical standpoint, it is my strong belief that Sullivan's intentions were exactly the opposite. In my mind, Sullivan was presenting his readers with a system of philosophy and

the success or failure of *Democracy: A Man-Search* should be judged from that point of view.

77 *Democracy*, pp. 68–93.

78 Crane Brinton, *Nietzsche* (Cambridge: Harvard University Press, 1941), 372; Emilio Molina, *Nietzsche, dionisíaco y asceta* (Santiago de Chile: Editorial Nascimiento, 1944), p. 190.

79 Aristotle, *Nicomachean Ethics*, VI, 3; VI, 4; VI, 7.

80 In *Kindergarten Chats and Other Writings*, pp. 227–41.

81 Ibid., p. 233.

82 *Craftsman* 15 (January 1909): 402–4.

83 Claude Bragdon, "Architecture in the United States—I," *Architectural Record* 25 (June 1909): 432.

4 New Ventures, New Perspectives, and Their Failures

1 Connely, *Louis Sullivan, as He Lived*, p. 203.

2 Montgomery Schuyler, *American Architecture and Other Writings*, ed. William H. Jordy and Ralph Coe, 2 vols. (Cambridge: Harvard University Press, 1961), II, 385; for Root, see Thomas E. Tallmadge, *Architecture in Old Chicago* (Chicago: University of Chicago Press, 1941), pp. 159–60; for Burnham's opinion, see Wright, *An Autobriography*, p. 126. Projecting his image as an architectural planner, builder, and structural designer became a preoccupation of Sullivan's. See, for instance, the following of his articles: "The High Building Question," *Graphic* 5 (1891): 405; "Opinions on the Use of Burned Clay for Fireproofing," *Brickbuilder* 7 (September 1898): 189–90; "Sub-Structure at the New Schlesinger and Mayer Store Building," *Engineering Record* 47 (1903): 194–96; and "Basements and Sub-Basements," *Economist* (Chicago) 31 (1904): 254.

3 Connely, *Louis Sullivan*, pp. 212–13; for Margaret Sullivan's character, see pp. 237–38.

4 Sullivan, *The Autobiography of an Idea*, pp. 296–98; this quotation, p. 297, emphasis added.

5 Wright, *Genius and the Mobocracy*, p. 87.

6 Related to and published by Bernard C. Greengard, in "Sullivan/Presto/The Krause Music Store," *Prairie School Review* 6 (Third Quarter 1969): 8.

7 Burnham's diary, as quoted by Thomas S. Hines, *Burnham of Chicago, Architect and Planner* (New York: Oxford University Press, 1974), p. 232.

8 For the relation of Jensen and Sullivan, see Leonard K. Eaton, *Landscape Architect in America: The Life and Work of Jens Jensen* (Chicago and London: University of Chicago Press, 1964), pp. 109–10. Concerning Sullivan's mistress, see Wright, *Genius and the Mobocracy*, p. 88; and Connely, *Louis Sullivan*, pp. 245, 267.

9 Emerson's description of the artist in "Thoughts on Art" (1841), as quoted in Don Gifford, ed., *The Literature of Architecture* (New York: Dutton, 1966), pp. 104–5.

10 William Gray Purcell's "Parabiography" ("Work of the 7th Year—1913"), Northwest Architectural Archives, University of Minnesota.

11 This is not to imply that there are no Prairie houses with elongated plans, but even in these the dynamic effect of the plan, considered as an abstract design, is evident. See, for example, Marion Mahony Griffin's project for the Henry Ford House of c. 1912 and Walter Burley Griffin's Holahan House of the same year. These are illustrated in Brooks, *Prairie School*, pp. 162, 248.

12 Sullivan himself declared his use of Beaux-Arts methods of design. See Claude Bragdon, "Letters from Louis Sullivan," *Architecture* 64 (July 1931): 7–10. Sullivan's endorsement was corroborated by Elmslie's letter to Wright of June 12, 1936, *JSAH* 20 (October 1961): 140–41.

13 I am indebted to Mr. George Talbot, Curator of Iconography of the State Historical Society of Wisconsin, for pointing out to me the existence of this project. It consists of eight blueprint reproductions—four plans and four elevations. They are among the papers of the McCormick Collection. Mr. Goodrich, a successful Chicago businessman, was president and chairman of the Goodrich Transportation Company. As the McCormick papers in Madison reveal, the Goodriches and the McCormicks were close friends, and it was probably through the latter (for whom Sullivan had done a number of projects) that the Goodriches heard of Sullivan. See M. R. Hafstad, ed., *Guide to the McCormick Collection of The State Historical Society of Wisconsin* (Madison: State Historical Society of Wisconsin, 1973), p. 14.

14 Mariana G. Van Rensselaer, *Henry Hobson Richardson and His Works* (New York: Houghton, Mifflin and Company, 1888), p. 79. Listed in the *Auction Catalogue of the Household Effects.*

15 Brooks, *Prairie School*, p. 57.

16 Again, I am grateful to Mr. Talbot for allowing me the use of the McCormick plans.

17 That architects of the period were concerned with these problems of comfort is evident not only in the houses they designed but also in the articles they wrote on the planning of suburban houses. For an excellent example of such articles, see Bruce Price, "The Suburban House," *Scribner's Magazine* 8 (July 1890): 3–19, especially p. 8, where he explains how to achieve privacy in a dwelling without sacrificing the openness of plan desirable in a resort house.

18 *JSAH* 20 (October 1961): 140–41.

19 See appendix C.

20 The house was considerably damaged by fire on March 17, 1972. Restored by Mark Purcell, AIA, it was re-inaugurated on September 30, 1973. See Wisconsin Chapter of the Sigma Phi Society, *Trial by Fire* (Madison, n.d.)

21 *Prairie School*, p. 146; and Wright, "A Home in a Prairie Town," *Ladies' Home Journal* 18 (February 1901): 17. For the participation of Claude and Starck, the Madison architects, in the design and construction of the Bradley

House, see Gordon Orr, "The Collaboration of Claude and Starck with Chicago Architectural Firms," *Prairie School Review* 12 (Fourth Quarter 1975): 5–8.

22 Sprague, "The Architectural Ornament of Louis Sullivan and His Chief Draftsmen," p. 433. For the friendship between Bennett and Sullivan, as well as other matters pertaining to Sullivan's life during the twentieth century, see the following three articles by Robert R. Warn: "Two House Projects for the Carl K. Bennett Family by Louis Sullivan and Purcell and Elmslie," *Northwest Architect* 36 (March–April 1972): 64–72; "Bennett and Sullivan, Client and Creator," *Prairie School Review* 10 (Third Quarter 1973): 5–15; and "Louis H. Sullivan, '. . . an air of finality,'" ibid. (Fourth Quarter 1973): 5–19.

23 *Prairie School*, p. 228.

24 The Bennetts, however, rejected Purcell and Elmslie's design; ibid., p. 230. When the Babsons wanted to enlarge their house with a serving wing in 1915, they also called upon Purcell and Elmslie rather than Sullivan. See ibid., pp. 303–4.

25 The Burnham Library of the Art Institute of Chicago holds a four-page letter addressed to that institution by W. G. Nichols, owner of the Ocean Springs cottage after Sullivan, listing those books of Sullivan's that Mr. Nichols had found on the estate. An entry reads "Plays of Maurice Maeterlinck —Hovey." This refers to *The Plays of Maurice Maeterlinck*, trans. Richard Hovey, 2 vols. (New York: Duffield, 1906). Hovey's introduction is in I, 3–11; II, ix–xv, carries an introduction by Maeterlinck, in French, in which the author explains his esthetic purposes.

26 Quoted by Robert R. Warn, "Bennett and Sullivan, Client and Creator," *Prairie School Review* 10 (Third Quarter 1973): 7.

27 Ibid., p. 6.

28 Warn, "Louis H. Sullivan, '. . . an air of finality,'" *Prairie School Review* 10 (Fourth Quarter 1973): 6.

29 Carl K. Bennett, "A Bank Built for Farmers: Louis Sullivan Designs a Building Which Marks a New Epoch in American Architecture," *Craftsman* 15 (November 1908).

30 Sullivan, "Artistic Brick," *Prairie School Review* 4 (Second Quarter 1967): 26.

31 Bennett, "A Bank Built for Farmers," p. 184.

32 Sullivan, "Lighting the People's Savings Bank, Cedar Rapids, Iowa," *Illuminating Engineer* 6 (February 1912): 632.

33 Montgomery Schuyler, "The People's Savings Bank of Cedar Rapids, Iowa," *Architectural Record* 31 (January 1912): 44–56.

34 Connely, *Louis Sullivan*, p. 269.

35 The glass front of an addition to the bank has changed the relationship of Sullivan's facade to the rest of the block.

36 See Greengard, "Sullivan/Presto/The Krause Music Store," pp. 5–10.

37 Morrison, *Louis Sullivan*, p. 224.

5 A Concept of Design

1 Sullivan, *Kindergarten Chats*, p. 23.
2 Ibid.
3 Wright, *Genius and the Mobocracy*, p. 70.
4 Herbert Spencer, *First Principles of a New System of Philosophy*, 2d ed. (New York: Appleton, 1872), chap. 24.
5 *Saturday Review of Literature* 13 (December 4, 1935): 6.
6 William H. Jordy, *American Building and Their Architects*, vol. 3, *Progressive and Academic Ideals at the Turn of the Twentieth Century* (Garden City: Doubleday, 1972) pp. 148–50.
7 For Sullivan's endorsement of Wright's architecture, see his "Concerning the Imperial Hotel, Tokyo, Japan," *Architectural Record* 53 (April 1923): 333–52; and "Reflections of the Tokyo Disaster," ibid. 55 (February 1924): 113–17. For Saarinen and the Chicago Tribune Building, see Sullivan, "The Chicago Tribune Competition," *Architectural Record* 53 (February 1923): 151–57.
8 Erich Mendelsohn, *Amerika, Bilderbuch eines Architekten* (Berlin: Mosse, 1928), p. 178; my translation.
9 I am grateful to Mr. Allan McNab, who at that time was the director of the Art Institute of Chicago, for this information.
10 Sherman Paul has recently restated his views on Sullivan by publishing together and commenting upon a number of his *Nation* reviews of books about Sullivan, Wright, the Chicago School, and other architectural subjects. See Sherman Paul, "Louis Sullivan and Organic Architecture," in *Repossessing and Renewing: Essays in the Green American Tradition* (Baton Rouge: Louisiana State University Press, 1976), pp. 111–36.

BIBLIOGRAPHY

WORKS BY LOUIS H. SULLIVAN

Published Collections

Bragdon, Claude. "Letters from Louis Sullivan." *Architecture* 64 (July 1931): 7–10.

McCoy, Esther, editor. "Letters from Louis H. Sullivan to R. M. Schindler." *Journal of the Society of Architectural Historians* 20 (December 1961): 179–84.

Sprague, Paul E. *The Drawings of Louis Henry Sullivan: A Catalogue of the Frank Lloyd Wright Collection at the Avery Architectural Library.* Princeton: Princeton University Press, 1978.

Sullivan, Louis H. *Kindergarten Chats and Other Writings.* Edited by Isabella Athey. 1947. Reprint. New York: Wittenborn, 1968. Hereafter referred to as *Chats*, ed. Athey.

Sullivan, Louis H. *The Testament of Stone: Themes of Idealism and Indignation from the Writings of Louis Sullivan.* Edited by Maurice English. Evanston: Northwestern University Press, 1963.

"Sullivan's Letters at Columbia." *American Architect and Architecture* 149 (November 1936): 100–101.

Chronological List

"Lotos Club Notebook." Student notebook of Louis Sullivan, with entries and drawings by him, John Edelmann, and others. 1872–82. New York. Avery Library.

"Characteristics and Tendencies of American Architecture." *Inland Architect* 6 (November 1885): 58–59; *Chats*, ed. Athey.

"Essay on Inspiration." *Inland Architect* 8 (December 1886): 61–64; Chicago: Inland Architect Press, 1886. Reprinted as *Inspiration: An Essay by Louis H. Sullivan, Architect.* Chicago: Ralph Fletcher Seymour, 1964.

"What Are the Present Tendencies of Architectural Design in America?" *Inland Architect* 9 (March 1887): 23–26.

"What Is the Just Subordination, in Architectural Design, of Details to Mass?" *Inland Architect* 9 (April 1887): 51–54; *Building Budget* 3 (April 1887): 62–63; *Chats*, ed. Athey.

"The Decoration of McVicker's Theater, Chicago." *American Architect and Building News* 23 (11 February 1888): 70–71.

"Style." *Inland Architect* 11 (May 1888): 59–60.

"The Artistic Use of Imagination." *Inland Architect* 14 (October 1889): 38–39.

"Ornamentation of the Auditorium." In vol. 2 of *Industrial Chicago*. 6 vols. Chicago: Goodspeed Publishing Company, 1891.

"The High Building Question." *Graphic* 5 (19 December 1891): 405. Reprinted in Donald Hoffman, "The Setback Skyscraper City of 1891: An Unknown Essay by Louis H. Sullivan." *Journal of the Society of Architectural Historians* 29 (May 1970): 186–87. Abridged in Alison Sky and Michelle Stone, *Unbuilt America: Forgotten Architecture in the United States from Thomas Jefferson to the Space Age.* New York: McGraw-Hill, 1976.

"Ornament in Architecture." *Engineering Magazine* 3 (August 1892): 633–44. *Chats*, ed. Athey.

Letter to Daniel Burnham, 11 November 1893. Chicago. Burnham Library.

"Emotional Architecture as Compared with Intellectual: A Study in Objective and Subjective." *Inland Architect* 24 (November 1894): 32–34. *Chats*, ed. Athey.

"The Tall Office Building Artistically Considered." *Lippincott's Magazine* 57 (March 1896): 403–9. *Inland Architect* 27 (May 1896): 32–34. *Chats*, ed. Athey.

"May Not Architecture Again Become a Living Art?" C. 1897. Unpublished. Chicago. Burnham Library.

"Opinions on the Use of Burned Clay for Fireproofing." *Brickbuilder* 7 (September 1898): 189–90.

The Bayard Building [Real Estate Brochure]. New York: Rost Printing and Publishing Company, n.d. [1898 or 1899]. New York. Avery Library.

"An Unaffected School of Modern Architecture—Will It Come?" *Artist* 24 (January 1899): xxxiii–iv.

"The Modern Phase of Architecture." *Inland Architect* 33 (June 1899): 40.

"Reply to the Proposed Slogan of the Architectural League of America, 'Progress before Precedent.'" *Brickbuilder* 9 (May 1900): 96.

"Reply to 'Indigenous and Inventive Architecture for America,' by Elmer Grey." *Inland Architect* 35 (June 1900): 42–43.

"The Young Man in Architecture." *Inland Architect* 35 (June 1900): 38–40. *Brickbuilder* 9 (June 1900): 115–19. *Chats*, ed. Athey.

"Reality in Architectural Art." *Interstate Architect* 2 (August 1900): 6–7. Reprinted in part in *Inland Architect* 36 (September 1900): 116.

"Open Letter." *Interstate Architect* 2 (8 December 1900): 7–9.

Kindergarten Chats. First published in installments in *Interstate Architect* 2 (16 February 1901) to 3 (8 February 1902). Revised by Sullivan in 1918. Published in book form and edited by Claude F. Bragdon. Lawrence: Scarab Fraternity Press, 1934. *Chats*, ed. Athey.

Telegram to the Third Annual Meeting of the Architectural League of America. *Brickbuilder* 10 (June 1901): 112.

"Architectural Style." *Inland Architect* 38 (September 1901): 16.

"Education." *Inland Architect* 39 (June 1902): 41–42. *Brickbuilder* 11 (June 1902): 114–16. *Chats*, ed. Athey.

"Sub-Structure at the New Schlesinger and Mayer Store Building." *Engineering Record* 47 (21 February 1903): 194–96.

"Basements and Sub-Basements." *Economist* (Chicago) 31 (20 February 1904): 254.

One project of a book of poetry entitled "Nature and the Poet." Unpublished. It consists of four parts: "Nature and the Poet, A Prose Song" (1888–89); "Inspiration" (1886); "Sympathy—A Romanza" (1904?); and "The Master" (1 July 1899). Chicago. Burnham Library.

"Natural Thinking: A Study in Democracy" (13 February 1905). Chicago. Burnham Library. Reprinted in part in *The Testament of Stone*, ed. English.

"Reply to Mr. Frederick Stymetz Lamb on 'Modern Use of the Gothic: The Possibility of New Architectural Style.'" *Craftsman* 8 (June 1905): 336–38.

"The Architectural Discussion: Form and Function Artistically Considered." *Craftsman* 8 (July 1905): 453–58.

"What is Architecture: A Study in the American People of Today." *American Contractor* 27 (January 1906): 48–54. *Craftsman* 10 (May 1906): 145–49. *Northwest Architect* 8 (October–November 1940): 13–20. *Chats*, ed. Athey.

Democracy: A Man-Search. Finished, 1 July 1907; revised, 18 April 1908. Microcard edition edited by Walter L. Creese with an introduction by Hugh Morrison. Louisville: Free Public Library of Louisville, 1949. Published in book form and edited with an Introduction by Elaine Hedges. Detroit: Wayne State University Press, 1961.

"Louis H. Sullivan Emphatically Supports the Viewpoint of Gutzon Borglum toward American Art." *Craftsman* 15 (December 1908): 338.

"Is Our Art a Betrayal Rather Than an Expression of American Life?" *Craftsman* 15 (January 1909): 402–4.

Suggestions in Artistic Brick. St. Louis: Hydraulic-Press Brick Company, c. 1910. Reprinted in *Prairie School Review* 4 (Second Quarter 1967): 24–26.

"Lighting the Peoples Savings Bank, Cedar Rapids, Iowa." *Illuminating Engineer* 6 (February 1912): 631–35.

"Client-Architect Co-Operation." *Western Architect* 22 (August 1915): 14.

"Development of Construction." *Economist* (Chicago) 55 (24 June 1916): 1252; 56 (1 July 1916): 39–40.

The Autobiography of an Idea. Published in installments in the *Journal of the American Institute of Architects* 10 (June 1922) to 11 (September 1923). Published in book form. New York: American Institute of Architects, 1924. New York: Norton, 1934. New York: Peter Smith, 1949. New York: Dover, 1956.

"The Chicago Tribune Competition." *Architectural Record* 53 (February 1923): 151–57.

"Concerning the Imperial Hotel, Tokyo, Japan." *Architectural Record* 53 (April 1923): 333–52.

"Reflections of the Tokyo Disaster." *Architectural Record* 55 (February 1924): 113–17.
A System of Architectural Ornament According with a Philosophy of Man's Powers. New York: American Institute of Architects, 1924. Park Forest: Prairie School Press, 1962. New York: The Eakins Press, 1967.

WORKS BY DANKMAR ADLER

Chronological List

"Bearing Chicago Soil." *Inland Architect* 2 (February 1886): 15–16.
"What Are the Present Tendencies of Architectural Design in America?" *Inland Architect* 9 (March 1887): 23–26.
"Theaters." *American Architect and Building News* 22 (October 1887): 206 ff.
"Foundations of the Auditorium Building." *Inland Architect* 2 (March 1888): 31–32.
"Stage Mechanisms." *Building Budget* 15 (February 1889): 21.
"An Address in Favor of the Columbian Exposition of 1893." *Inland Architect* 17 (February 1891): 6.
"The Auditorium Tower." *American Architect and Building News* 32 (April 1891): 15–16.
Letter to the Editor on "The First Elevators" of 4 May 1891. *Economist* (Chicago) 5 (May 1891): 798.
"Make the High Building Safe." *Economist* (Chicago) 5 (May 1891): 951.
"On the Inspection of Buildings." *Economist* (Chicago) 5 (May 1891): 946–47.
"Foundations." *Economist* (Chicago) 5 (June 1891): 1137.
"Lofty Buildings Again." *Economist* (Chicago) 5 (June 1891): 1038–39.
"Engineering Supervision of Building Operations." *American Architect and Building News* 32 (July 1891): 11–12.
"Pile Foundations." *Economist* (Chicago) 6 (July 1891): 112.
"High Buildings and Their Foundations, Chicago." *American Architect and Building News* 34 (October 1891): 54–55.
"Deliberation of Architects." *Economist* (Chicago) 6 (November 1891): 857–58.
"The Tall Buildings." *Economist* (Chicago) 6 (November 1891): 820.
"The Rights of the Lowest Bidder." *Inland Architect* 19 (January 1892): 77–78.
"Proposed Technological School from the Standpoint of the Architect." *Inland Architect* 19 (April 1892): 36–37.
"The Chicago Auditorium." *Architectural Record* 1 (April–June 1892): 415–34.
"Some Notes on the Earlier Chicago Architects." *Inland Architect* 19 (May 1892): 47–48.
"The Tall Office Building—Past and Future." *Engineering Magazine* 3 (September 1892): 765–73.
"Light in Tall Office Buildings." *Engineering Magazine* 4 (November 1892): 171–86.
"Pilings for Isolated Spread Footings Adjacent to Walls—A Discussion." *Inland Architect* 20 (January 1893): 63.

"Are There Any Set Canons of Art?" *Minutes of the Thirteenth Meeting of the Sunset Club*, December 7, 1893.

"Theater Buildings for American Cities." *Engineering Magazine* 7 (August 1894): 717–30; (September 1894): 815–29.

"Municipal Building Laws." *Inland Architect* 25 (May 1895): 30–38.

Letter Announcing His Resignation from the Profession. *Inland Architect* 25 (May 1895): 61.

"Convention Halls." *Inland Architect* 26 (September 1895): 13–14; (October 1895): 22–23.

"Slow Burning and Fireproof Construction." *Inland Architect* 26 (December 1895): 60–62; 27 (February 1896): 3–4.

"Architects and Trade Unions." *Inland Architect* 27 (May 1896): 32.

"Influence of Plate Glass and Steel on the Development of Modern Style." *Inland Architect* 28 (November 1896): 34–37.

"The Stimulus of Competition." *Engineering Magazine* 12 (January 1897): 643.

"Open Letter to Chicago Mason Builders." *Inland Architect* 29 (February 1897): 2–3.

"The Tall Business Building." *Cassier's Magazine* 12 (November 1897): 193–210.

"The Tarsney Act and the American Institute of Architects." *Inland Architect* 30 (November 1897): 36.

"The Architect's Duty Regarding the Enforcement of the Tarsney Law." *Inland Architect* 30 (December 1897): 46–47.

"The General Contractor." *Inland Architect* 32 (June 1899): 39.

"The Theater." Edited by Rachel Baron. *Prairie School Review* 2 (Second Quarter 1965): 21–27.

"Autobiography." Unpublished. Chicago. Newberry Library.

Thirty-one unpublished miscellaneous letters. Chicago. Newberry Library. Midwest Manuscripts Collection.

WORKS AND DOCUMENTS ABOUT SULLIVAN AND ADLER
(in alphabetical order by author)

Adler nominated for president of the AIA on October 21, 1885 in Nashville, Tennessee. *Inland Architect* 6 (October 1885): 43.

Adler serves as chairman of the committee drafting the legislation regulating Chicago contruction. *Inland Architect* 6 (November 1885): 73.

Adler suggests regulations to govern the architectural profession in Chicago. *Inland Architect* 6 (November 1885): 83.

Andreas, A. T. "Dankmar Adler." *History of Chicago*, 3 vols. Chicago: A. T. Andreas, 1884. II, 566.

Andreas, A. T. "Louis H. Sullivan." *History of Chicago*, 3 vols. Chicago: A. T. Andreas, 1884. II, 566.

Barker, A. W. "Louis H. Sullivan, Thinker and Architect." *Architectural Annual* 2 (1901): 49–66.

Baron, Rachel. "Forgotten Facets of Dankmar Adler." *Inland Architect* (April 1964): 14–26.

Bragdon, Claude. "An American Architect, Being an Appreciation of Louis H. Sullivan." *House and Garden* 7 (January 1905): 47–55.

Bragdon, Claude. "Louis H. Sullivan." *Journal of the American Institute of Architects* 12 (May 1924): 241.

Bragdon, Claude. *Merely Players*. New York: Knopf, 1929.

Bragdon, Claude. "The Whitman of American Architecture." *New York Herald-Tribune Books* 12 (22 December 1935): 4.

Bush-Brown, Albert. *Louis Sullivan*. New York: Braziller, 1960.

Caffin, Charles. "Louis H. Sullivan, Artist among Artists, American among Americans." *Criterion* 20 (28 January 1899): 20. *Architectural Annual* 2 (1901): 67–68.

Caldwell, Alfred. "Louis Sullivan." *Dimension* 2 (Spring 1956): 8–15.

Chamberlain, Betty. "Louis Sullivan." *Arts and Architecture* 73 (December 1956): 12–15.

Connely, Willard. "The Last Years of Louis Sullivan." *Journal of the American Institute of Architects* 23 (January 1955): 32–38.

Connely, Willard. "Later Years of Louis Sullivan." *Journal of the American Institute of Architects* 21 (May 1954): 223–28.

Connely, Willard. "Louis Sullivan and His Younger Staff." *Journal of the American Institute of Architects* 22 (December 1954): 266–68.

Connely, Willard. "Louis Sullivan in 1917–18." *Journal of the American Institute of Architects* 22 (October 1954): 172–76.

Connely, Willard. *Louis Sullivan as He Lived: The Shaping of American Architecture*. New York: Horizon, 1960.

Connely, Willard. "The Mystery of Louis Sullivan and His Brother." *Journal of the American Institute of Architects* 20 (November 1953): 226–29; (December 1953): 292–96.

Connely, Willard. "New Chapters in the Life of Louis Sullivan." *Journal of the American Institute of Architects* 20 (September 1953): 107–14.

Connely, Willard. "New Sullivan Letters." *Journal of the American Institute of Architects* 20 (July 1953): 9–13.

"Drawings by Louis Sullivan; From the Frank Lloyd Wright Collection, Avery Library, Columbia University." *Architectural Record* 139 (March 1966): 147–54.

Duncan, Hugh D. "Attualità di Louis Sullivan." *Casabella* 104 (February–March 1955): 7–32.

Eaton, Leonard K. "Louis Sullivan and Hendrik Berlage." *Progressive Architecture* 37 (November 1956): 138–41.

Edelmann, John. "The Pessimism of Modern Architecture." *Engineering Magazine* 3 (April 1892): 44–54.

Elmslie, George G. "Sullivan Ornamentation." *Journal of the American Institute of Architects* 6 (October 1946): 155–58.

Elstein, Rochelle S. "The Architecture of Dankmar Adler." *Journal of the Society of Architectural Historians* 26 (December 1967): 242–49.

Engel, Charlene S. "Dankmar Adler, Architect: Life, Theory and Practice." Master's thesis, University of Wisconsin–Madison, 1974.

Fields, Ronald M. "Four Concepts of an Organic Principle: Horatio Greenough, Henry David Thoreau, Walt Whitman, and Louis Sullivan." Ph.D. diss., Ohio University, 1968.

Fisker, Kay. "Louis Henry Sullivan." *Forum* (Amsterdam) 3 (1948): 347–55.

Fox, John A. "American Dramatic Theaters in Several Parts." *American Architect and Building News* 6 (1879), 20, 27, 35, 42, 59, 68, 74.

"France Honors Louis Sullivan." *Inland Architect* 25 (March 1895): 20–21.

"Frank Lloyd Wright on Louis Sullivan." *Architectural Forum* 91' (August 1949): 94–97.

Gebhard, David. "Review of *Democracy: A Man-Search*, by Louis Sullivan; *A System of Architectural Ornament*, by Louis Sullivan; *Louis Sullivan*, by Albert Bush-Brown". *Journal of the Society of Architectural Historians* 21 (December 1962): 194–95.

Graña, César. "Is There a Democratic Architecture?" In *Fact and Symbol: Essays in the Sociology of Art and Literature*. New York: Oxford University Press, 1971.

Gregerson, Charles E. "Early Adler and Sullivan Work in Kalamazoo." *Prairie School Review* 11 (Third Quarter 1974): 5–15.

Hindman, Kealy. "The Education Philosophy of Louis Sullivan." Master's thesis, Illinois Institute of Technology, 1957.

Hitchcock, Henry-Russell. "Sullivan and the Skyscraper." *Journal of the Royal Institute of British Architects* 60 (July 1953): 353–61. *Builder* 185 (7 August 1953): 197–200.

Hoffmann, Donald. "The Set-Back Skyscraper of 1891: An Unknown Essay by Louis Sullivan." *Journal of the Society of Architectural Historians* 29 (May 1970): 181–86.

Hope, Henry R. "Louis Sullivan's Architectural Ornament." *Magazine of Art* 40 (March 1947): 111–17. *Architectural Review* (London) 102 (October 1947): 111–14.

Jeanneret-Gris, Charles-Edouard. "Letter from Le Corbusier to Mayor Daley of Chicago." *Progressive Architecture* 42 (June 1961): 208.

Johnson, Philip. "Is Sullivan the Father of Functionalism?" *Art News* 55 (December 1956): 44–46.

Kaufman, Mervyn. *Father of Skyscrapers: A Biography of Louis Sullivan.* Boston and Toronto: Little, Brown and Company, 1969.

Kaufmann, Edgar, editor. *Louis Sullivan and the Architecture of Free Enterprise.* Chicago: Art Institute of Chicago, 1956.

Kennedy, Robert W. "Form and Function, and Expression: Variations on a Theme by Louis Sullivan." Journal of the American Institute of Architects 14 (November 1950): 198–204.

Kimball, Fiske. "Louis Sullivan, An Old Master." *Architectural Record* 57 (April 1925): 289–304.

Kramer, Ethel. "The Ornament of Louis Sullivan." Honors paper, Department of Art, Smith College, 1960.

Line, Ralph M. "Art and Architecture—The Past: Louis H. Sullivan." *Craft Horizons* 22 (May–June 1962): 18–21.

"Louis Sullivan." *American Society Legion of Honor Magazine* 23 (Summer 1952): 153–70.

"Louis Sullivan Honored Again." *Architectural Record* 120 (October 1956): 217–20.

McAndrew, John. "Who Was Louis Sullivan?" *Arts* 31 (November 1956): 23–27.

McLean, Robert C. "Dankmar Adler." *Inland Architect* 35 (May 1900): 26–27.

McLean, Robert C. "Louis Henry Sullivan, Sept. 3, 1856–April 14, 1924: An Appreciation." *Western Architect* 33 (May 1924): 53–55.

McQuade, Walter. "Sullivan Survives." A Review of John Szarkowski, *The Idea of Louis Sullivan. Architectural Forum* 105 (October 1956): 156–61.

Maginnis, Charles D., and William W. Wurster. "Honoring Louis Sullivan." *Journal of the American Institute of Architects* 6 (November 1946): 208–13.

Mansheim, Gerald. "Louis Sullivan in Iowa." *Palimpsest* 61 (March–April 1980): 56–64.

Manson, Grant C. "Sullivan and Wright, An Uneasy Union of Celts." *Architectural Review* (London) 118 (November 1955): 297–300.

Menocal, Narciso G. "Louis Sullivan: His Theory, Mature Development, and Theme." Ph.D. diss., University of Illinois–Urbana-Champaign, 1974.

Menocal, Narciso G. "Sullivan's Architecture and the Aesthetics of Democracy." *Journal of the Society of Architectural Historians* 21 (October 1972): 235.

Minutes of meeting for the formation of the State Association of Architects of Illinois (Adler is quoted several times). *Inland Architect* 5 (February 1885): 5–7.

Morrison, Hugh. Letter, *Saturday Review of Literature* 12 (8 February 1936): 9.

Morrison, Hugh. *Louis Sullivan, Prophet of Modern Architecture.* 1935. Reprint. New York: Norton, 1962.

Morrison, Hugh. "Louis Sullivan Today." *Journal of the American Institute of Architects* 26 (September 1956): 98–100.

Morrison, Hugh. Review of *Genius and the Mobocracy*, by Frank Lloyd Wright. *Magazine of Art* 44 (April 1951): 154–55.

Mostoller, Michael. "Louis Sullivan's Ornament." *Art Forum* 16 (October 1977): 44–49.

"Nature as an Ornamentalist." *Architectural Record* 9 (April 1900): 441–49.

Nickel, Richard. "A Photographic Documentation of the Architecture of Adler and Sullivan." Masters thesis, Illinois Institute of Technology, 1957.

Notice by the editors of the *Inland Architect* that Adler had resigned from the profession. *Inland Architect* 25 (July 1895): 57.

Owen, Allison. "Remembering Louis Sullivan." *Journal of the American Institute of Architects* 6 (August 1946): 90.

Paul, Sherman. *Louis Sullivan, An Architect in American Thought.* Englewood Cliffs: Prentice-Hall, 1962.

Paul, Sherman. "Louis Sullivan and Organic Architecture." In *Repossessing and Renewing: Essays in the Green American Tradition.* Baton Rouge: Louisiana State University Press, 1976.

Peisch, Mark L. Letter of George Grant Elmslie to Frank Lloyd Wright, 12 June

1936. "Letters to the Editor," *Journal of the Society of Architectural Historians* 20 (October 1961): 140–41.

Pellegrin, Luigi. "Eredità dell'ottocento: storicità di Louis H. Sullivan." *L'Architettura, cronache e storia* 1 (March–April 1956): 856–865.

Pettengill, George E. "The Biography of a Book: Correspondence between Sullivan and *The Journal.*" *AIA Journal* 63 (June 1975): 42–45.

Pettengill, George E. "'A System of Architectural Ornament . . .': Further Sullivan-*Journal* Correspondence." *AIA Journal* 64 (September 1975): 28–30.

Pond, Irving K. "Louis Sullivan's *The Autobiography of an Idea:* A Review and an Estimate." *Western Architect* 33 (June 1924): 67–69.

Purcell, William G. "Adult Kindergarten." *Architectural Forum* 66 (June 1937): 50.

Purcell, William G. "Louis H. Sullivan, Prophet of Democracy." *Journal of the American Institute of Architects* 16 (December 1951): 265–68.

Purcell, William G. "Sullivan at Work." *Northwest Architect* 8 (January–February 1944): 11.

Purcell, William G. "Sullivan's 'What is Architecture': An Interpretation." *Northwest Architect* 8 (July 1944): 4–19.

Randall, John D. *The Art of Office Buildings: Sullivan's Wainwright and the St. Louis Real Estate Boom.* Springfield, Illinois: privately printed, 1972.

Rebori, Arthur N. "Louis H. Sullivan." *Architectural Record* 55 (June 1924): 586–87.

Report on Sullivan's reading the "Essay on Inspiration." *American Architect and Building News* 20 (27 November 1886): 253–54.

Rice, Wallace. "Louis Sullivan as Author." *Western Architect* 33 (June 1924): 70–71.

Root, John W. "Architects of Chicago." *America* 5 (11 December 1890): 304–6. *Inland Architect* 16 (January 1891): 91–92.

Roth, Alfred. "Wörte und Bauten der Pioriere." *Werk* 39 (December 1952): 389–401.

Salerno, Joseph. "Louis Sullivan—Return to Principle." *Liturgical Arts* 16 (February 1948): 49–50.

Saltzstein, Joan. "Dankmar Adler and the Chicago Fire." *Inland Architect* (October 1967): 8.

Saltzstein, Joan. "Dankmar Adler: The Man, The Architect, The Author." *Wisconsin Architect* 38 (July–August 1967): 15–19; (September 1967): 10–14; (November 1967): 16–19.

Scully, Vincent J. "Louis Sullivan's Architectural Ornament: A Brief Note concerning Humanist Design in the Age of Force." *Perspecta* 5 (1959): 73–80.

Severens, Kenneth W. "The Reunion of Louis Sullivan and Frank Lloyd Wright." *Prairie School Review* 12 (Third Quarter 1975): 5–21.

Shulof, Suzanne. "An Interpretation of Louis Sullivan's Architectural Ornament Based on Its Philosophy of Organic Expression." Masters thesis, Columbia University, 1962.

Slade, Thomas M. "A Collated Edition of Louis H. Sullivan's *Kindergarten Chats.*" Masters thesis, State University of New York at Buffalo, 1971.

Sprague, Paul E. "The Architectural Ornament of Louis Sullivan and His Chief Draftsmen." Ph.D. diss., Princeton University, 1969.

Sprague, Paul E. "The European Sources of Louis Sullivan's Ornamental Style." *Journal of the Society of Architectural Historians* 23 (May 1974): 167.

Starret, Theodore. "The Architecture of Louis H. Sullivan." *Architects' and Builders' Magazine* 44 (December 1912): 469–75.

Stavenov, Elisabet. "Louis Sullivan." *Arkitektur* (Sweden) 61 (August 1961): 149–52.

"Sullivan Seen by His Contemporaries in His Centennial Year: Another Look." *Architectural Record* 120 (September 1956): 18 + .

Szarkowski, John. *The Idea of Louis Sullivan.* Minneapolis: University of Minnesota Press, 1956.

Tallmadge, Thomas. "Louis Sullivan." In *Dictionary of American Biography*, edited by D. Malone. New York: Scribner's, 1936.

"To Louis Henri Sullivan: The Gold Medal of the American Institute of Architects." *Journal of the American Institute of Architects* 6 (July 1946): 3–5.

Turak, Theodore. "French and English Sources of Sullivan's Ornament and Doctrines." *Prairie School Review* 11 (Fourth Quarter 1974): 5–30.

Van Ormer, Geraldine. "Louis Sullivan's Ornamentation as Exemplified in the Carson, Pirie, Scott Building." Masters thesis, Pennsylvania State University, 1960.

Vaughn, Edward J. "Sullivan and Elmslie at Michigan." *Prairie School Review* 6 (Second Quarter 1969): 20–23.

Vaughn, Edward J. "Sullivan and The University of Michigan." *Prairie School Review* 6 (First Quarter 1969): 21–23.

Weisman, Winston S. "Philadelphia Functionalism and Sullivan." *Journal of the Society of Architectural Historians* 20 (March 1961): 3–19.

Williams, Barker and Severn Company. *Auction Catalogue of the Household Effects, Library, Oriental Rugs, Paintings, etc. of Mr. Louis Sullivan, the Well-Known Chicago Architect, November 29, 1909.* Chicago: Williams, Barker and Severn Company, 1909. Chicago. Burnham Library.

Woltersdorf, Arthur. "A Portrait of Chicago Architects. II: Dankmar Adler." *Western Architect* 37 (July 1924): 75–79.

Wright, Frank Lloyd. *Genius and the Mobocracy.* 1949. Reprint. New York: Horizon, 1971.

Wright, Frank Lloyd. "Louis H. Sullivan—His Work." *Architectural Record* 56 (July 1924): 28–32.

Wright, Frank Lloyd. "Louis Sullivan, Beloved Master." *Western Architect* 33 (June 1924): 64–66.

Wright, Frank Lloyd. "Review of Hugh Morrison, *Louis Sullivan, Prophet of Modern Architecture.*" *Saturday Review of Literature* 12 (4 December 1935): 6. *Journal of the Society of Architectural Historians* 20 (October 1961): 141–42.

Wright, Frank Lloyd. "Sullivan Against the World." *Architectural Record* 105 (June 1949): 295–98.

DESCRIPTIONS OF BUILDINGS BY ADLER AND SULLIVAN AND BY LOUIS H. SULLIVAN
(in alphabetical order by building location)

ALGONA, IOWA: Algona Land and Loan Office:
Rebori, Andrew N. "An Architecture of Democracy: Three Recent Examples from the Work of Louis Sullivan." *Architectural Record* 39 (May 1916): 436–65.

BUFFALO, NEW YORK: Guaranty Building:
American Architect and Building News 53 (11 July 1896), pl. 1072. Rental Pamphlet. Buffalo, 1896. Chicago. Burnham Library.

CEDAR RAPIDS, IOWA: People's Savings Bank:
Schuyler, Montgomery. "The People's Savings Bank of Cedar Rapids, Iowa." *Architectural Record* 31 (January 1912): 44–56.
Sullivan, Louis H. "Lighting and Peoples Savings Bank of Cedar Rapids, Iowa." *Illuminating Engineer* 6 (February 1912): 631–35.

CEDAR RAPIDS, IOWA: St. Paul's Methodist-Episcopal Church:
"A Unique Church Building." *American Contractor* 32 (4 November 1911): 92–93.
St. Paul's Church: Descriptive Pamphlet. Cedar Rapids, May 31, 1914. Chicago. Burnham Library.
"St. Paul's Methodist-Episcopal Church." *Western Architect* 20 (August 1914): 85–88.

CHICAGO, ILLINOIS: Auditorium Building:
Adler, Dankmar. "The Auditorium Tower." *American Architect and Building News* 32 (April 1891): 15–16.
Adler, Dankmar. "The Chicago Auditorium." *Architectural Record* 1 (April–June 1892): 415–34.
Adler, Dankmar. "Foundations of the Auditorium Building." *Inland Architect* 2 (March 1888): 31–32.
"The Auditorium Building." *American Architect* 26 (28 December 1889): 299–300.
Garczynski, Edward R. *The Auditorium.* Chicago: Exhibit Publishing Company, 1890.
Hasbrouck, Wilbert R. "Chicago's Auditorium Theatre." *Prairie School Review* 4 (Third Quarter 1967): 7–19.
Historic American Building Survey no. Ill/1007. Seven sheets of drawings, bibliography.
Pearlman, Daniel H. *The Auditorium Building: Its History and Architectural Significance.* Chicago: Roosevelt University, 1976.
Sabine, Paul E. "Acoustics of the Chicago Civic Opera House." *Architectural Forum* 52 (April 1930): 599–604.
Sullivan, Louis H. "Ornamentation of the Auditorium." In vol. 2 of *Industrial Chicago.* Chicago: Goodspeed Publishing Company, 1891. Portions reprinted in Sherman Paul, *Louis Sullivan, An Architect in American Thought.* Englewood Cliffs: Prentice-Hall, 1962.

Wright, Frank Lloyd. "Chicago's Auditorium is Fifty Years Old." *Architectural Forum* 73 (September 1940): 10 + .

CHICAGO, ILLINOIS: Chicago Opera Festival Auditorium:
"A Mammoth Opera House." *Inland Architect* 5 (March 1885): 25.

CHICAGO, ILLINOIS: Central Music Hall:
Hallberg, L. G. Untitled letter concerning the Central Music Hall. *American Architect and Building News* 6 (1879): 174–75.

CHICAGO, ILLINOIS: Chicago Stock Exchange Building:
Vinci, John. *The Art Institute of Chicago: The Stock Exchange Trading Room.* Chicago: Art Institute of Chicago, 1977.

CHICAGO, ILLINOIS: Fraternity Temple Building:
An Announcement to the Independent Order of Odd Fellows of Chicago and the State of Illinois, September, 1891. Chicago. Burnham Library.
Chicago Tribune 51 (September 1891): 1.
Chicago Tribune 51 (6 September 1891): 29.

CHICAGO, ILLINOIS: Gage Building:
"Brick and Terra Cotta in American and Foreign Cities, Manufacturers' Department and Miscellany." *Brickbuilder* 8 (December 1899): 253–54.
Johnson, Richard D. "The Gage Panels, From Contractor's Scrap to Museum Display." *Prairie School Review* 1 (Third Quarter 1964): 15–16.
Perspective rendering. *Architectural Record* 8 (April–June 1899): 424.

CHICAGO, ILLINOIS: Getty Tomb:
"How the Rich Are Buried." *Architectural Record* 10 (July 1900): 23–54.

CHICAGO, ILLINOIS: Holy Trinity Cathedral:
Commission on Chicago Historical and Architectural Landmarks, editors. *Holy Trinity Orthodox Cathedral and Rectory.* Chicago: City of Chicago, 1978.
Turak, Theodore. "A Celt among Slavs: Louis Sullivan's Holy Trinity Cathedral." *Prairie School Review* 9 (Fourth Quarter 1972): 5–23.

CHICAGO, ILLINOIS: Krause Music Shop:
Commission on Chicago Historical and Architectural Landmarks, editors. *Krause Music Store.* Chicago: City of Chicago, 1977.
Greengard, Bernard C. "Sullivan/Presto/The Krause Music Store." *Prairie School Review* 6 (Third Quarter 1969): 5–10.

CHICAGO, ILLINOIS: McVicker's Theatre:
Blackall, Clarence H. "Notes on Travel: Chicago—I." *American Architect* 22 (24 December 1887): 299–300.
Sullivan, Louis H. "The Decoration of McVicker's Theatre, Chicago." *American Architect and Building News* 23 (11 February 1888): 70–71.
Twyman, Joseph. "Decoration of McVicker's Theatre, Chicago." *American Architect and Building News* 23 (March 1888): 118.

CHICAGO, ILLINOIS: Moody Tabernacle:
"Decoration of the Moody Church." *Chicago Tribune* (2 June 1876): 8.
"The Moody Tabernacle." *Chicago Sunday Times* (21 May 1876): 2.

CHICAGO, ILLINOIS: Ryerson Building:
"Store for Martin Ryerson." *American Architect and Building News* 17 (14 March 1885): 127.

CHICAGO, ILLINOIS: Ryerson Tomb:
"How the Rich Are Buried." *Architectural Record* 10 (July 1900): 23–54.
CHICAGO, ILLINOIS: Schiller Building (Garrick Theatre Building):
"Chicago." *American Architect and Building News* 39 (4 February 1893): 72.
Condit, Carl W. "The Structural System of Adler and Sullivan's Garrick Theatre Building." *Technology and Culture* 5 (Fall 1964): 523–40.
Ferree, Barr. "Architecture." *Engineering Magazine* 4 (November 1892): 297–302.
Fletcher, Bannister. "American Architecture through English Spectacles." *Engineering Magazine* 7 (June, 1894): 314–21.
"New German Opera House." Perspective drawing. *Architectural Record* 1 (January–March 1892): 277.
Schiller Building. Rental Pamphlet. Chicago: C. P. Dose and Company, 1892.
Sprague, Paul E. "Adler And Sullivan's Schiller Building." *Prairie School Review* 2 (Second Quarter 1965): 5–20.
Twose, George. "Steel and Terra Cotta Buildings in Chicago." *Brickbuilder* 3 (January 1894): 1–5.
CHICAGO, ILLINOIS: Schlesinger and Mayer Store (Carson-Pirie-Scott):
"Architecture in the Shopping District." *Inland Architect* 34 (January 1900): 46–47.
"A Big House Still Growing." *Economist* (Chicago) 18 (18 September 1897): 319–20.
Commission on Chicago Historical and Architectural Landmarks, editors. *Carson Pirie Scott & Company Building*. Chicago: City of Chicago, 1979.
Millet, Louis J. and Henry W. Desmond. "The Schlesinger and Mayer Building." *Architectural Record* 16 (July 1904): 53–67.
"The New Schlesinger and Mayer Building in Chicago." *Brickbuilder* 12 (May 1903): 101–4.
Perspective rendering of the 1899 nine-story project. *Architectural Record* 8 (April–June 1899): 425.
Photograph of metal bridge linking the store with the Wabash Avenue elevated railroad. *Inland Architect* 29 (April 1898), photographic section.
"Schlesinger and Mayer Leases." *Chicago Tribune* 51 (26 July 1891): 10.
"Schlesinger and Mayer Lease the Barker Property." *Economist* (Chicago) 15 (30 May 1896): 666–67.
Sullivan, Louis H. "Basements and Sub-Basements." *Economist* (Chicago) 31 (20 February 1904): 254.
Sullivan, Louis H. "Sub-Structure at the New Schlesinger and Mayer Store Building." *Engineering Record* 47 (21 February 1903): 194–96.
CHICAGO, ILLINOIS: Scoville Building:
Sprague, Paul E. "Sullivan's Scoville Building: A Chronology." *Prairie School Review* 11 (Third Quarter 1974): 16–23.
CHICAGO, ILLINOIS: Standard Club:
"The Standard Club's New Building." *American Architect and Building News* 25 (23 March 1889): 137.

CHICAGO, ILLINOIS: Transportation Building:
"Colour Decoration at the Chicago Exhibition." *Builder* (London) 65 (26 August 1893): 151–52.
Crook, David H. "Louis Sullivan and the Golden Doorway." *Journal of the Society of Architectural Historians* 26 (December 1967): 250–58.
Ferree, Barr. "Architecture at the World's Fair." *Engineering Magazine* 5 (August 1893): 651–59.
Fletcher, Bannister. "American Architecture through English Spectacles." *Engineering Magazine* 7 (June 1894): 314–21.
"The Larger Buildings of the Chicago Exhibition." *Builder* (London) 65 (19 August 1893): 131–32.
Sullivan, Louis H., to Daniel H. Burnham, 11 November 1893. Burnham Library, Chicago.
CINCINNATI, OHIO: Burnet Hotel:
Contract News 7 (7 August 1895): 9.
COLUMBUS, WISCONSIN: Farmers' and Merchants' Bank:
Tallmadge, Thomas E. "The Farmers' and Merchants' Bank of Columbus, Wisconsin." *Western Architect* 29 (July 1920): 63–65.
GRINNELL, IOWA: Merchants' National Bank:
"The Merchants' National Bank, Grinnell, Iowa." *Western Architect* 23 (February 1916): 20.
Rebori, Andrew N. "An Architecture of Democracy: Three Recent Examples from the Work of Louis Sullivan." *Architectural Record* 39 (May 1916): 436–65.
MADISON, WISCONSIN: Harold C. Bradley House:
Bennett, James R. "A House with a Soul." *Midwest, the Chicago Sun-Times Magazine* (31 August 1975): 12–13.
Orr, Gordon. "The Collaboration of Claude and Starck with Chicago Architectural Firms." *Prairie School Review* 12 (Fourth Quarter 1975): 5–12.
"Restoration of the Harold C. Bradley House." *Wisconsin Architect* (October 1975): 13–14.
Sigma Phi Society. *Trial by Fire.* Madison: Sigma Phi Society, n.d.
NEWARK, OHIO: Home Building Association Bank:
Rebori, Andrew N. "An Architecture of Democracy: Three Recent Examples from the Work of Louis Sullivan." *Architectural Record* 39 (May 1916): 436–65.
NEW YORK, NEW YORK: Bayard Building:
"Bayard Building, Bleecker Street, New York City." *Brickbuilder* 7 (June 1898): 127–28.
Berger, Meyer. "About New York." *The New York Times* 106 (May 15, 1957): 71.
"Condict Building, Bleecker Street, New York." *American Architect and Building News* 70 (6 October 1900), pl. 1293; (13 October 1900), pl. 1294.
Sturgis, Russell. "Good Things in Modern Architecture." *Architectural Record* 8 (July–September 1898): 92–110.
Sullivan, Louis H. *The Bayard Building.* Real Estate Brochure! New York: Rost Printing and Publishing Company, n.d. [1898 or 1899].

Tuft, Margaret H. "The Bayard (Later Condict) Building by Louis Sullivan: Its Role in New York Life." Unpublished paper, 1969. New York. Avery Library, 1969.

OCEAN SPRINGS, MISSISSIPPI: Louis Sullivan Cottage:

"A Chicago Architect's Winter Retreat." *American Architect and Building News* 55 (23 January 1897), p. 31, pl. 1100.

"Rose-Garden and Residence of Louis H. Sullivan, Architect, Ocean Springs, Miss." *American Architect and Building News* 55 (23 January 1897), photographic section.

Smith, Lyndon P. "The Home of an Artist-Architect: Louis H. Sullivan's Place at Ocean Springs, Mississippi." *Architectural Record* 17 (June 1905): 471–90.

OWATONNA, MINNESOTA: Carl K. Bennett House:

Warn, Robert R. "Bennett and Sullivan, Client and Creator." *Prairie School Review* 10 (Third Quarter 1973): 5–15.

Warn, Robert R. "Louis H. Sullivan, '. . . an air of finality.'" *Prairie School Review* 10 (Fourth Quarter 1973): 5–19.

Warn, Robert R. "Two House Projects for the Carl K. Bennett Family by Louis Sullivan and Purcell and Elmslie." *Northwest Architect* 36 (March–April 1972): 64–72.

OWATONNA, MINNESOTA: National Farmers' Bank:

Bennett, Carl K. "A Bank Built for Farmers: Louis Sullivan Designs a Building Which Marks a New Epoch in American Architecture." *Craftsman* 15 (November 1908): 176–85.

Economist (Chicago) 36 (27 October 1906): 662.

"Making a Monument Work. How Sullivan's Minnesota Bank Was Remodeled and Restored to Its Original Beauty and Grade." *Architectural Forum* 109 (July 1958): 99–106.

Millet, Louis H. "The National Farmers' Bank of Owatonna, Minn." *Architectural Record* 24 (October 1908): 249–54.

"Recent Bank Buildings of the United States." *Architectural Record* 25 (January 1909): 1–66.

Sprague, Paul E. "The National Farmers' Bank, Owatonna, Minnesota." *Prairie School Review* 4 (Second Quarter 1967): 5–21.

RIVERSIDE, ILLINOIS: Henry Babson House:

"A Departure from Classical Tradition: Two Unusual Houses by Louis Sullivan and Frank Lloyd Wright." *Architectural Record* 30 (October 1911): 327–38.

Eaton, Leonard K. "Henry Babson Estate (1909–11)." In *Landscape Artist in America: The Life and Work of Jens Jensen*. Chicago and London: University of Chicago Press, 1964.

"House at Riverside, Ill." *Brickbuilder* 19 (September 1910), pls. 129–31.

"House of William Babson, Esq." *Architectural Record* 38 (October 1915): 388–89.

Wight, Peter B. "Country House Architecture in the Middle West." *Architectural Record* 38 (October 1915): 385–421.

ST. LOUIS, MISSOURI: Colosseum:
 Contract News 9 (4 February 1897): 9.
 Engineering Record 37 (10 October 1898): 383–85.
ST. LOUIS, MISSOURI: Union Trust Building:
 "Architectural Drawings at Chicago." *Builder* (London) 65 (2 September
 1893): 167–70.
 Cox, James. *Old and New St. Louis*. St. Louis: Central Biographical Publish-
 ing Company, 1894.
ST. LOUIS, MISSOURI: Wainwright Building:
 Rental Pamphlet. St. Louis, 1891. Chicago. Burnham Library.
ST. LOUIS, MISSOURI: Wainwright Tomb:
 American Architect and Building News 91 (June 1907), pl. 1640.
 "How the Rich Are Buried." *Architectural Record* 10 (July 1900: 23–54.
SALT LAKE CITY, UTAH: Dooly Block:
 "Sullivan in the West." *Western Architect and Engineer* 218 (November
 1959): 34–37.
 Architect and Building 16 (23 January 1892): 42.
SALT LAKE CITY, UTAH: Hotel Ontario:
 Architect and Building 16 (23 January 1892): 42.
SIDNEY, OHIO: People's Savings and Loan Association:
 Tallmadge, Thomas E. "The People's Savings and Loan Association Building
 of Sidney, Ohio." *American Architect and Building News* 114 (23 October
 1918): 477–82.
OTHER MISCELLANEOUS PUBLISHED PROJECTS:
 Eliel Apartment Building, November 28, 1894. New York. Avery Library,
 FLLW/LHS 23. Published in David Gebhard and Deborah Nevins, *200
 Years of American Architecture*. New York: Whitney Library of Design,
 1977. Also in Paul E. Sprague, *The Drawings of Louis Henry Sullivan*.
 Princeton: Princeton University Press, 1979.
 Design for a Country Club, June 26, 1898. Avery Memorial Library, FLLW/
 LHS 116. Published in Frank Lloyd Wright, *Genius and the Mobocracy*.
 1949. Reprint. New York: Horizon, 1971. Also in Paul E. Sprague, *The
 Drawings of Louis Henry Sullivan*. Princeton: Princeton University Press,
 1979.
 Design for a Museum. Elevation rendering shown in the Chicago Architec-
 tural Club Exhibition of 1913. Published in *Architectural Record* 120 (Sep-
 tember 1956): 18.

OTHER WORKS

Adams, Richard P. "Architecture and the Romantic Tradition: Coleridge to
 Wright." *American Quarterly* 9 (Spring 1957): 46–62.
Bach, Ira J. *Chicago on Foot: An Architectural Walking Tour*. Chicago and
 New York: Follett, 1969.

Behrendt, Walter C. *Modern Building.* New York: Harcourt, Brace and Company, 1937.

Benevolo, Leonardo. *Storia dell'architettura moderna,* 2 vols. Bari: Editori Laterza, 1960.

Birkmire, William H. *The Planning and Construction of High Office Buildings.* New York: John Wiley and Son, 1900.

Blackall, Clarence H. "Notes of Travel, Chicago—I–V." *American Architect and Building News* 22 (December 1887): 299–300, 313–15; 23 (February 1888): 89–91, and (March 1888): 140–42, 147–48.

Bragdon, Claude. *Architecture and Democracy.* New York: Knopf, 1918.

Bragdon, Claude. "Architecture in the United States." *Architectural Record* 25 (June 1909): 426–33; 26 (August 1909): 85–96.

Bragdon, Claude. "L'Art Nouveau and American Architecture." *Brickbuilder* 12 (October 1903): 204–6.

Bragdon, Claude. "'Made in France' Architecture." *Architectural Record* 16 (December 1904): 561–68.

Brooks, H. Allen. *The Prairie School: Frank Lloyd Wright and His Midwestern Contemporaries.* Toronto: University of Toronto Press, 1972.

Burchard, John and Albert Bush-Brown. *The Architecture of America: A Social and Cultural History.* Boston: Little, Brown and Company, 1961.

Burg, David F. *Chicago's White City of 1893.* Lexington: The University Press of Kentucky, 1976.

Campbell, James B. *Illustrated History of the World's Columbian Exposition.* 2 vols. Philadelphia: Sessler and Dungan, 1894.

Cheny, Sheldon. *The New World of Architecture.* London: Longman's, Green and Company, 1930.

Collins, Peter. *Changing Ideals in Modern Architecture, 1750–1950.* Montreal: McGill University Press, 1967.

Conant, Kenneth J. *Tres conferencias sobre arquitectura moderna en los Estados Unidos.* Buenos Aires: Instituto de arte e investigaciones estéticas, 1949.

Condit, Carl W. *American Building Art, The Nineteenth Century.* New York: Oxford University Press, 1960.

Condit, Carl W. *American Building Art, The Twentieth Century.* New York: Oxford University Press, 1961.

Condit, Carl W. *The Chicago School of Architecture: A History of Commercial and Public Buildings in the Chicago Area, 1875–1925.* Chicago and London: University of Chicago Press, 1964.

Condit, Carl W. *The Rise of the Skyscraper.* Chicago: University of Chicago Press, 1952.

Darling, Sharon S. *Chicago Ceramics and Glass: An Illustrated History from 1871 to 1933.* Chicago: Chicago Historical Society, 1979.

David, Arthur C. "The Architecture of Ideas." *Architectural Record* 15 (April 1904): 361–84.

Dean, George S. "Progress before Precedent." *Brickbuilder* 9 (May 1900): 91–92.

Duis, Perry. *Chicago: Creating New Traditions.* Chicago: Chicago Historical Society, 1976.

Duncan, Hugh D. *Culture and Democracy*. Totowa, N.Y. Bedminster Press, 1965.

Early, James. *Romanticism and American Architecture*. New York: Barnes, 1965.

Eaton, Leonard K. *American Architecture Comes of Age: European Reaction to H. H. Richardson and Louis Sullivan*. Cambridge, Mass.: MIT Press, 1972.

Edgell, G. H. *The American Architecture of Today*. New York: Scribner's, 1928.

Egbert, Donald D. "The Idea of Organic Expression and American Architecture." In *Evolutionary Thought in America*, edited by Stow Persons. New Haven: Yale University Press, 1950.

Egbert, Donald D., and Paul E. Sprague. "In Search of John Edelmann." *Journal of the American Institute of Architects* 45 (February 1966): 35–41.

Elmslie, George G. "The Chicago School of Architecture: Its Inheritance and Bequest." Unpublished manuscript. Chicago. Burnham Library.

Ferree, Barr. "Architecture at the World's Fair." *Engineering Magazine* 5 (August 1893): 651–59.

Ferree, Barr. "The High Building and Its Art." *Scribner's Magazine* 15 (March 1894): 297–318.

Ferree, Barr. "The Modern Office Building." *Inland Architect* 27 (February 1896): 4–5; (April 1896): 23–25; (May 1896): 34–35; (June 1896): 45–47.

"First Convention of Architectural Clubs." *Inland Architect* 33 (June 1899): 41–43.

Fitch, James M. *American Building: The Forces That Shape It*. Boston: Houghton Mifflin, 1948. 2d ed., *American Building: The Historical Forces That Shaped It*. Boston: Houghton Mifflin, 1966.

Fitch, James M. *Architecture and the Esthetics of Plenty*. New York: Columbia University Press, 1961.

Flinn, John J. *Chicago, The Marvelous City of the West: A History, an Encyclopedia and a Guide*. 2d ed. Chicago: National Book and Picture Company, 1893.

Gebhard, David. "William Gray Purcell and George Grant Elmslie and the Early Progressive Movement in American Architecture from 1900 to 1920." Ph.D. diss., University of Minnesota, 1957.

Gebhard, David, and Deborah Nevins. *200 Hundred Years of American Architectural Drawing*. New York: Whitney Library of Design, 1977.

Gebhard, David, and Tom Martinson. *A Guide to the Architecture of Minnesota*. Minneapolis: University of Minnesota Press, 1977.

Giedion, Siegfried. *Space, Time and Architecture*. Cambridge: Harvard University Press, 1941. 5th rev. ed. 1967.

Gilbert, Catherine. "Clean and Organic: A Study of Architectural Semantics." *Journal of the Society of Architectural Historians* 10 (October 1951): 3–7.

Gifford, Don, editor. *The Literature of Architecture: The Evolution of Architectural Theory and Practice in Nineteenth-Century America*. New York: Dutton, 1966.

Goldberger, Paul. *The City Observed. New York: A Guide to the Architecture of Manhattan*. New York: Vintage Books, 1979.

Gowans, Alan. *Images of American Living: Four Centuries of Architecture and Furniture as Cultural Expression.* New York: Lippincott, 1964.

Grey, Elmer. "Indigenous and Inventive Architecture for America." *Brickbuilder* 9 (June 1900): 121–23.

Hamlin, A. D. F. "L'Art Nouveau, Its Origin and Development." *Craftsman* 3 (December 1902): 129–43.

Hamlin, Talbot F. *The American Spirit in Architecture.* New Haven: Yale University Press, 1926.

Hamlin, Talbot F. "George Grant Elmslie and the Chicago Scene." *Pencil Points* 22 (September 1941): 575–86.

Hermant, Jacques. "L'Art à l'exposition de Chicago." *Gazette des Beaux-Arts* (troisième periode) 10 (September 1893): 237–53; (November 1893): 416–25; (December 1892): 441–61; and 11 (February 1894): 149–69.

Hitchcock, Henry-R. *Architecture, Nineteenth and Twentieth Centuries.* 1958. 2d ed., Baltimore: Penguin, 1963.

Hoffmann, Donald. "The Brief Career of a Sullivan Apprentice: Parker N. Berry." *Prairie School Review* 4 (First Quarter 1967): 7–15.

Johnson, Diane C. *American Art Nouveau.* New York: Abrams, 1979.

Jordy, William H. *American Buildings and Their Architects.* Vol. 3. *Progressive and Academic Ideals at the Turn of the Twentieth Century.* Garden City: Doubleday, 1972.

Kaufmann, Edgar, editor. *The Rise of an American Architecture.* New York: Praeger, 1970.

Kimball, Fiske. *American Architecture.* Indianapolis and New York: Bobbs-Merrill, 1928.

Koeper, Frederick. *Illinois Architecture from Territorial Times to the Present.* Chicago and London: University of Chicago Press, 1968.

Kouwenhoven, John A. *Made in America, The Arts in Modern Civilization.* New York: Anchor Books, 1962.

Kulski, J. E. "American Experimentation of the Nineteenth Century in Structure and Space." *Journal of the American Institute of Architects* 44 (December 1965): 37.

Lamb, Frederick S. "Modern Use of the Gothic: The Possibility of New Architectural Style." *Craftsman* 8 (May 1905): 150–70.

Larkin, Oliver. *Art and Life in America.* New York: Rinehart, 1949.

Lorch, Emil. "Some Considerations upon the Study of Architectural Design." *Inland Architect* 37 (June 1901): 34.

Manson, Grant C. *Frank Lloyd Wright to 1910: The First Golden Age.* New York: Reinhold, 1958.

Maurice Spertus Museum of Judaica, editors. *Faith and Form: Synagogue Architecture in Illinois.* Chicago: Spertus College Press, 1976.

Mayer, Harold M., and Richard C. Wade. *Chicago: Growth of a Metropolis.* Chicago and London: University of Chicago Press, 1969.

McCue, George. *The Building Art in St. Louis: Two Centuries.* St. Louis: American Institute of Architects, 1967.

Mendelsohn, Erich. *Amerika: Bilderbuch eines Architekten.* Berlin: R. Mosse, 1928.

Mumford, Lewis. *The Brown Decades: A Study of the Arts in America.* 1931. Reprint. New York: Dover, 1955.

Mumford, Lewis. *Roots of Contemporary American Architecture.* 1952. Reprint. New York: Dover, 1972.

Mumford, Lewis. *Sticks and Stones: A Study of American Architecture and Civilization.* 1924. 2d rev. ed. New York: Dover, 1955.

Peisch, Mark L. *The Chicago School of Architecture.* New York: Random House, 1964.

Rand, McNally & Company. *Handbook of the World's Columbian Exposition.* Chicago: Rand McNally & Company, 1893.

Randall, Frank. *History of the Development of Building Construction in Chicago.* Urbana: University of Illinois Press, 1949.

Roos, Frank J. "Concerning Several American Architectural Leaders." *Design* 3 (December 1935): 3–5 + .

Rowe, Colin. "Chicago Frame." *Architectural Review* 120 (November 1956): 285–89.

Schuyler, Montgomery. *American Architecture and Other Writings.* Edited by William H. Jordy and Ralph Coe. Cambridge: Harvard University Press, 1961.

Scully, Vincent. *American Architecture and Urbanism.* New York: Praeger: 1969.

Siegel, Arthur. *Chicago's Famous Buildings.* 1965. 2d ed. Chicago: University of Chicago Press, 1969.

Staber, M. "Funktion, Funktionalismus: Eine Geschichte der Missverstandnisse." *Werk* 3 (1974): 286–87.

Starrett, W. A. *Skyscrapers and the Men Who Build Them.* New York and London: Scribner's, 1928.

"The Statics and Dynamics of Architecture." *Western Architect* 19 (January 1913): 1–10.

Tallmadge, Thomas E. *Architecture in Old Chicago.* Chicago: University of Chicago Press, 1941.

Tallmadge, Thomas E. "The Chicago School." *Architectural Review* 15 (April 1908): 69–74.

Tallmadge, Thomas E. *The Story of Architecture in America.* New York: Norton, 1936.

Tselos, Dimitri. "The Chicago Fair and the Myth of the 'Lost Cause.'" *Journal of the Society of Architectural Historians* 26 (December 1967): 259–68.

Weisman, Winston S. "The Chicago School Issue. The Chicago School of Architecture: A Symposium—Part I." *Prairie School Review* 9 (First Quarter 1972): 6–30.

Whitaker, Charles H. *The Story of Architecture from Rameses to Rockefeller.* New York: Halcyon House, 1934.

White, Norval, and Elliot Willensky. *AIA Guide to New York City.* Rev. ed. New York: Macmillan Publishing Company; London: Collier Macmillan Publishers; 1978.

Wight, Peter B. "Modern Architecture in Chicago." *Pall Mall Magazine* 18: 293–308.

Wilson, Richard Guy, and Sidney K. Robinson. *The Prairie Architecture in Iowa.* Ames: The Iowa State University Press, 1977.

"The Work of Purcell and Elmslie, Architects." *Western Architect* 21 (January 1915): 3–8; 22 (July 1915): 1–12.

Wright, Frank Lloyd. *An Autobiography.* 1932. Reprint. New York: Duell, Sloan and Pearce, 1943.

INDEX

DESIGNED BY CAROLINE BECKETT
COMPOSED BY METRICOMP, GRUNDY CENTER, IOWA
MANUFACTURED BY THOMSON-SHORE, INC., DEXTER, MICHIGAN
TEXT AND DISPLAY LINES ARE SET IN CALEDONIA

Library of Congress Cataloging in Publication Data
Menocal, Narciso G
Architecture as nature.
Bibliography: pp. 203–223.
Includes index.
1. Sullivan, Louis H., 1856–1924. 2. Functionalism
(Architecture) 3. Philosophy of nature. 4. Nature
(Aesthetics) I. Title.
NA737.S9M46 720′.92′4 80-5118
ISBN 0-299-08150-8